MASTERPIECES

PRINCETON ESSAYS ON THE ARTS

MASTERPIECES

Chapters on the History
of an Idea

Walter Cahn

PRINCETON UNIVERSITY PRESS
PRINCETON, NEW JERSEY

Copyright © 1979 by Princeton University Press

Published by Princeton University Press, Princeton, New Jersey
In the United Kingdom: Princeton University Press, Guildford, Surrey

ALL RIGHTS RESERVED

Library of Congress Cataloging in Publication Data will be
found on the last printed page of this book

Publication of this book has been aided by a grant from the
Paul Mellon Fund of Princeton University Press

This book has been composed in VIP Baskerville

Clothbound editions of Princeton University Press books
are printed on acid-free paper, and binding materials are chosen for strength
and durability

Illustrations printed by Meriden Gravure Company,
Meriden, Connecticut

Printed in the United States of America by Princeton
University Press, Princeton, New Jersey

*Les grands monuments font une partie es-
sentielle de la gloire de toute société
humaine: ils portent la mémoire d'un
peuple au delà de sa propre existence, et le
font vivre contemporain des générations
qui viennent s'établir dans ses champs
abandonnés.*

Chateaubriand,
Mémoires d'outre-tombe

CONTENTS

LIST OF ILLUSTRATIONS

PREFACE

This essay is an outgrowth of a seminar for undergraduates which I taught at Yale University during the spring semester of the academic year 1974-75. The interest shown by students and colleagues alike encouraged me to explore the subject more thoroughly. For advice on various points in this endeavor, I must thank Professors Robert S. Lopez, Judith Colton, Steven E. Ozment, Nancy Vickers, John Montias, Roberta Reeder, Leon Plantinga, Dr. Annabelle Simon Cahn, and not least my young son, Claude, who contributed the first of my illustrations. My excellent friend and colleague George L. Hersey read an earlier draft of my manuscript and made many helpful suggestions on matters of both substance and style.

<div style="text-align: right">

Walter Cahn
Yale University
July 1978

</div>

INTRODUCTION

When a work of art impresses us as the highest embodiment of skill, profundity, or expressive power, we call it a masterpiece. In this way, we acknowledge its supreme place in our esteem, and at the same time, seek to set our judgment, insofar as this is possible, beyond challenge or equivocation (Fig. 1). Our ordinary stance in such matters is more flexible. We see things in relative terms, discerning excellence here, mediocrity there or, through a finer exercise of discrimination, more subtle shades of value. But masterpieces are not so much the best of a given class as objects in a class by themselves. Of necessity, only one of Beethoven's nine symphonies may be thought of as the best, but one, several, all, or none have been termed masterpieces. In the confusing hubbub of conflicting opinion, the word has an authoritative ring and will not suffer depreciation. Masterpieces are masterpieces, or they are not. They cannot be what they are in some lesser proportion.

Such an assertion, many would say, is linguistic wishful thinking, representing matters as we somehow mean them to be, not as they are in ordinary discourse. If the inclination to praise is strong, absolute praise is suspect. We have been accustomed for some time to celebrate as minor masterpieces works of an admired author of a limited scope or in a lesser genre. Near masterpieces fall short of unqualified approval by some small yet unbridgeable gap. But the most ambivalent of backhanded compliments is reserved for the flawed masterpiece, which like some raucous nightingale, can only delight us with an impure song.

Superlatives grow weak through overuse, and we employ them sparingly lest we be thought too easy to please. But such reticence is not universal, and those inclined by temperament or professional duty to enthusiasm find themselves in the presence of masterpieces with enviable ease. Foremost in the ranks of these positive thinkers are the copywriters of motion picture advertisements, compelled by the unceasing flow of new productions to vie for a few instants of a large public's already overtaxed attention. As our term is now caught up in a verbal inflationary spiral, we have begun to discover great

masterpieces, absolute masterpieces, universal masterpieces, of all time. How serious a problem this may be is a matter of opinion, but the imaginable remedies are not dissimilar to those proposed for the disorders of monetary inflation and are just as unpopular: limitation of consumption (of the term) or increased production (of masterpieces). In heavy spenders and thrifty folk alike, however, we observe as a common denominator in the use of the word its tendency to assume its full worth in the context of public display rather than private discourse. We are more likely to encounter it on the printed page and in broadcast utterance, striving for a larger, portentous resonance, than to hear it spoken by friends, who are apt to communicate their impressions of an unforgettable esthetic experience in a more concrete way.

This observation draws attention not only to the inherently comical effect which the transposition of a commonplace into noble speech is bound to have, but also to the particular overtones and associations of the word "masterpiece." Calling something a masterpiece is to canonize it, neutralizing its asperities and making it the common cultural property of friend, foe, and the indifferent alike. We erect a kind of Hall of Fame in which the objects of our admiration can be permanently enshrined, not for our selfish contemplation only, but for the benefit of humanity at large. Why we are moved to do so is a question with both psychological and historical dimensions which has yet to be satisfactorily answered. The explanation most frequently heard is that we mean thereby to edify, to illustrate beyond the shifts of styles and values, the constancy of human purpose and condition. Every age, we hold, has had its masterpieces, when inspired men, rising to the highest challenge and transcending the expectations of their time and milieu, have set their mark upon some particle of universality. Such a temple of renown, however, must have its cult, its priests, and inevitably, its guardians, to whom we look for news concerning new arrivals and assurance that their honors have been justly earned.

Have there always been masterpieces? Are we to expect that new ones will always be forthcoming? As regards the past, the most generous surmise that could be made would also be the most reasonable one: the assertion of our humanity, even in the most rudimentary sense, and the onset of higher forms of social organization were themselves major triumphs should they be envisaged on a commensurate scale. Against the skeptics, the cave paintings of prehistoric man which inaugurate our surveys of art history are a sufficient answer. What about the future? Optimists and pessimists will view the

matter differently, but we must bear in mind that there are master-pieces of all kinds. The furious Macduff announces thus the bloody murder of Duncan: "Confusion now hath made his masterpiece!" An anthology of native folklore is called *Masterpieces of American Wit and Humor*; a collection of mystery tales, *Masterpieces of Murder*; and a work of amusing trivia, suitably illustrated, *Masterpieces of Kitsch*. We may well find perfection easier to achieve than to endure.

The present essay intends no more than an introduction to the subject. To attempt anything truly comprehensive would indeed be self-defeating, for the history of masterpieces has become largely synonymous with the history of art itself. The raw materials for its construction would be the biographies of a very large number of monuments and sites, natural or man-made, elaborated out of forms, colors, sounds, or words, yet at the same time biographies of things whose life is not yet complete and never will be. Nor would such a chronicle be adequate without an account of those arrangements by which art and people are brought together for the crucial revelatory encounter and the liturgies designed to lend permanence to these transactions. For though we cannot doubt that masterpieces owe their reputations to intrinsic qualities, some form of public sanction of these merits is required. An American nineteenth-century travel guide describes the awed reaction of visitors to the Dresden Art Gallery in the presence of Holbein's famous *Madonna of Burgomaster Meyer*. "Wunderschön!" or "Ach, Himmel, wie geistreich!" they are heard to exclaim in hushed tones. How much is to be learned from such banalities—if not about the artist, then about museums, about education and psychology, about travel, about Germans and Americans!

Of the sources from which I have drawn, the French contribution is the largest. To a greater degree than is surely justifiable, this is a reflection of the emphases of my reading. But it is also a fair reflection, I believe, of the fortunes of the masterpiece idea. The term *chef d'oeuvre* is documented earlier than its equivalents in other European languages, and insofar as such judgments can claim any validity, it penetrated more deeply into the fabric of discourse than its counterparts elsewhere. The line from Shakespeare (1605) quoted above is in fact among the first citations of "masterpiece" recorded in English, and it is not found again in that writer's works. The Italian *capolavoro* (or more commonly at first, *capodopera*) was an even later entry into the field. So far as I have been able to determine, neither Vasari (1550), Dolce (1557), nor Bellori (1672), to mention three prominent figures

in the historiography of Italian Renaissance art, employ the term at all, relying on other expressive formulas when a superlative is called for. The dictionaries do not register its existence before the eighteenth century, and as far as *capodopera* is concerned, suggest a French derivation. By contrast, *chef d'oeuvre* is of High Medieval origin and by the fifteenth century it was no longer rare. Decorously italicized, it has also infiltrated other languages, seeming to furnish in its foreign setting that extra shade of refined elevation, or, as in Mark Twain's *Innocents Abroad*, a goad for snobbery-deflating laughter.

Within the chronological limits of my account, the late Middle Ages and the Renaissance receive the greatest share of attention. This could be called the subject's heroic period, and masterpieces as we know them would indeed be inconceivable without the profound transformation of the intellectual and social status of works of art wrought in this time. The richly documented enterprises of Margaret of Austria at Brou presented a case, unique to my knowledge, of a *chef d'oeuvre* elaborated in a seemingly deliberate way. It demanded an attentive exploration. The later history of masterpiece has not lacked feats of such ambition, but the goal, elevated to a universal or even metaphysical ideal, everywhere and nowhere at once, has of necessity become less accessible.

Curiously enough, my topic has thus far received little if any serious attention. It is not a category of esthetics or art theory that might be explicated on the basis of an anthology of basic texts and a body of related commentary. Like the more specifically literary concept of the Classic, which is sometimes made to function as its synonym, masterpiece acquired a problematic status only at a time when the accepted hierarchy of values came into question. Where, formerly, the evidence was thought to be plain enough to see or hear, testimony had to be given and proof to be found. But dealing with masterpieces has remained almost entirely a naming activity. The identity of the greatest work, of the best ten, fifty, or one hundred titles on our best seller lists and hit parades is what counts, not the justification for their election. Intuitively or otherwise, we are probably right to feel that arguments which would define the essence of a *chef d'oeuvre* must of necessity have a defensive ring, and if masterpieces cannot speak for themselves, the battle is already lost. Gertrude Stein's "What Are Masterpieces and Why There Are so Few of Them," delivered on a lecture tour of America in 1936, dissents from the common wisdom in its title only and trades instead, in characteristically whimsical fashion, on the elusive qualities of the word and on those pangs of insecurity

which it arouses in those who in increasingly large numbers now feel excluded from its mysteries. Is it capable of yielding a greater treasure of significance? If so, it is not likely to be discovered in ready-made formulas, but in an account of the values and expectations which, over time, masterpiece has successively proclaimed.

MASTERPIECES

I

THE ARTISANAL
MASTERPIECE

Chef d'oeuvre and "masterpiece" are words of Medieval origin. The fact is worthy of special note, since so many of our critical concepts are rooted in the hallowed ground of Classical Antiquity. Moreover, they are not a part of the philosophic vocabulary of the Latin tradition, but terms which we initially encounter in the context of regulatory legislation governing artisanal activity. The exercise of a profession during the Middle Ages necessitated admission to a guild or corporation, made manifest by the candidate's recognition as a master. This step marked the end of a period of apprenticeship, often followed by a further stage of training as a journeyman. The ultimate moment in this process of qualification was obviously of the greatest importance to the young artisan and to the corporation alike. The former depended on its successful outcome for the possibility of earning his livelihood. For the latter, a number of contradictory pressures were involved. It was desirable for the collective prosperity and welfare that a sufficient number of new masters be admitted. The new arrivals assured the continuity of an enterprise and the material security of the household following the death of the former head. In good times, they took care of increased demand. But new guild members were also potential competitors and the impulse to control their numbers must have been strong. Professional pride also led guilds to seek to verify the competence of petitioners for admission. But here, too, other motives can be discerned. It served the interest of stability that goods be produced and services rendered in accordance with accepted formulas and norms of craftsmanship. Esthetic and economic value were both enhanced when work was carried out, as it is frequently expressed in the documents, "in the accustomed manner."

Such an admission procedure accompanied by a test of competence

could be accomplished in a variety of ways and may well have assumed in many cases a rather informal character. From the second half of the thirteenth century onward, however, we hear, first in isolated instances and with greater frequency toward the end of the Middle Ages, of a more clearly specified challenge: in order to demonstrate his skill, the candidate must execute a work for official examination, the masterpiece. So far as is known, this requirement is mentioned for the first time in the documents in Etienne Boileau's *Livre des métiers*, datable between 1261 and 1271, which contains the statutes governing the corporations in the city of Paris. Curiously, among the hundred trades mentioned in this most absorbing compilation, there is only a single and fairly casual reference to the existence of this practice. It occurs among the statutes of the carpenters employed in the making of frames for saddles (*chapuiseurs*), where it is stipulated that "as soon as an apprentice is able to make a masterpiece (*chief d'oevre*), his master may take another one in his employ, because when an apprentice knows how to do this, it is reasonable that he should ply his trade, be active in it and receive greater honor for it than he who cannot do it."[1] Boileau's handbook in all likelihood records an existing state of affairs rather than a departure from custom, and he does not provide any details on the workings of this institution. Presumably, it was already sufficiently familiar to his readers. When it was initially introduced is a question shrouded in the general obscurity which still surrounds the history of professional associations in the early Middle Ages. It is most easily comprehended as an aspect of the increasing significance of an artisanal class which accompanied the growth of towns beginning in the later decades of the eleventh century and continuing in the twelfth.

The Parisian statutes in Boileau's compilation were in subsequent times to be repeatedly reaffirmed, with appropriate amendments or amplifications, and newer professions were provided with constitutions of their own. These texts, of course, represent only a single thread in the vast and variegated tissue of guild legislation which has come down to us. In this, there is no end of variation, the product of the special circumstances and the particular set of social and economic

[1] R. de Lespinasse and F. Bonnardot, *Les métiers et corporations de la ville de Paris, XIIIe siècle: Le livre des métiers d'Étienne Boileau*, Paris, 1879, p. 175, tit. LXXIX: "Si le aprentis set faire 1 chief d'oevre tout sus, ses mestres puet prendre 1 autre aprentiz, pour la reson de ce que, quant 1 aprentis set faire son chief d'oevre, il est reson qu'il se tiegne au mestier et soit en l'ouvroir, et est resons que on l'oneurt et deporte plus que celui qui ne le set faire." See also A. Tobler and E. Lommatzsch, *Altfranzösiches Wörterbuch*, Berlin, 1938, II, 389-90.

factors operative in every town of the extremely fragmented late Medieval polity.[2] It must also be borne in mind that the guild system did not disappear at the end of the Middle Ages but only much later, at the onset of industrial methods of production and the capitalist economy. Our information on the making of these qualifying masterpieces in all its ramifications is correspondingly uneven in its scope and especially conditioned by the nature of the documents involved. They are exclusively of a legal character, presenting the masterpiece as a requirement and briefly setting forth the manner in which it must be carried out: the length of time which is to be spent on the work, the place and conditions under which it must be executed, and usually some indication of the type of project to be assigned to the aspiring master. But they necessarily leave us in the dark about the standards and expectations of the judges, the aims and emotions of the candidates, and perhaps most crucially the wider significance in social and symbolic terms of this rite of passage.

From the present vantage point, a most striking feature of this Medieval institution of masterpiece-making was its wholly artisanal purview. Masterpieces were executed by goldsmiths and tapestry weavers, to whose handiwork we would readily ascribe an "artistic" quality or intention. But they were also expected of apothecaries, carpenters, rope makers, and other professions which it is not our habit to surround with an esthetic aura. At Reims, during the fifteenth century, apprentice barbers hoping to become masters were asked to demonstrate that they could "wet well and shave in a competent manner; comb, trim and thin a beard; prepare lancets suitable for the bleeding of the ill, and be knowledgeable enough in this operation to be able to distinguish between a vein and an artery . . . and know also the appropriate time to carry out a bleeding."[3] Cooks showed their mettle by preparing prescribed dishes. In 1576, at Calais, the masterpiece required was the successful preparation of "a turkey in rum and vanilla sauce, three partridges in a pâté, a milk-fed kid roasted on a spit, a

[2] E. Coornaert, *Les corporations en France avant 1789*, Paris, 1968; F. Olivier-Martin, *L'organisation corporative en la France d'ancien régime*, Paris, 1938; G. Fagniez, *Documents relatifs à l'histoire de l'industrie et du commerce en France*, Collection de textes relatifs à l'étude et à l'enseignement de l'histoire, Paris, 1898-1900; T. and L. T. Smith, eds., *English Gilds*, Early English Text Society, Original Series, vol. XCLX, Oxford, 1870; and R. Wissell, *Des alten Handwerks Recht und Gewonheit*, Einzelveröffentlichungen des Historischen Komission zu Berlin, VII, Berlin, 1971. The vast bibliography on Medieval labor organization at the local level is most conveniently approached through *The Cambridge Economic History of Europe*, II, 1962, 526ff., and III, 1963, 625-34.

[3] Coornaert, *Corporations*, 188.

boar with lard, a tart with jellied filling decorated with fleurs-de-lys of different colors, a basket made with candied sticks interlaced and variously colored, a lion carved in jellied cream, an imitation bunch of grapes made of jelly and an almond tart."[4] Tailors made clothes, butchers dressed meat and locksmiths made locks as their masterpieces. In such a role, the term must have carried with it a strong emphasis on technical prowess—though surely not *mere* technical prowess, as we might well be tempted to say. At the same time, the restriction of the *chef d'oeuvre* to the artisanal domain largely excluded its use from those aspects of human endeavor upon which its lofty connotations would now seem to us most appropriately focused—the products of intellect and imagination at some distance from narrowly utilitarian considerations. A crucial development in the history of the word, which is to be more closely examined below, was its eventual acceptance into the pantheon of higher cultural achievements.

These lofty endeavors of the spirit were in the Middle Ages predominantly assigned to the domain of the liberal arts. This was not to remove poets, philosophers, and learned men of all kinds from the obligation to demonstrate their competence before a jury of their peers. From the twelfth century onward, the principal agent in this confirmatory function was no doubt the university, where apprentice practitioners of the *artes* in debate, examination, and defense of theses hoped to establish their claim to mastery. It is indeed arguable that the rise of universities represented a striving to rationalize and standardize the transmission of knowledge in the intellectual sphere thoroughly comparable to the thrust of guild legislation in the artisanal arena. The thesis is a *chef d'oeuvre* of sorts and has remained so to the present time, since it is still taken as proof of its author's command of a given field and constitutes an accomplishment indispensable toward entry into gainful academic employ. In this respect, universities have remained, for better or for worse, more faithful repositories of Medieval traditions than other institutions of present-day society. In spite of these functional parallels, however, such scholarly labors were never masterpieces in the Medieval sense of the term, for there would always persist in this setting an irreducible difference in the conception and social status of manual and intellectual activity.

If we are thus unable to think of masterpieces of literature or music except within the categories of modern experience, some of the enterprises which are now subsumed under the heading of the fine arts

[4] Ibid.

have an antecedent connection with the artisanal sphere and thus with inspired masterpieces of the older kind. However, the advent of the masterpiece is itself ultimately founded on the recognition of mastery as a special category within the scope of intellectual or technical performance, sanctioned or not by a legally defined status. The word "master" (*magister*) initially signified "one who possesses authority over others," as a Roman jurist succinctly puts it.[5] In the Roman Empire, *magistri* presided over religious societies and private associations of all kinds. The professional guilds or *collegia* had at their head a master elected for a specified length of time and responsible for the running of current affairs and the organization of banquets, sacrifices, and other institutional functions.[6] The Vulgate Bible bestows the title of such offices on the chief butler and baker (*magistri pincernarum et pistorum*) in the story of Pharaoh's dream (Gen. 40:16 and 20), and we now still occasionally employ the term in this sense to designate a person in authority, as, for example, when we refer to the captain as the master of the ship.

Mastery as a term of high competence rather than hierarchical superiority in the narrow sense of the word is expressed in the classical vocabulary by the figure of the *magister* as teacher, himself the leader of a school, and thus by extension an exponent of right thought or doctrine. The Vulgate again gives witness to this usage,[7] and St. Augustine's *De magistro* offers a portrait of the ideal master in action.[8] Such a figure is not only a master over others but over his material. Yet the conception of his mastery remains largely synonymous with that of a leader: he stands alone at the head of a body of students or disciples, among whom there can be no other masters, whatever their qualifications. Mastery in Medieval artisanal practice also embodies a certain didactic function, since in his work, the master not only exemplifies the norms of his craft to the community at large, but contractually undertakes to instruct his apprentices in them in order to prepare them for entry into the profession. The strictly authoritar-

[5] Julius Paulus, *Sententiarum libri*, 126, 6, quoted by J.-P. Waltzing, *Etudes historiques sur les corporations professionelles chez les romains*, Louvain, 1895, I, 388-89: "Magistri non solum doctores artium, sed etiam pagorum, societatum, ricorum, collegiorum equitum dicuntur quia omnes hi magis ceteris possunt."

[6] See Waltzing, I, 385ff., and IV, 342, as well as the entry by B. Kübler, "Magistratus," in Pauly-Wissowa-Kroll, *Realencyclopädie der classischen Altertumswissenschaft*, XXVII, 400ff.

[7] Prov. 5:13, and II Mach. 1:10.

[8] See the edition of G. Weigel, *Corpus scriptorum ecclesiasticorum latinorum*, LXXVI, Vienna, 1961, 1-55.

ian significance of mastery, however, receded in the presence of the notion of mastery as a badge of professional aptitude. A well-known edict of the Lombard king Rothair (643) concerns a group of masons referred to as *magistri comacini*,[9] and, more pointedly, eleventh-century sources speak of a *magister aurificae artis*, of *magistri vitrei*, and of *magistri caementarii*, and thus of men whose identity as a class is defined by their commanding skill in a particular craft.[10] Leo of Ostia (ca. 1075), in his account of the accomplishments of Abbot Desiderius of Monte Cassino, records the latter's intention to repair the loss of the *magistra latinitas*, the collective artistry of the old Roman masters.[11] In a poem of the early sixteenth century, Vitruvius is called "le maistre Charpentier."[12] The expansion in the meaning of mastery in the Middle Ages is further demonstrated by the eventual appearance of the office of the *magisterium*, occupied by a master of masters, a *magister* in the role of leader of artisanal *magistri*.[13]

In the early Medieval documents, the artisans designated as masters are with the rarest exceptions anonymous. But from the eleventh century onward, artisans mentioned by name tend in an ever increasing degree to be distinguished with the master's title. Bernard, *magister mirabilis*, is credited with supervising the construction of the cathedral of Santiago de Compostela, begun in 1078.[14] Gervase's narration of the rebuilding of Canterbury Cathedral after the fire of 1174 calls both architects, William of Sens and his successor William the Englishman, masters, and he regularly resorts to *magister* when, for reasons of style, he does not wish to repeat their names.[15] As these examples suggest, the title was by preference attributed to architects or, more generally, to supervisory agents of building projects (*magister*

[9] *Monumenta Germaniae Historica, Leges,* IV, 1868, 176-80; U. Monneret de Villard, "Note sul memoratorio dei magistri comacini," *Archivo Storico Lombardo,* XLVII, 1920, 1-16; and M. Salmi, "Maestri comacini e maestri lombardi," *Palladio,* III, 1939, 49-61.

[10] O. Lehmann-Brockhaus, *Schriftquellen zur Kunstgeschichte des 11. und 12. Jahrhunderts fur Deutschland, Lothringen und Italien,* Berlin, 1938, nos. 2961, 2187; and V. Mortet, *Recueil de textes relatifs à l'histoire de l'architecture et à la condition des architectes en France au Moyen Age, XIe-XIIe siècles,* Paris, 1911, 73.

[11] H. Hahnloser, "*Magistra latinitas* und *peritia greca,*" in *Festschrift für Herbert von Einem,* Berlin, 1965, 77-93.

[12] Quoted by M. Bruchet, *Marguerite d'Autriche: Duchesse de Savoie,* Lille, 1927, 170.

[13] R. Eberstadt, *Magisterium und Fraternitas: Eine verwaltungsgeschichtliche Darstellung der Enstehung des Zunftwesens,* Leipzig, 1897.

[14] K. J. Conant, *The Early Architectural History of the Cathedral of Santiago de Compostela,* Cambridge, 1926, 57.

[15] O. Lehmann-Brockhaus, *Lateinische Schriftquellen zur Kunst in England, Wales und Schottland,* Munich, 1955-60, nos. 815, 817, 819, and 821-23.

operis, magister fabricae), and this emphasis recalls the older sense of dominance attached to the word. But the master's title was far from obligatory at this time, and we cannot be sure whether its omission tells us something about the status of the artisan concerned or only about the style and purpose of the writer. Thus, Rainier of Huy, whose admirable Liège font (1108-19) should certainly attest to his mastery, is qualified in the documents only as a goldsmith (*aurifaber*).[16] Gislebertus, the sculptor of Autun, is simply Gislebertus, while Wiligelmo, on the contrary, is floridly ushered into immortality through an inscription on the façade of Modena Cathedral which ranks him as "first among sculptors."[17] *Magister* would in this instance have signified much less. In its Medieval context, and not yet burdened with romantic and metaphysical accretions of later times, mastery suggested professional competence rather than distinction, and it primarily defined social and legal status rather than honorific standing. Thus, inevitably, one is led to suspect that the citation of artisans as *magistri* reflects as much as anything else the nature of labor organization in a particular locality and specifically the establishment and official recognition of a guild, not everywhere as yet the rule or custom.

It seems nonetheless pertinent to our inquiry to record the onset of a more assertive display of the master's title, when, toward the end of the twelfth century, it is no longer solely a descriptive term in the written sources, but appears as part of artists' signatures on the monuments themselves. Although the evidence which would enable us to trace this development in detail is of necessity fragmentary and may thus yield a somewhat arbitrary picture, its cumulative substance is telling enough. The inscription of the Portico de la Gloria, the western entrance of the cathedral of Santiago de Compostela, announces the work under construction in 1188 and the name of the builder, Mateo.[18] The latter, in whom scholars have seen the author of an important oeuvre, is called "magister" and also identified as the head of a *magisterium*, presumably of the local corporation of stonemasons. A ciborium from Limoges of the end of the twelfth century bears the inscription of the maker, "Magister G. Alpais."[19] Nicolas of Verdun's

[16] M. Laurent, "La question des fonts de Saint-Barthélemy de Liège," *Bulletin monumental*, LXXXIII, 1924, 333-34.

[17] D. Grivot and G. Zarnecki, *Gislebertus, sculpteur d'Autun*, Paris, 1960, 7; and A. Kingsley Porter, *Lombard Architecture*, New Haven, London, Oxford, 1917, 15.

[18] G. Gaillard, "Le porche de la Gloire à Saint-Jacques de Compostelle et ses origines espagnoles," *Cahiers de civilisation médiévale*, I, 1968, 465f.

[19] M.-M. Gauthier, *Emaux du moyen âge occidental*, Freiburg, 1972, 109, 112.

Klosterneuburg altar of 1181 furnishes us only his name and place of origin, but on the Tournai shrine of 1205, he is called "Magister" in an inscription whose Medieval substance is admittedly not altogether certain.[20] The "Magister Alexander" who takes credit for the execution of an early thirteenth-century illuminated Parisian Bible was apparently the head of a large workshop of book production.[21] In the field of painting, such signatures do seem rarer and in any case later in date, like the emergence of independent painters' guilds themselves. In Italy, from which alone in Europe a reasonably large body of panel paintings of the thirteenth century is still extant, I have found only one artist's signature preceded by the designation *magister*, that of the otherwise obscure master Rainaldo Rainucci of Spoleto, whose painted cross in Bologna is dated 1265.[22] The more renowned figures of the period—Giunta Pisano, Guido da Siena, Margaritone d'Arezzo—have all left us works inscribed with their names unaccompanied by any title save for the occasional designation *pictor*.

The middle of the thirteenth century brings us to the point when economic motives, group solidarity, and craftsmanly pride, no doubt combined in varying proportions from place to place, led some guilds to require a test of competence for mastery. In Paris, the masterpiece is first mentioned as a requirement for admission in the statutes of the painters' company approved in 1391.[23] In Germany, the useful study

[20] *Rhein und Maas: Kunst und Kultur 800-1400*, ex. cat., Cologne, Kunsthalle, 1972, 323-24, no. K5. On the inscription, see J. Warichez and St. Leurs, *La cathédrale de Tournai*, Ars Belgica, 2, Brussels, 1934, 132ff. Other examples are Magister Gundisalvus, whose name appears on the façade of the church of Manhente in Portugal (C. A. Ferreira de Almeida, *Primeiras impressões sobre a arquitectura Românica Portugesa*, Porto, 1972, 25). Rainaldus is called "Operator" and "Magister" in an inscription of the cathedral of Pisa (P. Sanpaolesi, *Il Duomo di Pisa e l'architettura romanica toscana delle origini*, Pisa, 1975, 235ff.). A chalice and paten from Weingarten abbey in Constance are signed "Magister Cunradus" (N.-J. Henser, *Oberrheinische Goldschmiedekunst im Hochmittelalter*, Berlin, 1974, 146, no. 44). Ubertus Magister and his brother Peter, both styled *magistri piacentini*, executed the large bronze doors of the Lateran as well as the doors between the cloister and the sacristy (P. Lauer, *Le palais du Latran*, Paris, 1921, 187-88).

[21] F. Avril, "A quand remontent les premiers ateliers d'enlumineurs laïcs à Paris," *Enluminure gothique*, Les dossiers de l'archéologie, May-June 1976, 40-41.

[22] E. B. Garrison, *Italian Romanesque Panel Painting: An Illustrated Index*, Florence, 1949, no. 532. The signature of a Magister Paescius on an altar frontal in Perugia (Garrison, no. 369) is considered questionable. The situation, however, is very different in the written sources where *magister* is more firmly established. See, for example, those concerning Nicola Pisano, called in a document of 1266 *magister lapidum* (G. Nicco Fasola, *Nicola Pisano*, Rome, 1941), 209, 212, and 216, nos. 4, 5, and 8.

[23] These statutes are printed in *Statuts, ordonnances et règlements de la Communauté des maistres de l'art de peinture et sculpture, graveure et enlumineure de cette ville et fauxbourg de*

of H. Huth enables us to observe more closely the workings of this institution.[24] As elsewhere, guilds of painters here and there associated with sculptors, artisans in stained glass, or saddle makers came into being for the first time in the course of the fourteenth century, though possibly these were descendants of older fraternities under the patronage of St. Luke.[25] At first, the competence of would-be masters does not seem to have been formally tested, but by the middle of the fifteenth century, masterpieces were required in an increasing number of cities of north and central Europe.

The task imposed on painters was generally the execution of a panel of given dimensions; on sculptors, a statue; and on glaziers, a panel of stained glass. The subject is sometimes specified, along with the nature of the material to be used and the technical procedure to be followed. The subjects are those which a fifteenth-century master would most commonly be asked to carry out in the practice of his profession: a depiction of the Virgin Mary, of Christ on the Cross, or of a saint.[26] A more detailed list of subjects is found in the statutes of the painters', sculptors', and glaziers' guild of Lyon, approved by Charles VIII in 1496, which asks the aspiring master sculptor to carry out one of the following projects: "a Jesus Christ in stone, entirely naked, showing his wounds, wearing a little loincloth, with wounds appearing on his hands, side and feet, a crown of thorns on his head, and with a good and pitiful countenance, the entire work measuring five and one-half feet in height; or an image of Our Lady holding her Child in her arms, the same height as the above, handsome in appearance and

Paris, Paris [Louis Colin.], 1698. Article I, pp. 4-5, reads as follows: "Que nul ne soit receu audit Métier pour estre Maistre, ne qu'il ne puisse ou doive à Paris ouvrer et en la Prevosté et Vicomté, ne qu'il tienne Apprentifs jusques à ce qu'il ait fait un Chef-d'oeuvre, et qu'il soit témoigné suffisant par les Jurés et Gardes dudit Métier."

[24] H. Huth, *Künstler und Werkstatt der Spätgotik*, Augsburg, 1925 (reprint, Darmstadt, 1967), 1, 14, 16, 73, and nn. 17ff.

[25] G. Hoogewerff, *De Geschiednis van de St. Lucas Gilden in Nederland*, Amsterdam, 1947; H. Floerke, *Studien zur niederländischen Kunst und Kulturgeschichte: Die Formen der Kunsthandels, das Atelier und der Sammler*, Munich and Leipzig, 1905; E. Camesasca, *Artisti in Bottega*, Milan, 1966; E. Baes, *La peinture flamande et son enseignement sous le régime des confréries de Saint-Luc*, Académie Royale de Belgique: Mémoires couronnés et mémoires de savants étrangers, XLIV, 1812; and J. Schlosser-Magnino, *La letteratura artistica*, Florence and Vienna, 1967, 48-49.

[26] Huth, *Künstler und Werkstatt*, 16; M. Pangerl, ed., *Das Buch der Malerzeche in Prag*, Quellenschrifte für Kunstgeschichte, XIII, ed. R. Eitelberger von Edelberg, Vienna, 1878, 17-18; B. Bucher, *Die alten Zunft und Verkehrs-Ordnungen der Stadt Krakau*, Vienna, 1889, xxx-xxxi, Statute of 1490; and F. C. Heitz, *Das Zunftwesen in Strasbourg*, Strasbourg, 1856, 160-61.

dress; or other good images of Saint Barbara, Saint Margaret or Saint Catherine; or a representation two and a half feet high and three feet wide, with eight well carved and rounded figures, of the Arrest of Christ or a Carrying of the Cross, or a Flagellation in the house of Caiaphas, or a Baptism with Saint John the Baptist accompanied by angels holding his clothes, the whole work of good appearance."[27] A separate article further suggests "a Saint George on horseback, five and a half feet in all, a girl on a rock near him, a serpent near her, seeming to want to devour her, and the figure of Saint George, looking as if about to destroy the serpent with his lance or sword."[28] This list is an anthology of the most popular religious imagery of the time; evidently no effort was made to assess the candidate's ability to realize a complete iconographic program as a test of true mettle. It might be observed, on the other hand, that the choice of the most ordinary subject no doubt enabled the judges to rule on a broader, more familiar ground sustained by experience and comparison.

The kind of skill to be demonstrated may be illustrated by the stipulation of the Strasbourg guild statutes of 1516, which call for the aspirant to make a picture of the Virgin or "some other appropriate image with garments that are carved [which] he should paint, polish, gild, varnish, along with other decoration."[29] Such requirements may similarly be thought of as tests of standard skills, acquired in a period of apprenticeship during which the novice was by all accounts kept busy with the grinding of pigments, the preparation of grounds and similar technical procedures. The Würzburg Guild of St. Luke which asked the candidate to execute a Pietà (*Vesperbild*) went beyond technical specifications in requiring that the body of Christ held in the lap of the Virgin or lying on the ground before Her "be shown in true proportion or posture, and in such a way that the correct structure [*lineamente*] of the figure be made apparent."[30] In general, though, the documents only hint at the expectations of the jury through laconic phrases: the work must be "well and suitably made," "in the appropriate manner and style," and the like. These words presuppose the existence of stable and commonly shared norms of craftsmanship whose mastery could be readily expected. There is no hint that a

[27] Ch. Ouin-Lacroix, *Histoire des anciennes corporations d'art et métiers et des confréries de la capitale de Normandie*, Rouen, 1850, 744, Article XXXIII.

[28] Ibid., 744-45, Article XXXIV.

[29] Huth, *Künstler und Werkstatt*, 89, n. 18.

[30] P. Weissenburger, "Die Künstlergilde St. Lukas in Würzburg," *Archiv des Historischen Vereins von Unterfranken und Aschaffenburg*, LXX, 1936, no. 2, 199, Statute of 1652.

demonstration of such skill should involve notable difficulty or efforts of a truly exceptional kind. Over time, however, there was a tendency for the requirements of the masterpiece to be spelled out in greater detail in guild statutes, and it seems very probable that they became more demanding as well.

Some other stipulations are often found in the statutes with respect to the execution of the masterpiece. Sons of masters and native artisans are quite often given preferential treatment and may be excused from the *chef d'oeuvre* altogether, while the full brunt of the regulation falls as a rule on foreigners. In Paris, for example, local-born locksmiths were initially exempt from the requirement and a "demy chef d'oeuvre" only was imposed on them at the end of the fifteenth century.[31] A time limit, furthermore, is set within which the work must be completed, and it is insisted that the candidate's performance must be his own and not receive the benefit of advice or assistance. The time element naturally varies from one profession to another and may, as in the case of a butcher carving up the carcass of an ox, be simply a matter of observing the action in progress.[32] The specified time was sometimes astonishingly short: several hours at most in the case of the Namur potter of 1793 whose three different vessels were examined by the jury on the same day they were made.[33] The Strasbourg apprentice goldsmiths who had to present as their masterpiece a chalice and a seal die and set a precious stone in a gold ring were given three months to complete their work.[34] The Paris embroiderer Pierre Navaretz asked the guild officials to give him one year to finish an image of St. Bartholomew following a pattern made available to

[31] H. d'Allemagne, *Les anciens maîtres serruriers et leurs meilleurs travaux*, Paris, 1943, 65ff. E. Binet, *Essai des merveilles de nature et des plus nobles artifices . . .* , Rouen, 1621, 344, describes the situation among the embroiderers: "Le chef d'oeuvre d'un Brodeur qui est fils de maistre, se fait d'une Image seule d'or nüe; il faut qu'il monstre son pourtraict a tous les maistres par le clerc du mestier; de plus il faut que l'Image soit d'un demy-tiers de haut. Mais le compagnon qui n'est fils de maistre, doit faire une histoire entiere, ou il y ait plusieurs personnages, ce qui se nomme un quarré, tout d'or nüe. Ce qui est bien plus difficile, car plus il y a de personnages, plus il y a de varieté, de Broderie de toute sorte, et partant, plus de hazard d'estre renvoyé au mestier."

[32] J. George, "Les corporations d'Angoulême," *Bulletin et mémoires de la Société archéologique et historique de la Charente*, 1937, 34: "habiller un boeuf, un veau, un mouton et un cochon."

[33] J.-B. Goetstouwers, *Les métiers de Namur sous l'ancien régime*, Louvain and Paris, 1908, 39.

[34] H. Meyer, *Die Strasburger Goldschmiedezunft von ihrer Enstehen bis 1681*, Leipzig, 1881, 76, Statute of 1482, and 89, Statute of 1534.

him by them, but he was granted only nine months.[35] In certain trades, the amount of time varied in accordance with the nature of the project assigned, and not infrequently, as in the case of the Lyon painters and sculptors already mentioned, no limit is specified at all. The aspiring master could thus be engaged on his assignment for considerable lengths of time, and this could be extended by the dilatory attitude of the jury, which could in a variety of ways retard or withhold its decision. In 1581, King Henry III of France, finding that some poor artisans were occupied on their projects for an entire year or even more, ordered that judges were to assign the subject of the masterpiece within eight days after being requested to do so, and that the work was to be completed within a period not longer than three months for the most difficult trade.[36] In 1691 an edict of Louis XIV, noting that previous legislation had not achieved the desired effect, reduced the length of time still further to one month.[37]

The requirement that the masterpiece be carried out unassisted seems to us to have a self-evident justification. It is nonetheless deserving of note, since in Medieval workshop practice, originality was not particularly prized, and the activity of artisans involved a high degree of cooperation. The execution of a statue or panel might thus under ordinary circumstances be the work of a number of hands. Guild regulations seem eventually to have made some allowance for narrower kinds of specialization through which an apprentice could tailor the masterpiece requirement to the limitations of his own competence. Thus, the candidate was sometimes given a choice of projects to carry out; in Amiens, rope makers could present as their masterpiece either a wicker chair, a rope made of hemp to pull boats, or a harness for a horse.[38] Mastery could be limited to the immediate sphere of demonstrated competence. In 1487, it was ruled that a pewter fabricant of Angers, if he wished to restrict his professional activity to the manufacture of pots, could execute one as his masterpiece. But if he wanted to diversify his production to encompass other types of ware, he would have to accept whatever other qualifying task the guild jurors might impose on him.[39] In Nuremberg, the statutes of the painters' guild of 1596 left it up to the candidate to prove his skill in

[35] J. Guiffrey, *Artistes parisiens du XVIe et du XVIIe siècle*, Paris, 1915, 314-15, no. 646.

[36] R. de Lespinasse, *Les métiers et corporations de la ville de Paris: I, XIV-XVIIIe siècle: Ordonnances générales, Métiers de l'alimentation*, Paris, 1886, 84f., No. XXV.

[37] Ibid., 123, no. XXXIX.

[38] E. Levasseur, *Histoire des classes ouvrières*, Paris, 1900, I, 570.

[39] Ibid., 567.

whatever area of his craft he most excelled.[40] No matter how narrow the exhibition of competence might be, however, it had to be original, and we can see this notion still forcefully articulated in the seventeenth century by La Bruyère in his *Caractères*, when he remarks: "A masterpiece of the spirit which is the work of several persons has hardly been seen up to the present time: Homer wrote his *Iliad*, Virgil his *Aeneid*, Titus Livius his *Decades* and the Roman orator (Cicero) his *Orations*."[41] In order to ensure that work on a masterpiece would proceed unaided, the guild statutes might decree that the candidate had to move to the house of his master and be locked in during the period of his labors. In some instances, the guild organization had a special room (*chambre de chef d'oeuvre*) set aside for this purpose. The wheelwrights' guild of St. Georg an der Stiefing (Styria) assessed a fine of one pound of wax against anyone who so much as set foot in the place where the execution of a masterpiece was in progress.[42]

After the completion of the masterpiece, a jury of the guild masters had to render its judgment. In connection with this procedure, the candidate had to pay certain fees, as well as bear the cost of toasts or even elaborate feasts following the decision—and this whether he was successful or not. Royal pronouncements in France and legislation elsewhere repeatedly stigmatized this custom, apparently to little practical effect. An ordinance of 1535 states that when the masterpiece is finished, the masters of the jury must attend to it, and if it is satisfactory, they must accept it "without the selfsame petitioners being forced to pay for guests to banquets."[43] In his edict of 1691, Louis XIV still deplores the fact that notwithstanding the decrees of his predecessors, "the most skillful and well-trained aspirants to the mastery have been discouraged because they could not afford the excessive costs of banquets and toasts which were expected of them."[44]

[40] Bucher, *Stadt Krakau*, xxxi.

[41] La Bruyère, *Les caractères*, ed. R. Garapon, Classiques Garnier, Paris, 1962, 69: "L'on'a guère vu jusques à présent un chef d'oeuvre d'esprit qui soit l'ouvrage de plusieurs: Homère a fait son *Iliade*, Virgile l'*Enéide*, Tite-Live ses *Décades* et l'Orateur romain ses *Oraisons*."

[42] O. Haberleitner, *Handwerk in Steiermark und Kärnten vom Mittelalter bis 1850: Von der Auffindung bis zur Erlangung des Meisterwürde*, Graz, 1962, Forschungen zur Geschichtlichen Landeskunde der Steiermark, XX, 138-42.

[43] Lespinasse, *Métiers et corporations*, 66-67, no. XV. See also the decree against the cost of masterpieces enacted in 1661 by the Strasbourg goldsmiths (Meyer, *Strasburger Goldschmiedezunft*, 141) and a similar ordinance for Zurich in 1674 (W. Schnyder, *Quellen zur Zürcher Zunftgeschichte*, Zurich, 1936, II, 655ff.).

[44] Lespinasse, *Métiers et corporations*, 123, no. XXXIX.

For the successful apprentice at least, this was the last hurdle. Those whose masterpieces were judged to be deficient had to undergo a further period of training before presenting their skills for examination again. As might be expected, the masters comprising the jury were sometimes in disagreement over the merits of a masterpiece submitted to them. Such a division of opinion, we must assume, would most likely work to the disadvantage of the candidate. The already mentioned edict of Henry III addresses itself to such a situation by providing for an arbitration procedure: in the event of a deadlock, the judges were to ask a small number of masters in the same profession and three or four citizens to review the work. If this panel found it satisfactory, the apprentice must be declared a master, even if the original judges did not agree.

What happened to the masterpiece thereafter is not made entirely clear in the sources. It would appear that by the seventeenth century at least, the guilds might claim ownership of them or expect to realize some gain through their resale. The earlier cited edict of Louis XIV acknowledges this practice even though it treats it as an evident abuse in demanding that "the work be given back to the apprentice and not withheld by the judges or by the guild in order to compel them to buy it back."[45] The contrary opinion seems nonetheless to have been well entrenched in guild legislation. The statutes of the painters and sculptors of Lyon stipulate that the painting or statue executed as a masterpiece project shall belong to the guild if the apprentice does not want it back. If the latter sells it, he must turn over to the guild a sum in cash equal to the estimated value of the work, which is to be used to pay for masses on behalf of the confraternity.[46] This legislation makes it clear that the masterpiece represented for both the guild and the master an object invested with more than passing value, though this is represented in purely material terms, both parties hoping to reap some income from the disposal of the work.

This fact has naturally rendered very difficult the examination of the Medieval institution of the masterpiece from a concrete archaeological standpoint. Some masterpieces, like the sumptuous fare prepared by the apprentice chef or baker, were soon consumed. Others, of a somewhat more durable nature but destined to a purely workaday purpose—clothes, common articles of carpentry or hardware—would have been casually used and eventually cast away. There

[45] Ibid. The Statutes of the tapestry makers of Paris (1719) also specify that the masterpiece is to be given back to the candidate (J. Deville, *Recueil de documents et de statuts relatifs à la corporation des tapissiers de 1258 à 1875*, Paris, 1875, 171).

[46] Ouin-Lacroix, *Anciennes corporations*, 742, Article IX.

is evidence, on the other hand, that some striking specimens found their way into late Renaissance collections of natural and artificial curiosities.[47] The scattered number still preserved and known to me are of a comparatively late date.[48] In the área of painting, sculpture, or goldsmithwork, the inclination to preserve might be supposed to have been greater and the effect of wear and tear surely less drastic. It is quite likely that among the many anonymous works of late Medieval art stored in our museums, there are some objects that were executed and once presented as masterpieces. However, positive identification would in most cases be impossible in view of the conventional nature of the descriptions of masterpiece projects found in the documents. In due course, the rise in the esteem accorded to works of art, no longer seen as merely handicraftsmanly products, led painters' and sculptors' guilds to seek to preserve their *chefs d'oeuvre* rather than sell them for gain, as other corporations continued to do with the projects of their apprentices. Thus, in 1659, the painters of Namur added to their statutes the rule that the masterpieces were to be "used for the decoration of the assembly hall (of the guild), in order to inspire minds to greater perfection."[49] We recognize here an entirely new at-

[47] P. Borel, *Les antiquitez, raretez, plantes, mineraux . . . de la ville de Castres*, Castres, 1649, 146, lists as in his own *cabinet*, under the heading "Choses artificielles": "Deux chefs d'oeuvres de tournerie, l'un de douze gobelets, espais seulement comme du papier, l'autre est de tous les utensiles d'une maison dans une boete." In the *Kunstkammer* of the ducal palace in Munich, Martin Zeiller, *Itinerarium Germaniae . . .* 1632, 286, found "Auff einem Tisch allerhand eiserne Schlösser, Kügel, Bänder und andere Schlosserarbeit und Meisterstück." On the nature and historical background of these collections, see J. von Schlösser, *Die Kunst- und Wunderkammern der Spätrenaissance*, Leipzig, 1908. The pieces of virtuoso craftsmanship found in them were, of course, generally the work of mature and established artisans rather than apprentice trials. The distinction, however is not always clear in the terminology of the inventories.

[48] A number of masterpieces of various trades, most of them of fairly recent date, are found in the Musée du Compagnonnage at Tours. The *chef d'oeuvre* of a glazier with the initials I. L., dated 1691, has been published by L. Bégule, "Chapiteau à incrustation et 'chef d'oeuvre' de vitrerie au Musée de Reims," *Congrès archéologique*, 1912, II, 146-50. The masterpiece of a wax chandler of Graz (Austria) dated 1789 is preserved in the Österreichichen Museum für Volkskunde in Vienna (L. Schmidt, *Zunftzeichen: Zeugnisse alter Handwerkskunst*, Salzburg, 1973, 153, pl. 40). For masterpiece locks and keys, see n. 58, below.

[49] Goetstouwers, *Métiers de Namur*, 40. The Nuremberg painters' guild (Statute of 1596) ordered that all masterpieces be kept in the *Rathaus* so that the skill of the master be exhibited to all (J. Stockbauer, *Nürnbergisches Handwerksrecht des XVI. Jahrhunderts*, Nuremberg, 1879, 1-2; and G. Strauss, *Nuremberg in the Sixteenth Century*, New York, London, Sydney, 1966, 142). The statutes of the Paris Academy of St. Luke also provide for that body's retention of the *chef d'oeuvre* (L. Vitet, *L'Académie royale de peinture et de sculpture*, Paris, 1861, "Pièces Justificatives," 315).

titude, in all likelihood fostered by the example of the Academies, which also established collections of great works of art or copies for the same didactic and inspirational ends.

At the end of the Middle Ages, there took place a development in the history of the artisanal masterpiece which already contains the seeds of this new outlook. In a number of places and in certain professions, the candidate was asked to present not the finished product but a graphic conception of his project only. These drawings, presumably executed on the basis of specifications furnished in advance and under the usual conditions set forth in the guild statutes, bear the name of the artisan, the date of the work, and in some instances a signature recording the approval of the jury. The *Llibres de Passanties* of the goldsmiths' guild of Barcelona are a collection in three volumes of the qualifying designs submitted by candidates for membership from the late years of the fifteenth century into the seventeenth. Incidentally, they thus present a remarkably full survey of the stylistic developments of this branch of art from late Gothic times into the Baroque period.[50] The substitution of drawings for the finished object is no doubt related to the larger phenomenon represented by the wide diffusion after their initial appearance toward the end of the second quarter of the fifteenth century of engraved pattern sheets destined for goldsmiths, woodcarvers and, so it now seems, illuminators.[51] In artisanal industry, a distinction now arose between the inventive and the manual faculty, the former taken to be superior to the latter and eventually cited in support of the artist's claim to the dignity of a liberal vocation. Interestingly enough in this regard, the design of a goldsmithwork object in the Barcelona *Llibres* (Fig. 2) executed by one Gomes Alonso in 1556—perhaps a saltcellar—relies in almost every detail on a slightly earlier engraving by Cornelis Floris.[52] Even though

[50] J. C. Davillier, *Recherches sur l'orfèvrerie en Espagne*, Paris, 1879, 171; and P. E. Muller, *Jewels in Spain, 1500-1800*, New York, 1972, 9 and passim. The *Llibres* are preserved in the Archivo Historico de la Ciudad, Barcelona. The Musée Le Secq de Tournelles in Rouen exhibits a series of tinted drawings executed as masterpieces by apprentice locksmiths in Strasbourg during the eighteenth century. On these, see H. d'Allemagne, ed., *Musée Le Secq de Tournelles à Rouen: Ferronerie ancienne*, Paris, 1924, nos. 5815-24.

[51] R. Berliner, *Ornamentale Vorlageblätter des 15. bis 18. Jahrhundert*, Leipzig, 1925-26. In the introduction to his catalogue *Master E.S.*, Philadelphia Museum of Art, 1967, n.p., A. Shestack surveys the influence of that master's engravings. For the use of pattern sheets on illuminators, see A. H. van Buren and S. Edmunds, "Playing Cards and Manuscripts: Some Widely Disseminated Fifteenth-Century Model Sheets," *Art Bulletin*, LVI, 1974, 12-30.

[52] Muller, *Jewels*, 36.

the Barcelona goldsmiths did not themselves publish their designs and presumably remained artisans in the traditional sense of the word, able and equipped to bring their projects to practical realization, the division between design and execution and the unequal value attached to these tasks could only encourage the view that masterpieces were less the result of manual skill than of the processes of thought and special illumination.

The designs in the Barcelona *Llibres* also permit a few general observations on the character of masterpieces in formal terms, allowance being made for the particular set of circumstances governing this case. The designs are characterized by the greatest variety, and many by remarkable inventiveness. In large measure, this must be ascribed to the high standing of the jeweler's art in Renaissance Europe, vividly illustrated in the career of Benvenuto Cellini. Extraordinary feats of technical brilliance were achieved, and the Mannerist esthetic, favoring the cultivation of the exquisite and the rarefied, gave every incentive for their display. The Barcelona artisans show themselves aware of permutations in taste and style. Contrary to the supposition that the need to please a jury of older and presumably more old-fashioned craftsmen might tend to work in favor of the perpetuation of established formulas, the examinees eagerly take up new ideas, as is shown by several designs of the later sixteenth century based on American (Pre-Columbian) jewelry.[53] In a time of high fashion and elegant self-assertion, they unhesitatingly embrace the cause of novelty.

As the example of the Namur painters and Barcelona goldsmiths also shows, the ideals embodied in the masterpiece within the artisanal setting were not uniform. The level of technical skill required for the proficient exercise of a trade was not the same for all professions. New discoveries or a rapid rate of progress affected the nature of the work and, therefore, the understanding of what constituted mastery. The cultural standing of certain types of craftsmanly endeavor fluctuated in accordance with broader social and economic imperatives. In the course of the fifteenth century, as has been pointed out, there was an outburst of enthusiasm for mechanical devices and a decisive turn toward a favorable view of technology in general.[54] What might amount to competence in the manufacture of

[53] Ibid, 34-35.

[54] L. White, Jr., "The Iconography of *Temperentia* and the Virtuousness of Technology," in *Action and Conviction in Early Modern Europe*, eds. T. K. Rabb and J. R. Seigel, Princeton, 1969, 197-219; and M. Meiss, "Raphael's Mechanized Seashell: Notes on a

clocks and firearms must have been affected accordingly. In the areas now embraced by the fine arts, the notion of competence cannot have been identical for Giotto and for Raphael, and must therefore reflect in some measure the unfolding of new values within the larger panorama of the history of art. Yet in this process, the artisanal corporations were not necessarily passive recipients of ideals forged outside of their immediate domain. Their own experience and interests brought out certain emphases which cut across more assertive values and may occasionally have entered into contradiction with them.

Elaboration and technical virtuosity are qualities which would seem to have been intimately related to the requirements of a demonstration of skill that the exercise of the masterpiece was intended to offer. These qualities were evidently prized by the judges even when they contributed nothing to the usefulness of the work. An account of the events which took place in Tournai between 1609 and 1611 written by an *échevin* of the town, Théodore de Hurges, mentions the complaint of several candidates to the mastery against the imposition of "strange masterpieces" whose execution is deemed by them "most laborious, lengthy, and what is worse, useless." De Hurges gives as examples of such projects one given to carpenters, consisting of a bed "joined and turned so delicately that it could serve only for display," while shoemakers could be asked to make "shoes in the 'apostolic' style, having only the tip of the foot, the heel and the sole of leather, the rest being woven with straps."[55] In his edict of 1691, Louis XIV still inveighs against the extravagance of certain masterpieces demanded of examinees and, like the earlier critic, insists that they be of some use to their makers.[56] Elsewhere, it is similarly observed that the elaborate and impractical nature of many masterpieces make them little more than curiosities.[57]

How is the merit of these complaints to be assessed? In the historical context of the seventeenth century, they are perhaps only a symptom of conflict between an older generation of artisans, steeped in the exuberant taste of late Mannerism, and the younger advocates of a simpler, more practical ideal. The partisans of simplicity who

Myth, Technology and Iconographic Tradition," in *Gatherings in Honor of Dorothy E. Miner*, eds. U. McCracken, L. M. Randall, and R. H. Randall, Baltimore, 1973, 317-32.

[55] Th. de Hurges, "Mémoires d'échevin de Tournai," *Mémoires de la Société historique et littéraire de Tournai*, V, 1855, 50-51, 199.

[56] Lespinasse, *Métiers et corporations*, 123, Article XXXIX. The projects assigned were such as not to be "inutiles à l'aspirant qui les aura faits."

[57] Duhamel du Monceau, *Art du serrurier*, Paris, 1767, 203.

dominate our sources are not so open-minded and blame the execution of useless masterpieces on the egotistical motives of the guild establishment. De Hurges' Tournai petitioners claim that projects of such contrived difficulty were as a rule assigned to foreigners, while the sons of local artisans were favored with simpler assignments, and more generally one may conclude that judges, when they perceived it to be to their advantage, did not hesitate through this and similar tricks to hamper an entrant and delay his admission to the guild. Yet the issue is likely not to be so one-sided. Judgment of quality in the artisanal sphere not unnaturally places a high value on dexterity, ingenuity, and technical prowess and may exalt these qualities beyond the degree warranted by functional considerations. Vexatious impracticality might well appear from this angle a necessary defense of professional standards, and if the early history of the masterpiece could be assumed to have evolved one consistent esthetic premise, it is likely to have been this conviction of the inherent merit of the finely wrought object, exhibiting in unanswerable fashion the skill of the maker.

The masterpieces of the apprentice locksmiths provide an instructive illustration of the effect of these concerns. For a number of reasons, these masterpieces can be more readily picked out of the anonymous artisanal production of the past centuries than those of older professions. They are made of more durable materials than most and, since the seventeenth century at least, they have been sought out by collectors.[58] But, more important, the masterpiece evolved in this instance into a generic type, distinct from ware made for ordinary use, which remained in vogue for a very long time and can thus easily be recognized. The locksmiths' masterpieces generally consisted of a lock with its key, either for a door or a chest. For although locksmiths also made other kinds of objects, such as iron grilles, armatures for windows, and even artificial limbs, locks were considered a more appropriate test since, as an eighteenth-century

[58] The locksmith *chef d'oeuvre* is described by M. Jousse, *La fidelle ouverture de l'art du serrurier* . . . , La Flèche, 1627, 10-11; and Duhamel du Monceau, *Art du serrurier*, 159, 196, and 203. See also the treatment of the subject in D'Allemagne, *Anciens maîtres serruriers*, 65ff. Duhamel acknowledges the interest of collectors in these locks by the observation that in his time, "On ne trouve plus de ces sortes de serrures que chez les curieux." A number of masterpiece locks and keys are exhibited in the Musée Le Secq de Tournelles, Rouen (D'Allemagne, *Musée Le Secq de Tournelles*, I, pls. LVI and LVII, and *La collection Spitzer*, Paris and London, 1861, II, nos. 12, 15, 18, and 19). The Musée des Arts Décoratifs in Bordeaux houses a substantial collection of such pieces. See its publication *La clef et la serrure*, Bordeaux, 1973, 17ff.

author remarks, "There is nothing in this trade that calls for more skill and dexterity on the part of the artisan."[59]

Locks required for strongboxes necessitated the most complex mechanisms and were therefore deemed the most difficult masterpieces. The masterpiece key (*clef de chef d'oeuvre*) was given a particular form, which is first formally prescribed in the statutes of the guild issued in 1650 (Figs. 3 and 4).[60] The bow is not the expected ring but a substantial three-dimensional structure shaped like a baluster or a truncated pyramid and pierced with finely scaled ornament. The stem is short, and the bit is termed "à peigne" because of its close parallel incisions. Lock and key, it is recorded, sometimes kept the apprentice busy for up to two years and more, though the results of these labors, as critics pointed out, could not be wholeheartedly endorsed, for these complicated objects were difficult to handle and easily subject to malfunction.[61] The artisan's formal horizons and the expectations of his peers were rooted in the sphere of late Medieval art, whose rich decorative resources furnished the esthetic counterpart of the minute intricacies of the lock mechanism. The face of the masterpiece lock reminded one of a Gothic church,[62] perpetuating the Flamboyant Gothic well into the eighteenth century in a consciously archaizing attachment to the virtues of ingenuity and complexity. But this phenomenon signifies something else as well: masterpieces had gradually ceased, for some at least, to be a modest test of competence only and had developed into a more formidable challenge.

[59] Duhamel du Monceau, *Art du serrurier*, 159.

[60] D'Allemagne, *Collection Spitzer*, II, 159ff.

[61] Jousse, *Fidelle ouverture*, 10; and Duhamel du Monceau, *Art du serrurier*, 203-204.

[62] Duhamel du Monceau, *Art du serrurier:* "Elles sont semblables à des églises gothiques, ce qui prouve du reste qu'il faut chercher bien loin leur origine."

II

MAN,
THE DIVINE MASTERPIECE

Our discussion of the artisanal *chef d'oeuvre* must now concern itself with a handicraft labor of an altogether exceptional kind by a Master of no ordinary competence. The basis of a comparison between the Creator's actions and those of a skilled artisan is found in Scripture itself. While the Lord's initial, decisive gesture is characterized by the word *creavit*, and therefore, at least until the sixteenth century, radically set apart from mundane labors, He is said to have divided the waters, to have made (*fecit*) the sun and the moon and affixed them to the heavens, and to have planted a garden in Eden. The text represents these accomplishments, extraordinary as they are, as essentially manual operations. The creation of the first parents involves a further display of skills: the Lord forms Adam from the dust of the earth and fashions Eve from one of his ribs. Creation scenes in Medieval art give us literal interpretations of these actions and, in a number of cases, go beyond the immediate sense of the text in showing the Lord carrying out His work in the guise of an architect, with the help of a compass. He also makes garments for Adam and Eve (Gen. 3:21) and might thus be thought a tailor. We have here, to be sure, only the broadest of hints toward the singular perception of the divine work in artisanal terms. But the idea is worked out more fully in the glosses and the rich commentary literature which the creation account inspired.[1]

[1] For a survey of these writings, see F. E. Robbins, *The Hexameral Literature*, Ph.D. Diss., University of Chicago, 1912. The theme of *Deus artifex* is treated by E. R. Curtius, *European Literature and the Latin Middle Ages*, New York, 1953, 544-46, and in its artistic ramifications by A. Heimann, "Iconography of Some Anglo-Saxon Drawings," *Journal of the Warburg and Courtauld Institutes*, XXIX, 1966, 48ff. G. Scholem discusses some conceptions of man's creation in the Jewish tradition in "The Idea of the Golem" in *On the Kabbalah and Its Symbolism*, New York, 1965, 159ff.

Among these writings, we may distinguish two distinct but ulti-
mately convergent strands with respect to the characterization of the
Lord and the Creation. For certain authors, the labor of the *Deus ar-
tifex* is like that of an artisan only in the most painfully naive sense.
The creative act, viewed in the perspective of Platonic cosmology, is
perceived by these authors as a process of pure intelligence. Au-
gustine's important commentary *De Genesi ad litteram* and the later
compositions on this theme associated with the School of Chartres can
be taken as illustrations of this persuasion. Although the whole of
Augustine's text is suffused with it, the section entitled "How God
Works" (I, 18) makes his viewpoint explicit: "But, above all, let us re-
member, as I have often said, that God does not work by temporal
motions that might be said to take place in His soul or body, as does a
man or an angel, but by the eternal, immutable and stable reasons of
His coeternal Word . . ."; or again: "We must not imagine, in a carnal
manner, God speaking temporal words during the days when He ac-
complished His divine works. . . ."[2] Speaking of the creation of Adam,
Augustine considers it childish to hold that the Lord formed man
from the loam of the earth with corporeal hands. This is only a figure
employed by Scripture for our understanding (VI, 12).[3] The confec-
tion of garments for the first parents must have some other sense, too,
even if the event itself undeniably took place (XI, 39).[4] Not having
worked in the literal sense of the word, the Lord cannot be said to
have required repose, either: "It is written that God rested on the
seventh day of all the works which He had accomplished. . . . In order
to try to comprehend this as best as we can and as well as God's help
will permit, we must drive away on this subject all carnal thought from
our spirit. Can one truly believe and say that God fatigued himself on
the labor of Creation when with a word, He brought all things into
being? Even man would not tire if in order to make something, he
merely had to say that it should be made. . . . "[5] Could God by chance

[2] *Patrologia latina*, XXXIV, 260.

[3] Ibid., 347: "Jam ergo videamus quomodo eum fecerit Deus, primum de terra cor-
pus ejus; post etiam de anima videbimus, si quid valebimus. Quod eum manibus cor-
poralibus Deus de limo finxerit hominem, nimium puerilis cogitatio est, ita ut si hoc
Scriptura dixisset, magis eum qui scripsit translato verbo usum creder deberemus. . . ."

[4] Ibid., 451.

[5] Ibid., 301-302: "Jamvero quod scriptum est, requievisse Deum in die septimo ab
omnibus operibus suis quae fecit. . . . Ut quomodo possumus, quantum ab ipso adjuti
fuerimus, intellectu conemur attingere, prius de hoc carnales hominum suspiciones a
nostris mentibus abigamus. Numquid enim dici vel credi fas est Deum laborasse in
operando, cum ea quae supra scripta sunt condidit, quando dicebat, et fiebant? Ita
quippe nec homo laborat si aliquid faciendum, mox ut dixerit, fiat."

have become fatigued not from ordering things into being, but by thinking about it? That is impossible, because in God, "the facility of creating things is incomparable and ineffable."[6]

Augustine's view that Scripture's depiction of Creation in artisanal terms is not to be taken literally, but only as a figure of more momentous actions, far removed from ordinary processes of human industry, is not apt to arouse contradiction. However, the thrust and flavor of St. Ambrose's slightly earlier *Hexameron* are different. Whereas Augustine is at pains to represent the work of the Lord as something other than artisanal labor, the Bishop of Milan delights in the comparison. Commenting on the sequence of the works of Creation beginning with the heavens and the earth and terminating with the bringing forth of plant, animal, and human life, he reasons that "the good architect first establishes the foundation. After this, he lays out the various parts of the building, and then, he proceeds to adorn it."[7] The words which sum up the work of the second day—"God saw that it was good"—are accompanied by the following exegesis: "Artists work first on individual parts and afterwards join them together with skill. Those who start to carve out of marble the features or bodies of men or mold them in bronze or wax do not know exactly how the individual components will blend together, nor the beauty which will be the result of the final work. And so they dare not praise fully, but only in part." But God foresees the whole, and so He is able to praise the total work.[8] About Adam's creation, Ambrose says: "Man has been depicted by the Lord God, his artist. He is fortunate in having a craftsman and painter of such distinction."[9] The analogy of God's work with the making of a painting leads him to a criticism of vain attempts to improve on the Lord's efforts—attempts comparable, it would seem, to the depreciation wrought on original works of art by restorers: "He [man] should not erase that painting, one that is the product of truth, not semblance, a picture, expressed not in mere

[6] Ibid., 302.

[7] Ibid., XIV, 135: "Bonus artifex prius fundamentum ponit: postea, fundamento posito, aedificationis membra distinguit, et adjiungit ornatum."

[8] Ibid., 155: "Solent artifices singula prius facere, et postea habili commissione connectere: ut qui vultus hominum vel corpora excudunt de marmore, vel aere fingunt, vel ceris exprimunt, non tamen sciunt quemadmodum sibi possint membra singula convenire, et quid gratiae afferat futura connexio: et ideo aut laudare non audent, aut pro parte laudant. Deus vero tamquam aestimator universitatis, praevidens quae futura sunt, quasi perfecta jam laudat, quae ad huc in primi operis exordiosunt, finem operis cognitione praeveniens."

[9] Ibid., 260: "Pictus es ergo, o homo, et pictus a Domine Deo tuo. Bonum habes artificem atque pictorem."

wax, but in the grace of God. I speak, also, of women. They erase that painting by smearing on their complexion a color of material whiteness or by applying an artificial rouge. The result is not a work of beauty, but of ugliness; not of simplicity, but of deceit. It is a temporal creation, a prey to perspiration or to rain. . . . This is displeasing to your Creator, who sees His own work obliterated. Tell me, if you were to invite an artist of inferior ability to work over a painting of another of superior talent, would the latter not be grieved to see his own work falsified?"[10]

Ambrose and Augustine, as is to be expected, are in agreement on man's high place on the list of God's accomplishments. But there are once again significant divergencies in their appreciation of this lofty position. Augustine's generally pessimistic view of man's merits leaves him little inclined to celebrate his worth, and we have also seen him reject the idea that the Lord's creative actions might in any sense be likened to those of an artisan and thus be admired for their functional or esthetic potential. Man, he asserts, is "the principal work of God" but this is not, as some hold, because the Lord made him with His own hands rather than merely calling him into being, as He had done in the case of the plants and animals. The privileged position of man is due solely to the fact that he was made in God's image and this necessarily sets him apart from other creatures of the world and expresses his superiority over them. Man's resemblance to God consists of his enjoyment of the faculty of reason. "The rest, though it may be beautiful as such, he has in common with the animals and consequently merits little esteem."[11] At the most, Augustine would perhaps mention one other reflection of the divine image in man, his prerogative of an upright body, which makes it possible for him to look at the sky and thus not be so far removed from it as the beasts, who are forced by their posture to stare at the ground.[12]

For Ambrose, on the other hand, man's creation in the divine image

[10] Ibid.: "Noli bonam delere picturam, non fuco sed veritate fulgentem, non cera expressam sed gratia. Deles picturam, mulier, si vultum tuum materiali candore oblinas, si acquisito rubore perfundas. Illa pictura vitii, non decoris est: illa pictura fraudis, non simplicitatis est: illa pictura temporalis est aut pluvia, aut sudore tergitur. . . . Et tuo displiceas auctori, qui videt opus suum esse deletum. Dic mihi, si supra artificem aliquem inducas alterum, qui opus illius superioris novis operibus obducat, nonne indignatur ille, qui opus suum adulteratum esse cognoverit?"

[11] Ibid., XXXIV, 243.

[12] Ibid., 244. On the fortune of this idea, see L. Sozzi, "La 'dignitas hominis' dans la littérature française de la Renaissance," *Humanism in France at the End of the Middle Ages and in the Early Renaissance*, ed. A.H.T. Levi, Manchester, 1970, 186ff.

has for him extensive esthetic advantages which make his superior place among God's works evident. Speaking of the human body, he asks: "Who can deny that it excels all things in grace and beauty?" Although certain wild animals have superiority in strength and size, "the form of the human body, by reason of its erectness and stature, is such that it lacks massive hugeness as well as abject lowliness. Moreover, the very appearance of the body is gentle and pleasing without those extremes in size and insignificance which might lead either to dread or indifference."[13] It may be noted that while Ambrose, like Augustine, singles out man's erect stance as a trait which marks his superiority over the animals, it is for the Bishop of Milan an esthetic rather than a moral gain. Consistent with this position, his argument is followed by a detailed consideration of the parts of the human body, each an illustration of the purposeful and harmonious constitution of the whole design.[14]

The influence of Augustinian ideas predominates in early Medieval commentaries on Genesis. Bede, Abelard, and Rupert of Deutz, among others, repeat in various formulations his assertion that God's creation of man in His own image refers not to man's external appearance, but to his rational faculty.[15] Some authors also consider, without departing from this perspective, whether not only man but also woman was made in God's image, a question whose answer gives rise to a division of opinion. Thus, while Rupert argues that the image of God was impressed on man and woman without distinction, Abelard holds that man is superior in having been made *ad imaginem Dei* but woman only *in similitudine*. This is a question on which the Biblical tradition eventually encountered the effective challenge of the poets. God's working procedure also received further elucidation. He was assisted, according to the influential cosmology of Alan of Lille, by *Natura*. Herself a creation of God, she acted as the executrix and overseer of the divine projects. God, according to this Platonizing conception, determined the forms of all things and their proper relation to one another. But wishing to remain personally aloof from their actualization and perpetuation, He turned to her for help. *Na-*

[13] *Patrologia latina*, XIV, 264.

[14] Ibid., 265-66. Some Antique and patristic statements on man's special place in the Creation are considered by A. Buck, "Die Rangstellung der Menschen in der Renaissance: dignitas et miseria hominis," *Archiv für Kulturgeschichte*, XLII, 1960, 63ff.

[15] Bede, *In Pentateuchum, Patrologia latina*, XCI, 200: "Homo autem ad imaginem Dei factus dicitur secundum interiorem hominem, ubi est ratio et intellectus; non propter corpus. . . ."; Rupert of Deutz, *De Trinitate et operibus ejus, Patrologia latina*, CLXVII, 247; and Abelard, *Expositio in Hexameron, Patrologia latina*, CLXXVIII, 760.

tura's special field of competence lay in the making of copies based on the divine archetypes.[16] Alan compares her activity to the striking of multiple impressions from a master die, while for Walter of Metz, author of a mid-thirteenth-century *Image du monde*, she is to God as an axe is to a carpenter: when the latter does his work, "the axe does nothing more than cut. And he who holds it brings it down wherever he wishes. By the axe the work is made following the intention of the artisan. In the same way, nature yields before the aims of God."[17]

Notwithstanding these limitations on her role, *Natura* produced a whole series of marvelous creatures which people the writings of twelfth- and thirteenth-century storytellers—Chrétien de Troyes' Enide, Philomena, and Soredamors, and their male counterparts—Erec, Cligés, and Lancelot. In his description, the poet adheres to certain stereotypical conventions, beginning his litany of praise with the hair of the head and moving downward as he enumerates the qualities of different parts of the body. Beautiful women have astonishingly white skin, golden hair, brightly sparkling eyes, and ruby red lips. They have long necks, slender bodies, and white hands with long fingers. Ideally handsome men are tall and well-built, with blond, curly hair, regular features, a big chest, slender waist, and straight, well-formed legs and feet. Nature is said to have realized her most beautiful works in these ideal figures. She would never, the poet may assert, be able to produce another one so fine. In some instances, it is God himself who is named as the author of the work, or else God rivals *Natura* or seeks to surpass her capabilities. The beauty of the figure is said to equal or exceed that of Narcissus or Helen of Troy. It may, in the eyes of the poet, be unequaled in a given city, country, or in the entire world. Finally, it may be such that he confesses it to be beyond his power to adequately describe.[18]

In their characterization of ideal beauty, Chrétien and his contemporaries often refer to it as marvelous, or to one of its embodiments as a marvel (*merveille*). Thus, Troilus is said to have been "beaus à merveille" (*Roman de Troie*, 5393). Fenice in Chrétien's novel *Cligés* was

[16] Alan of Lille, *Anticlaudianus*, VII, 74ff., ed. R. Bossuat, Paris, 1955, 159; H. Gelzer, *Nature: Zum Einfluss der Scholastik auf der altfranzösischen Roman*, Halle, 1917; and C. Luttrell, "The Figure of Nature in Chrétien de Troyes," *Nottingham Medieval Studies*, XVII, 1973, 3-16.

[17] O. H. Prior, ed., *L'image du monde de Maître Gossuin*, Lausanne and Paris, 1913, 86.

[18] J. Houdoy, *La beauté des femmes dans la littérature et dans l'art du XIIe au XVIe siècle*, Paris, 1876; J. Loubier, *Das Ideal der männlichen Schönheit bei der altfranzösischen Dichter des XII. Jahrhunderts*, Halle, 1890; and A. M. Colby, *The Portrait in Twelfth-Century French Literature*, Geneva, 1965.

made by God "por la gent feire merveillier" (2680) and in Blancheflor, "Fist Diex en li passe merveille/C'onques puis ne fist sa pareille."[19] The word is better known to us as it was used since late Hellenistic times to single out the great wonders of the world. A list of Seven Marvels, which took shape by the middle of the second century B.C., was familiar to Medieval writers and exercised a profound influence on the architectural imagination of the subsequent era: the Pyramid of Cheops, the Tomb of Mausolus at Hallicarnassus, the Lighthouse of Alexandria, the Colossus of Rhodes, the Hanging Gardens of Babylon, Phidias' statue of Jupiter at Olympia, and the Temple of Diana at Ephesus.[20] But the identity of these *mirabilia* (or *miracula*) was not wholly fixed. Some authors mention other monuments and do not necessarily adhere to the number seven. Or else, the consciousness of a canonical number suggests to the writer a still more brilliant cause for wonder, an eighth marvel, as Cassiodorus was to call Rome.[21]

The Ancients' notion of marvel, illustrated in these works, carried with it a strong emphasis on the value of technical prowess. Although their artistic merit may well have been considerable, the *mirabilia* were first and foremost triumphs of sheer ingenuity and skill on a colossal scale, man's highest achievements in the realm of magnitude rivaling the great works of the physical world. They were not, however, comprehended as achievements of a supernatural order, as is still clearly shown by the titles of the lists of marvels as they appear in Medieval documents: *De septem miraculis ab hominibus factis*, or *De septem miraculis manu factis*.[22] Yet the wording of these titles also conveys the sense that man-made *mirabilia* were no longer the only ones imaginable. In the sixth century, Gregory of Tours produced a list of marvels studded with Biblical wonders, among them Noah's Ark and the Temple of Solomon, works of men but of men implicitly or explicitly acting under divine inspiration or guidance.[23] A collection of marvels found by Omont in a twelfth-century manuscript distinguishes between artificial and perishable wonders, and those of a natural kind, which exhibit the power of God. The latter, also seven in number, are the

[19] Colby, *Portrait*, 25ff.

[20] J. Lanowski, "Weltwunder," in Pauly-Wissowa-Kroll, *Realencyclopädie der classischen Altertumswissenschaft*, Suppl. X, 1965, 1020-30; and Th. Dombart, *Die sieben Weltwunder des Altertums*, Munich, 1967.

[21] *Variorum libri XII*, VII, 15, quoted by Lanowski, "Weltwunder," 1022.

[22] H. Omont, "Les sept merveilles du monde au moyen âge," *Bibliothèque de l'Ecole des Chartes*, 1882, 52.

[23] *Liber de cursu stellarum, Monumenta Germaniae Historica, Scriptorum rerum Merovingicarum*, I, 875ff., quoted by Lanowski, "Weltwunder," 1022.

tides, germination, the phoenix, Mount Etna, a hot fountain near Grenoble, the sun and the moon; and these *merveilles de la nature*, the anonymous author says "are the marvels which age will not render old, accidents cannot destroy, time cannot diminish and whose end cannot precede the end of all things."[24] In the Medieval understanding of the term, man is not the exclusive purveyor of marvels, and his ingenuity is necessarily overshadowed by the *mirabilia* of the divine architect. At the same time, marvels tend to become truly marvelous, miracles in the modern sense of the word in that their existence is held to proceed from causes beyond the agency of human and natural processes.

The Middle Ages also witnessed a considerable inflation in the number of marvels. In the twelfth or thirteenth century, a certain Master Gregory compiled a description of Rome with the title *Narracio de mirabilibus urbis Romae*.[25] Ranulph Higden (d. 1364), who mentions the work in his chronicle, characterizes these marvels as "arte magica seu opere humano constructa."[26] The fountain of Grenoble, one of Gregory of Tours's divine *mirabilia*, is also cited as one of the Seven Marvels of the province of Dauphiné.[27] The fact that the ancient list of Seven Marvels of the World comprised monuments exclusively concentrated around the eastern shores of the Mediterranean seems to have encouraged a search for examples at closer proximity. Noting that the prodigies of the East had been made thoroughly familiar, the English writer Gerald of Wales proposed in his *Topographia Hiberniae* to investigate those of the West.[28] But the larger cause for the proliferation of wonders lay, no doubt, in the absence of a clear line of demarcation between the natural and the supernatural world. In its place, the realm of the marvelous constituted a zone of shifting contours embracing all exceptional performances of man and

[24] Omont, "Sept merveilles," citing from Bibl. Nat. lat., 12277.

[25] G. McN. Rushforth, "Magister Gregorius de mirabilibus urbis Romae: A New Description of Rome in the Twelfth Century," *Journal of Roman Studies*, IX, 1919, 44ff.; and the new edition of this text by R.B.C. Huygens, *Magister Gregorius. Narracio de mirabilibus urbis Romae*, Textus minores, XLII, Leiden, 1970.

[26] *Polychronicon Ranulphi Higden monachi cestrensis*, ed. Ch. Babington, Rerum Britannicarum Medii Aevi Scriptores, I, 1865, 212.

[27] J. Tardin, *Histoire naturelle de la fontaine qui brusle près de Grenoble*, Tournon, 1618; and H. Pallias, *Sept merveilles du Dauphiné*, Lyon, 1854.

[28] Giraldus Cambrensis, *Topographia Hiberniae et Expugnatio Hiberniae*, ed. J. F. Dimock, *Giraldi Cambrensis opera*, Rolls Series, 21, V, London, 1867, discussed in J. K. Wright, *The Geographical Lore of the Time of the Crusades*, New York, 1925 (Dover reprint, New York, 1965), 337.

nature, from the incomparable and the amazing to the curious and beyond, the altogether weird. "Do not marvel," Walter of Metz urges in his *Image du monde*, "at anything that you have heard about, which may seem to you very strange or most unexpected. For God, in whom all goodness resides, has made on earth many marvels and many works to be marveled at, whose purpose no man knows. And therefore, we ought not to disbelieve that such marvels exist when we are told about them until the time we can verify the matter. For the works of the Lord are so mighty and so difficult to comprehend that every man may say to himself that it is so. . . ."[29]

Only a few years after the death in the full bloom of young manhood of the emperor Otto III (1002), his biographers saw fit to embellish his memory with a truly novel qualification: *mirabilia mundi*. Although some antecedents in Byzantine courtly panegyrics have been suggested, Otto would seem to have been the first human world marvel.[30] In this lofty role, he is shown on one of the narrower sides of the arm reliquary of Charlemagne in the Louvre, made in the years 1165-66 on the orders of Frederick Barbarossa (Fig. 5).[31] As we have seen, however, wondrous men and women were by this time becoming fairly populous in romance literature, if not in real life. Otto was like these heroes and heroines, a very handsome youth, possessed of great charm and, in comparative terms, well educated. But whether it was for these reasons, allied to his imperial status, that he was remembered as a marvel is uncertain. Modern commentators have looked for more profound causes in the political actions and intentions of the

[29] Prior, *Image du monde*, 132; also known in Caxton's version *Mirrour of the World*, ed. O. H. Prior, Early English Text Society, 10, London, 1912, 96-97. The entire world as a theater of marvels is the basis of the work of Etienne Binet, *Essai des merveilles de nature, et des plus nobles artifices* . . . , Rouen, 1621, which seems to have enjoyed considerable popularity in its time. See, on this work, P. Godefroy, "Etienne Binet et ses merveilles de nature," *Revue d'histoire littéraire de la France*, IX, 1902, 640-45; and the considerations from a linguistic perspective of G. Genette, "Mots et merveilles," *Figures I*, Paris, 1966, 171-83.

[30] P. E. Schramm, *Kaiser, Rom und Renovatio*, Studien der Bibliothek Warburg, XVII, 1929 (reprint, Darmstadt, 1962), 185-86 and 353; and E.-R. Labande, "Essai sur la personnalité d'Otton III," *Cahiers de civilisation médiévale*, IV, 1963, 476. A Byzantine parallel is found in a poem of Joannes Mavropous alluding to an image of Constantine Monomachos at Euchaita (C. Mango, *The Art of the Byzantine Empire, 312-1453*, Sources and Documents in the History of Art, ed. H. W. Janson, Englewood Cliffs, N.J., 1972, 220). I owe this reference to Prof. Anthony Cutler of Pennsylvania State University.

[31] E. G. Grimme, *Der Aachener Domschatz*, Aachener Kunstblätter, 42, 1972, 64-66, no. 43; and most recently the entry by D. Kötzsche in *Die Zeit der Staufer*, ex. cat., Stuttgart, Württembergisches Landesmuseum, 1977, 398-99, no. 538.

ruler, or in considerations of a moral and psychological order. Although this must remain hedged by uncertainty, it draws attention to the evident difference between monumental (man-made or natural) and human *mirabilia*. Our esteem of the latter cannot be wholly bound up with outward appearance and physical constitution. It is necessarily solicited to a greater or lesser degree by the conduct of the person, his character and accomplishments, aspects of his being that cannot be encompassed at a glance and require an assessment at longer range. In their judgment of Otto as world miracle, his biographers take an entire lifetime as the appropriate span of their concern. Man, this posthumous praise would seem to imply, is a work fully realized only at the end of his life. In death, he presents himself to his mourners like a ruin. Like the marvels of Rome to which Otto was so sensitive, it is this ruinous state which evokes in posterity the true dimension of his being.

Marvel and masterpiece are now much closer in meaning than they once were, for it is evident that the first independent demonstration of his skill submitted by an apprentice or journeyman to a guild jury could not in ordinary circumstances be expected to arouse extraordinary wonder. When the works of God and nature, and foremost among them, men and women, were called masterpieces, the word had clearly become the terms of superlative praise which we now know it to be, a synonym or substitute for *merveille*. This is how it is employed in a beautiful *rondeau* by Charles d'Orléans (1391-1465):[32]

> Comment ce peut il faire ainsi
> En une seule créature,
> Que tant ait des biens de nature,
> Dont chascun en est esbahy!
> Oncques tel chief d'oeuvre ne vy
> Mieulx acomply, oultre mesure;
> Comment se peut il faire ainsi
> En une seule créature!
> Mes yeulx cuiday qu'eussent manty,
> Quant apporterent sa figure
> Devers mon cueur, en pourtraiture;
> Mais vray fut et plus que ne dy.
> Comment ce peut il faire ainsi!

[32] *Poésies complètes de Charles d'Orléans*, ed. Ch. d'Héricault, Paris, 1874, II, 179, no. CLXXI.

Several fifteenth-century rondels take as their theme the praise of a woman of incomparable beauty. In them, the description of the heroine as a masterpiece functions, in the terms set forth by E. R. Curtius, as a *topos* of outdoing.[33] The poet's beloved is perfection itself. Words cannot do her justice, the efforts of the best painters would be in vain. He is caught in an inextricable dilemma: nothing he can say will adequately meet the challenge, but he is compelled to try to rise to the occasion anyway. Happily, a resolution of the difficulty presents itself: she is her Creator's masterpiece. Could more be said?

> Je la soustiens ung chef d'euvre en nature
> Et ne cognois au monde creature
> A mon plaisir si parfaicte en beaulté
> Ne qui tant ayt de sens et loyaulté
> Pour soy garder de toute forfaiture.
>
> De pareille trouver c'est avanture
> De tel maintien ne de telle stature
> Soit pres ou loing en toute honnesteté,
> Je la soustiens ung chef d'euvre en nature.
>
> Il n'est paintre qui sceust faire en painture
> Ne grant docteur mettre par escripture
> Le parfaict bien qui en elle est dompté
> Par sa treshaulte, excellente bonté;
> Louer la doy en tous lieux par droiture:
> Je la soustiens ung chef d'euvre en nature.[34]

The same theme figures prominently among the poets, who, in the second quarter of the sixteenth century, participated, following the lead of Clément Marot, in the collective celebration of the adornments of the female body, known as the *blasons du corps féminin*.[35]

[33] Curtius, *European Literature*, 162-65.

[34] *Poèmes de transition, XV-XVIe siècles: Rondeaux du Ms. de Lille 402*, ed. M. Françon, Cambridge and Paris, 1938, 203, no. XC. A fifteenth-century ballad perhaps written by Antoine de Lussay goes on in the same vein (*Rondeaux et autres poésies du XVe siècle*, ed. G. Raynard, Société des Anciens Textes Français, 1889, no. CXXXIII, 114-15):

> Pour un chief d'oeuvre vous fist Dieu,
> Car vous estes belle a merveille,
> Et pour ce ne point ne me m'esmerveille,
> Sy l'on vous sert en plusieurs lieux.

[35] H. Guy, *Clément Marot et son école*, Paris, 1926, 210-13. Dr. Nancy Vickers of Dartmouth College, who is preparing a comprehensive study on the *blasons*, kindly ad-

Thus, Mellin de Saint-Gelais, taking the hair as the subject of his *blason*, enthusiastically proclaims:[36]

> Cheveux, qui futes couverture
> Du grand chef d'oeuvre de nature,
> Où le ciel, qui tout clost et voit,
> A monstré combien il pouvoit
> Assembler en petite espace
> De beauté et de bonne grace. . . .

Gilles d'Aurigny praises the fingernail as a masterpiece; Bonaventure des Périers, the navel; and Jacques le Lieur, the thigh.[37] Marot, whose encomium on the female breast had moved the *blasonneurs* into action, did not have solely a remote feminine ideal in mind, but found masterpieces among his flesh and blood contemporaries. One of his epigrams terms a divine *chef d'oeuvre* a noble lady, Gilberte de Rabutin, known as "the beautiful Huban,"[38] and another epigram, written by him in 1537, takes as a masterpiece the royal princess Jeanne d'Albret (Fig. 6), considered by him not the Lord's or nature's sublime handiwork, but that of her parents: "Leur fille unique et le chef d'oeuvre d'eux."[39] Jean Marot, for his part, gallantly calls all Frenchwomen "chefs d'oeuvre de la nature."[40]

The championship of the ideal of feminine beauty inevitably encountered opposition from the sphere of a clerical misogyny deeply rooted in Medieval intellectual culture. It was to refute the arguments of women's detractors that François de Billon wrote his *Le fort inexpugnable de l'honneur du sexe feminin*, published in 1555. In defense of

vised me on this subject. The first edition of the collection, of which a rare copy is preserved in the Bibliothèque Nationale (*Les blasons anatomiques du corps féminin*, Paris, Nicolas Chrestien, 1554), contains some mediocre woodcuts representing each of these adornments.

[36] *Poètes du XVIe siècle*, ed. A.-M. Schmidt, Bibliothèque de la Pléiade, Paris, 1959, 305.

[37] Ibid., 328, 335, and 343, as well as the *blasons* of Jean de Vauzelles on the hair (page 303), and that of Lancelot Carles on the foot (contained in the original collection).

[38] *Oeuvres de Marot*, ed. J. Plattard, Paris, 1929, IV, 261-62.

[39] Ibid., 188-89. Of Henry IV, it was said: "C'est une épreuve de Dieu, un chef d'oeuvre . . ." (H. Boys, *De l'origine et autorité des roys*, Paris, 1604, quoted by R. Mousnier, *L'assassinat d'Henri IV*, Paris, 1964, 229). For the entry of his successor Louis XIII into Aix in 1622, François Malherbe provided a series of verses for triumphal arches, of which the second begins: "Grand fils du Grand Henri, grand chef d'oeuvre des cieux" (Malherbe, *Oeuvres*, ed. A. Adam, Bibliothèque de la Pléiade, Paris, 1971, 143).

[40] *Oeuvres de Clément Marot . . . augmentées avec les ouvrages de Jean Marot son père . . .*, The Hague, 1731, V, 251.

women he develops a vast array of arguments from Scripture, history, and from natural as well as personal observation in order to illustrate the accomplishments of women and their superiority over men in many particulars. As might be expected, Billon also considers that woman's physical beauty and special gifts show her to be God's masterpiece. Even the Genesis narrative yields him a proof of this. God made Eve, he argues, in the Garden of Eden, "a place more noble and delicious," while Adam was created outside, in the plain fields of the open country, and only afterward transferred to Paradise. Moreover, while both man and woman were formed in God's image, Eve's creation followed that of Adam and was God's final work before He rested. Since it would be unseemly to hold that the divine labor could at any point have declined in quality or come to an end on a note of disappointment, Eve must be considered God's climactic accomplishment, His "final chef d'oeuvre."[41]

Billon's massive volume seems to have had the effect of silencing the outpourings of women's detractors for the following half-century. Like the poets celebrating a woman's perfect beauty, Billon was, of course, traveling a well-trodden path, and virtually all his arguments and examples can be found in the copious literature of the *querelle des femmes* before him.[42] The major antecedent in the genre was the treatise entitled *De nobilitate et praexellentia foemini sexus* by the Renaissance polymath Henry Cornelius Agrippa of Nettesheim, written in 1509 though not published until two decades later, and dedicated to Margaret of Austria, whose connection with the history of the concept of masterpiece will occupy us further on. In Agrippa's work are already found, among other arguments for women's superiority, her creation as the final work in the sequence of God's labors and the place of her formation in Paradise in contrast to man's manufacture, together with the animals, "in agro rurali." Women are to him, of all creatures, the most perfect imaginable, *spectacula, mirabilia,* and *miracula*.[43] Not long after its initial appearance, the work was pub-

[41] F. Billon, *Le fort inexpugnable de l'honneur du sexe feminin*, Paris, 1555 (reprint, with a foreword by M. A. Screech, Mouton, The Hague, 1970), 126ff., 152.

[42] E.-V. Telle, *Marguerite d'Angoulême, reine de Navarre et la querelle des femmes*, Toulouse, 1937.

[43] I have used the Lyon edition (1531?) of Agrippa's *Opera*, II, 516ff., especially 520-21. On these arguments for the superiority of women, see also P. Meyer, "Plaidoyer en l'honneur des femmes," *Romania*, VI, 1877, 499-503; and Telle, *Marguerite d'Angoulême*, 25-26. On the author, see most recently C. G. Nauert, *Agrippa and the Crisis of Renaissance Thought*, Urbana, Ill., 1965; and earlier, A. Prost, *Les sciences et les arts occultes au XVIe siècles: Corneille Agrippa, sa vie et ses oeuvres*, Paris, 1881-82.

lished in French (Lyon, 1537) and English editions (London, 1542). An Italian adaptation by L. Domenichini appeared at Ferrara in 1549 and was itself the principal source of another version by William Barker, which was printed in London ten years later. New translations made in the seventeenth and eighteenth centuries attest to the continued interest in Agrippa's text.[44]

In spite of the similarity of language, the excellence of woman as defined by Billon, Agrippa, and their predecessors in this genre of literature has a somewhat different scope than for the *blasonneurs* and their forerunners. For one thing, woman's merits are not solely the attributes of an idealized heroine, but are shared by the sex as a whole. Women's bodies in general are masterpieces, not merely Eve's. Moreover, the arguments of the defenders of the fair sex are concerned not with establishing the perfection of women in a neutral sense, but with their superiority over men. This involves the assumption that the sequence of the works of Creation reveals, first, a descent from an initial high point represented by the appearance of the angels and the souls, then an upward progress from the mineral to the animal world, a gradual "improvement" in God's labor leading to the creation of the first parents. According to this line of reasoning, the masterpiece is not the first work of professional competence, nor any achievement of outstanding excellence, but the final, climactic accomplishment at the end of a long chain of admirable but lesser productions.

Late Medieval literature offers another genre in which people may be described as masterpieces. It is the poetic epitaph or lament on the death of an admired person, whose perfection in life is contrasted with his low estate in death.[45] Here, too, masterpiece functions as a substitute for *miraculum* or other superlatives attributed to the deceased according to the conventions of funerary oratory. The beneficiaries of this kind of praise are as a rule men rather than women. Thus, in his *Depreciation* for Pierre de Brezé, who had distinguished himself in the military campaigns of Charles VII and Louis XI and

[44] Among these are *Traité de l'excellence de la femme faict français du latin* . . . , Paris, J. Poupy, 1578; *De la grandeur et de l'excellence des femmes au-dessus des hommes*, Paris, F. Babuty, 1713; *Sur la noblesse et excellence du sexe feminin*, Leiden, T. Haak, 1726; and *De l'excellence et de la supériorité de la femme*, Paris, 1801.

[45] E. Dubruck, *The Theme of Death in French Poetry of the Middle Ages and the Renaissance*, London, The Hague, Paris, 1964. The long history of the *Ubi sunt* theme has been traced by E. Gilson, "De la Bible à François Villon," *Les idées et les lettres*, Paris, 1932, 1-28. See also L. Friedman, "The 'Ubi sunt,' the 'Regretz,' and the 'Effictio,' " *Modern Language Notes*, LXXII, 1957, 499-505.

was killed in action at the Battle of Monthléry (1465), the historian of the Burgundian court, Georges Chastellain (ca. 1415-1475), adjures kings, dukes, princes, and others whom the lamented victim had served to gaze upon this "chef d'oeuvre entre les bons, et maintenant voyez sa decadence, plorez et le condolez."[46] Upon his death, Chastellain was himself mourned in a *Complainte* by the poet Jean Robertet, for whom the deceased in his prime was "le chef d'oeuvre du monde."[47] Jean Molinet, Chastellain's successor as the official historiographer of the court of Burgundy, was familiar with the chivalric praise of ideal beauty and noble women as masterpieces. In a poem written some time after 1497, he addresses his patron, Margaret of Austria (Fig. 7), with the words:[48]

> Chief d'oeuvre exquis, sapiente Sebille,
> Du tout abille en science et vertu,
> Dieu vous crea gracieuse et humile. . . .

In the same spirit, in another poem he plays on Margaret's name as that of a beautiful flower:

> La doulce rose a grant meritte,
> Mais la tres noble margueritte
> Est le triumphe de beaulté,
> Des fleurs le chief d'oeuvre et l'eslitte. . . .[49]

But in a different vein, the death of Charles the Bold in 1477 occasioned the following lament on a lost masterpiece:

> . . . Nature
> N'a chief d'oeuvre plus parfaict.
> Faulse Atropos, que as tu faict?
> Tu a brassé grand mesfait;
> Par ton faict
> Perdons vie et nourriture.[50]

Seven years later, Molinet mourns the passing of the Emperor Frederick III, compared to a large and beautiful tree in the middle of a

[46] *Oeuvres de Georges Chastellain*, ed. Kervyn de Lettenhove, Brussels, 1865, VII, 56.

[47] Robertet, *Oeuvres*, ed. M. Zsuppan, Geneva, 1970, 160.

[48] *Les faictz et dictz de Jean Molinet*, ed. N. Dupire, Société des Anciens Textes Français, Paris, 1936, I, 341.

[49] Ibid., 344. See also, for Molinet's use of *chef d'oeuvre*, the *Collaudation à Madame Marguerite* (1493) in the same volume, 265.

[50] Ibid., 243-44.

forest, a cedar higher, greener, more fragrant and holier than all others:[51]

> Tous arbres grans et est leur propre roy,
> Cest arbre sainct exempt de tout desroy
> Resplendissant sus tous aultres chiefz d'oeuvre,
> On voit que c'est, la veue le descoeuvre.

In an epitaph on the death in 1495 of the famous composer Johannes Ockeghem, which was set to music by Josquin des Prés, the poet returns once more to the same image, and the contemplation of the grave of the deceased brings forth these melancholy sentiments:

> Vray tresorier de musique et chief d'oeuvre,
> Doct, elegant de corps et non point trappé;
> Grant dommaige est que la terre le coeuvre.[52]

For Jean Lemaire de Belges, Molinet's own successor as official historian of the Burgundian house, Isabelle of Bavaria was a "chef d'oeuvre advenir en honneur et en hautesse."[53] Like Molinet, he also employed the word in the context of funerary lament, as in his *Plainte du Désiré*, written on the death in 1503 of his first patron, the Count of Ligny:

> Ha! fiere mort horrible, et pestifere,
> As-tu osé, sans repit, sans recoeuvre
> Faire tarir un si noble chef d'oeuvre?[54]

The contrast between erstwhile perfection and misery in death is a frequent theme in late Medieval art and literature. Of particular interest to us here are the funerary monuments in which this idea is made manifest through the juxtaposition of an idealized effigy of the deceased with an image of his putrified and worm-eaten corpse. The monument of Cardinal Jean de la Grange (d. 1402), which formerly stood in the church of Saint-Martial in Avignon, is generally regarded as the oldest example of this "double decker" form of tomb design, widely diffused throughout northern Europe from the fifteenth

[51] Ibid., 272.

[52] Ibid., II, 1937, 833. Josquin's musical setting is published and discussed by E. Lowinsky, *The Medici Codex of 1518*, Monuments of Renaissance Music, III-V, Chicago and London, 1968, III, 213-14, and IV, 338-46, no. 46.

[53] *Couronne margaritique*, in *Oeuvres complètes de Jean Lemaire de Belges*, ed. M. Stecher, Louvain, 1891, IV, 102.

[54] *Oeuvres complètes*, III, 160.

through the sixteenth centuries (Fig. 8).[55] At the base of the monument we see the recumbent figure of the cardinal in his episcopal vestments and, below, his emaciated *transi*, with an inscription warning viewers to guard against the sin of pride since they too will one day be reduced to the same state. "We have been made a spectacle for the world," the cadaver is made to say, a spectacle made all the greater by the high status of the deceased and one which is given permanence before mankind by being enshrined in an imposing monument. This, then, is a world marvel of an ironic kind, a "sorry spectacle" as we would say, and for good reason. Scholarly investigation of the tomb, its antecedents, and its typological posterity has shown the connection of these works with the rich vein of late Medieval moralizing commentary upon the vanity of all earthly delights and the inescapable visitation of death on every creature.[56] The late E. H. Kantorowicz elucidated another dimension of the significance of these monuments when he demonstrated that the two contrasting representations of the defunct stand for two distinct aspects of his person. In the decaying corpse, we have the temporal vessel of flesh and blood, subject to the outrages of time and of the human condition. The idealized effigy stands, in this interpretation, for the dignity of the office occupied by the deceased, which cannot perish.[57] This division of the person into lasting and ephemeral constituents, rooted in political theory and applicable in the first instance to the figure of the king, was not known to the epitaph poets. For them, the concept of the deceased as a masterpiece embraces the entire being in all his capacities. Chastellain, Brezé, or Ockeghem are represented by them as singular and irreplaceable individuals, now tragically reduced to ruin. The contrast between the idealized living body, resplendent in his vestments, and the destitute, naked corpse, illustrates for them not complementary aspects of the same person in a timeless frame of reference, but separate moments of a single, undivided life.

In the poetic laments, the expression of sorrow, even of despair, inspired by the loss of an exceptional being must also strike us as remarkable. The moralizing character of the inscription of the La

[55] E. Panofsky, *Tomb Sculpture*, New York, 1964, 64-65; and A. McGee Morganstern, "The La Grange Tomb and Choir: A Monument of the Great Schism of the West," *Speculum*, XLVIII, 1973, 52-69.

[56] K. Cohen, *Metamorphosis of a Death Symbol: The Transi Tomb in the Late Middle Ages*, Berkeley, 1973.

[57] E. H. Kantorowicz, *The King's Two Bodies: A Study in Medieval Political Theology*, Princeton, 1957, 383-450.

Grange monument and other reflections on the vanity of earthly cares found on late Medieval tombs, is entirely foreign to them or much understated. Indeed, we find them wholly disconsolate, or else taking death to task for the injury which it has inflicted. These are sentiments notably lacking in late Gothic funerary monuments, and we are likely to find them more congruent with a humanistic outlook. A recent history of the *transi* tomb speaks well in this regard of a "new spirit" in funerary sculpture of the beginning of the sixteenth century, when not only the gisant effigy, but particularly the *transi* lost their expressive hyper-realistic asperity and became touched by the graceful idealism of Italian Renaissance art.[58] Molinet and Lemaire's activity partakes of the corresponding phenomenon in the literary domain, but as we have seen the metaphor of masterpiece applied in retrospective fashion to an exemplary life was not new with them and is already encountered at least a generation earlier. Thus, in spite of their divergent messages, the verbal and monumental forms of the "double decker" tomb appear as substantially contemporaneous manifestations.

When Augustine sought to deny that the Creator's works could in any way be likened to those of an artisan, he was moved by the belief that such a comparison would be inherently unworthy and undignified. The inclusion of the artist's labor within the category of a handicraft activity, held in low esteem by men of Augustine's class and Platonizing convictions, stands at the heart of this view. Although such a low assessment of manual labor was not necessarily universal in ancient times, the conception of the Lord as a maker of masterpieces must presuppose a considerable erosion of this position. The admiration of world marvels acknowledges the high merit of exceptional feats of craftsmanship, and insofar as it sees in them evidence of supernatural authorship, it imputes to their Maker an interest in invention, technique, and artifice. From the twelfth century onward, furthermore, it is possible to witness a sustained rise in the prestige of technical achievement. The revival of the Ovidian formula *ars auro prior* with its affirmation of the superiority of skilled workmanship over precious material may be taken as a small but significant piece of evidence in this direction.[59] The high regard which came to be accorded to the architect's profession in the thirteenth century is

[58] Cohen, *Metamorphosis*, 120ff.

[59] See J. Bialostocki, "Ars auro prior," *Mélanges de littérature comparée et de philologie offerts à Mieczyslaw Brahmer*, ed. C. V. Aubrun et al., Warsaw, 1967, 55-63.

another, affecting and, in turn, reciprocally illuminated by the perception of the Creator as architect of the universe. The builders of the Sainte-Chapelle or of the major Gothic cathedrals, beyond their functional and expressive intentions, persuade us as they must have persuaded their contemporaries, that mastery in the most accomplished sense has a kind of self-evident, autonomous claim to our admiration. If the personality of the Creator as the supreme artisan was thus vindicated, the view of man (or woman) as His highest accomplishment would seem to be its logical counterpart. Yet this notion, though it is already adumbrated in Ambrose's comments on the beauty of the human body, also required for its full fruition a different cultural climate, more optimistic in its assessment of the merits and possibilities of mankind. Chivalric literature and political oratory contributed a steady if conventional stream of laudatory verse in praise of excellent men and women, and we must wonder whether the scientific and political writings of the later Middle Ages did not play a part in the same process through the increasingly more complex and differentiated picture of human nature and potential which they suggested.

God as the supreme artist and man as His supreme creation is a theme which was especially congenial to authors of art history and theory. Vasari, among others, dilates on it in the preface of his *Lives of the Most Eminent Painters* (1550). In creating man, he argues, God established the perfect model from which sculpture and painting derive.[60] Vasari, so it would seem, extracts from the excellence impressed by God upon the form of man a basis for the argument that the human figure stands highest among the subjects with which an artist ought to concern himself. Since man is God's masterpiece, the depiction of man will be like an echo of the divine achievement. Perhaps we should see here, too, an assertion of the special claims of portraiture, capable of re-enacting through the pictures of the *uomini famosi* of every age, the Creator's most splendid labors. The painter who, in an engraving by Abraham Bosse, turns from other projects to

[60] Vasari, *Vite*, ed. G. Milanesi, Florence, 1906, I, 215-26. Sandrart similarly stresses this point when he remarks man that man "allein in sich alle göttliche Geschöpfe als das volkommenste Meisterstück des allerhöchste begreift" (*Academie der Bau-, Bild-und Mahlerey-Künste von 1675*, ed. A. R. Peltzer, Munich, 1925, 279). See on this and related ideas the chapter "*Deus artifex-Divino artista*" in E. Kris, *Die Legende vom Künstler*, Vienna, 1934, 47ff.; E. Panofsky, *Idea: Ein Beitrag zur Begriffsgeschichte der älteren Kunsttheorie*, Studien der Bibliothek Warburg, 5, Leipzig, 1924; and in relation to architecture, G. L. Hersey, *Pythagorean Palaces*, Ithaca and London, 1976, chap. 3.

a portrait of the king of France, is fated, so the accompanying inscription assures us, to realize a *chef d'oeuvre* (Fig. 9).[61]

In the Biblical account of man's formation from the dust of the earth, we discover a Renaissance master at work: "for the Divine Architect of time and nature, being wholly perfect, wanted to show how to create by a process of removing from and adding to material that was imperfect in the same way good sculptors and painters do when, by adding and taking away, they bring their rough models and sketches to the final perfection for which they are striving."[62] The sense of intimacy between divine and human industry, as it is here expressed, hides more fully than heretofore the awesome gap between the masterpieces of the Almighty and the mundane artifact. It matters less, in this subtle equation of unequal performances, that God works like man than that man's labor has come to resemble his Creator's.

[61] A. Blum, *Abraham Bosse et la société française au XVIIe siècle*, Paris, 1924, 117-18. According to the verses under the print,

> Mais quand il nous peint les lauriers
> De Louys, honneur des Guerriers,
> Et vray portrait de la Victoire
> Il fait un chef d'oeuvre sans prix
> Pour ce grand Roy, qui dans l'histoire
> Est l'objet des meilleurs Esprits

[62] Vasari, *Vite*, I, 216.

III

TOWARD THE ENDURING
MONUMENT:
NANTES, BROU,
MARGARET OF AUSTRIA

In the course of the later Middle Ages, the exclusive connection of the masterpiece with the artisanal world was severed, and the word came into broader usage. We can observe, on the other hand, an important element of continuity between its original significance and later application, showing its sense to be still distinct from that which it now possesses. Artisans continued to make *chefs d'oeuvre* as part of the procedure of their professional qualification. But these, the first efforts of young men about to strike out on their own, would, with few exceptions, not be likely to have met the high expectations which the word "masterpiece" now arouses in us. God and Nature's masterpieces, by contrast, easily meet the test. But they were and remain special cases. The view of the Creation as a work of the hand is bound to remain a problematic metaphor, while the contemplation of the divine labor surely draws on sentiments of piety and awe that are remote from ordinary commerce with works of art. In one instance, thus, we are confronted with masterpieces unworthy of the label, and in another, with superlative works by an admirable but surely overqualified artisan. We recognize in the modern concept of masterpiece a transference of the terms formerly reserved for the divine work to the best enterprises of man. It is the historical circumstances which attended this process which must now engage our attention.

If fifteenth-century commentary on art in northern Europe can be said to have been faced with a major issue, this was the ever increasing significance assumed by the achievements of the Italian Renaissance. The Italian masters did not merely practice a different style. Their art

was perceived within humanistically oriented circles as radically different from that cultivated in the north and, in its profound yearning for the recovery of the Classical past, as a challenge to that sensibility which we have learned to describe as Medieval. The renewed or more sustained contact with Classical Antiquity fostered beyond the Alps not only brought about a renewal of art, but a new way of talking about it, itself largely derived from the esthetic and rhetorical vocabulary of the Ancients. Our authors have heard of an outstanding Italian master, or learned to celebrate his work as the equal of Apelles or Zeuxis. But, as is to be expected, much of their outlook and mode of expression remains anchored in the intellectual framework of their own milieu. The way they deal with the notion of masterpiece is especially revealing, for this was a term of Medieval origin, and moreover indelibly colored by its connection with the artisanal world, in whose confines the more self-conscious of Renaissance artists were growing progressively more restive. A poem of Jean Robertet (d. 1503) deals with these matters in an original way.[1] The writer is moved to mockery in the presence of "an ugly painting, made with bad colors by the most inept painter in the world."

> Pas n'approchent les faictz maistre Rogier,
> Du Perusin qui est si grant ouvrier,
> Ne des painctres du feu roy de Cecille,
> Au chef d'oeuvre que voyez cy entier;
> Et semble bien qu'il n'est pas savetier,
> Le compaignon, mais homme tresabille. . . .

The work which Robertet calls a masterpiece here is presumably a conventional late Gothic painting whose mediocrity cries out before the artistry of Roger van der Weyden, Perugino, and the painters of King René of Anjou. True mastery is contrasted with what ordinarily passes for it, and it is noteworthy that the poet has chosen in order to exemplify the former a carefully balanced representation of Netherlandish, Italian, and French(?) practitioners. In Robertet's poem, "masterpiece" would seem to be employed in a derogatory sense, but we must bear in mind that the writer means to be ironical, and we are not left to doubt that true *chefs d'oeuvre* exist, nor who their authors

[1] *Soubz une meschante paincture faicte de mauvaises couleurs et du plus meschant peinctre du monde, par maniere d'yronnie, par meistre Jehan Robertet*, published by P. Champion, "Sur l'épigramme de Jean Robertet contre un mauvais peintre," *Bibliothèque de l'Ecole des Chartes*, VII, 1846, 69; and Robertet, *Oeuvres*, ed. M. Zsuppán, Geneva, 1970, 185-86, no. XXI.

are. Still, that the word seems to him somehow more appropriately applied to anonymous artisanal products than to works of Roger and Perugino has its interest, for it is a measure of the unmistakably negative connotation it had acquired for those whom it too readily reminded of the unassuming handiwork of shoemakers.

Other voices, however, have a different ring, and we discover "masterpiece" as a term of praise for high human artistry for the first time. The west front of the cathedral of St. Pierre in Nantes is the earliest beneficiary of this attribute to which I can point (Fig. 10). The nave of the cathedral was begun in 1434 under the direction of Guillaume de Dammartin, succeeded by Mathurin (or Mathelin) Rodier, who is first mentioned in office in 1454.[2] Ten years later, Duke Francis II of Brittany permitted the Chapter to levy a special tax so that work could proceed on the west façade "qui est tout bel, magnifique et somptueux."[3] In 1481, under Bishop Pierre de Chaffault, new bronze doors executed by a certain Pierre Frontin could be installed in the central portal. These doors, which were dismantled and destroyed during the French Revolution, bore an inscription recording their date and patronage.[4] In this, the verbal Rubicon is crossed:

> Sixt pape quart l'eglise gouvernait
> L'an mil cinq cens mis hors dix et neuf ans
> Francois second duc de ce nom regnait
> Pierre, prelat unique de ceans
> Quant fusmes mis aux portes bien seans

[2] See the documents published by A. de la Borderie, "La cathédrale de Nantes: Documents inédits," *Revue des Provinces de l'Ouest*, III, 1855-56, 27-40; and G. Druville, "Une architecte de cathédrale au XVe siècle: Mathurin Rodier," *Bulletin de la Société archéologique de Nantes*, XXXIX, 1898, 137-57. A brief recent history of the monument is found in P. Prunet, "Restauration de la cathédrale Saint-Pierre de Nantes," *Monuments historiques de la France*, 4, 1976, 5-19.

[3] La Borderie, "Cathédrale de Nantes," 33.

[4] The inscription was transcribed by the seventeenth-century traveler Dubuisson-Aubenay, *Itinéraire de Bretagne en 1636*, ed. L. Maître and P. de Berthou, Archives de Bretagne, 10, vol. II, 1902, 41. It is also given in Abbé N. Travers, *Histoire civile, politique et religieuse de la ville et du comté de Nantes*, ed. A. Savagner, Nantes, 1836-41, II, 170. Whereas Dubuisson-Aubenay reads "mis hors dix et neuf ans" in the second line, Travers has it "mis hors doux et vingt ans" which would make the date 1479. My own reading was made from the original bronze panel, which I was surprised to find mounted against the upper part of the present wooden doors within the interior of the church, and agrees on this point with the earlier writer. According to a document of 1806 (*Bulletin de la Société archéologique de Nantes*, XXVII, 1888, 140), some bronze panels from the doors were deposited at this time in the Lycée of the town. Perhaps this included the panel with the inscription now visible in the cathedral.

Pour decorer ce portail et chief d'oeuvre
Comme pourront cognoistre les passans
Car richement par nous se ferme et euvre

It cannot be said that this enthusiastic appraisal has been shared by posterity, and indeed the monument still awaits serious study. With the cathedral of Tours, it is remarkable for the attachment which it displays, given its date, to the classic triple-portal formula of the Ile-de-France High Gothic tradition. Tours and Nantes have in common their glazed tympana, a motif inaugurated at Reims in the middle of the thirteenth century, the arrangement of the statue columns in a smooth sequence across the entire width of the façade, or with regard to detail, the use of glass or slate inserts within the architectural canopies of the voussoirs.[5] Both structures are nearly identical in date, though at Tours, in contrast to the relative sobriety of Nantes, the brilliant web of gossamer tracery—the *somptueux* in full flower—is continued above the portal to the crowning lanterns of the twin towers.

The adaptable and versatile Jean Lemaire de Belges is an author for whom "masterpiece" was a highly prized word which he applied without hesitation to the great works of past and present. We make his acquaintance in connection with a second monument of the climactic end-phase of Gothic architecture much more insistently bruited as a *chef d'oeuvre*, the mausoleum church built for Margaret of Austria at Brou, near Bourg-en-Bresse (Ain). Born at Bavai in Hainaut, Lemaire studied at the University of Paris and thereafter served first as a financial agent of Duke Pierre of Bourbon, then as secretary of the Count of Ligny, Louis of Luxembourg.[6] Both of these men died in 1503, and for each, Lemaire wrote a panegyrical lament. The *Temple d'honneur et de vertu* in honor of Pierre de Bourbon is dedicated to his widow Anne de Beaujeu. The work, the author declares with rhetorical modesty, is a "petit oeuvre" by a humble yet benevolent hand, which an enlightened patron will regard as more appropriate

[5] The relationship between Nantes and Tours is also noted in the attractive recent work of R. Sanfaçon, *L'architecture flamboyante en France*, Quebec, 1971, 73-75; and by P. Vitry, *Michel Colombe et la sculpture française de son temps*, Paris, 1901, 88-96, who gives a sympathetic description of the Nantes portal sculpture. The fact that members of the Dammartin family of builders were active in the two structures may help to explain the connection between them. On Tours Cathedral, see F. Salet, "La cathédrale de Tours," *Congrès archéologique*, CVI, 1949, 29-40.

[6] P. Jodogne, *Jean Lemaire de Belges: Écrivain franco-bourguignon*, Académie Royale de Belgique: Mémoires de la Classe des Lettres, XIII, no. 1, 1972; and P. Spaak, *Jean Lemaire de Belges*, Paris, 1926.

than "a sumptuous masterpiece in a rich and extravagant manner."
After elaborate preliminaries, Anne is advised that having sufficiently
mourned the loss of her consort, she should move on to more positive
deeds and imitate the example of Artemisia, the spouse of King
Mausolus of Caria, and "devise a very great masterpiece, a miracle of
Nature surpassing all others." In this way, Anne will do honor for all
time to the illustrious memory of her late lord and husband. Lemaire,
to this end, offers to present her with a masterful design and model
("ung vif portraict et patron magistral") of the proposed structure, a
temple dedicated to the gods of honor and virtue, from which the title
of the work derives.[7]

Lemaire's reference to one of the Seven Marvels of the World, the
Mausoleum of Hallicarnassus, is further evidence of the intimate
connection between *mirabilia* and masterpiece. Sixteenth- and
seventeenth-century authors came to use the words interchangeably,
and we may take Renaissance reconstructions of the marvels of An-
tiquity, like those of Maerten van Heemskerck (Fig. 11), as idealized
projections of qualities which contemporaries recognized and ex-
pected in the greatest *chefs d'oeuvre*.[8] This interpretation of the Seven
Marvels was of considerable significance, for it made it possible to en-
visage man-made masterpieces worthy of the highest regard. Master-
pieces were not solely the pedestrian performances of artisans or, on
an entirely different scale of value, the result of the Creator's sublime
manipulations. Some had been executed, so it now seemed, by the
foremost talents of Antiquity and had been recognized as such. Pro-
posing to rival one of these, Lemaire was perhaps overextending him-
self. But his scheme, in spite of the precision suggested by the initial

[7] *Oeuvres complètes de Jean Lemaire de Belges*, ed. J. A. Stecher, Louvain, 1891, IV, 191
and 224. Anne de Beaujeu herself is called a masterpiece in a long fifteenth-century
poem published by J. M. La Mure in *Histoire des ducs de Bourbon*, Paris, 1868, II, 466-67:

> Qui vouldra veoir de bonté l'exemplaire
> Et de doulceur le patron et chef d'oeuvre
> Celle qui scet si sagement complaire
> Que nul ne pert, mais le perdu recoeuvre.

[8] For the Renaissance view of ancient marvels, see Th. Dombart, *Die sieben Weltwun-
der des Altertums*, Munich, 1967, 83ff.; and the studies of M. Greenhalgh: "Fantasy in
Archaeology: Reconstruction of the Ancient World," *Architectural Review*, CXLV, 1969,
339-44; "The Monument in the Hypnerotomachia and the Pyramids of Egypt," *Nou-
velles de l'Estampe*, 1974, no. 14, 13-18; and "Pliny, Vitruvius and the Interpretation of
Ancient Architecture," *Gazette des Beaux-Arts*, 1974, 297-304. Some of the literary impli-
cations are developed in F. Joukovsky, *La gloire dans la poésie française et néo-latine du
XVIe siècle*, Travaux d'Humanisme et Renaissance, CII, Geneva, 1969, 398ff.

offer of a model, is more of a poetic fantasy than a practical plan, loosely amalgamating reminiscences from the available descriptions of the Mausoleum of Halicarnassus, late Gothic funerary monuments, and the author's own luxuriant imagination. The structure was to be a kind of Parnassus, an "eternal mansion for great men who among human beings, have merited the accolade of excellence." Concerning the site of the monument, Anne is invited to think of the Garden of Paradise or of the Elysian fields, though her domains in Moulins are said to convey some small sense of the place.[9] The temple had an ornate portal decorated with figures of six virtues, each corresponding to a letter in the name of the deceased prince. The outer walls of the building were engraved with verses in his honor. Lemaire furnishes a long list of eminent personages who form a stately gathering around the deceased. The first mentioned are noble and ecclesiastical dignitaries in the immediate family of the Duke, and these are followed by kings and princes present and past, dominated by the figure of St. Louis. The assembled immortals further include heroes of the Bible and of classical Antiquity, followed by famous literary figures of ancient times and the more recent past, from Vincent of Beauvais, Dante, and Petrarch, down to Chastellain, Robert Gaguin, Meschinot, and others. These men are occupied in discussion, each with his neighbor, and this is concluded with their decision to award to the deceased the title "très bon, très heureux, très victorieux." Finally, Anne herself, though still among the living, is admitted to the temple by special permission of Honor and Virtue, the two governing hosts.[10]

After the death of his first two patrons, Lemaire, then thirty years old, entered the service of Margaret of Austria as court poet and historian (*indiciarus*), and in this office his eagerness to design a world marvel assumed a more practical turn. Margaret's life is a story which partakes of the Medieval theme of inconstant fortune as much as of the sentimental novel, and it has often been told (Fig. 7).[11] Born in 1480, the young princess immediately became the object of intense interest among contending dynasties, for she was the heiress to the great counties of Burgundy and Artois. In 1482, through the Treaty

[9] *Oeuvres complètes*, IV, 225: "Certes, nenny, combien que ton vergier de Moulins en Bourbonnois en semble figurer et representer quelque petite portion." On the constructions of the Beaujeu in Moulins, see P. Pradel, "Le premier édifice de la Renaissance en France," *Mémoires de la Société Nationale des Antiquaires de France*, IV, 1969, 243-58.

[10] *Oeuvres complètes*, IV, 226ff.

[11] M. Bruchet, *Marguerite d'Autriche: Duchesse de Savoie*, Lille, 1927; and Gh. de Boom, *Marguerite d'Autriche-Savoie et la Pré-Renaissance*, Paris and Brussels, 1935.

of Arras, her father Maximilian was compelled to deliver her to the
king of France, and at the age of three, she was married to the heir of
the French crown, the future Charles VIII. Margaret spent her young
years among the princely residences of the Loire valley, receiving in-
struction appropriate to her status. According to Olivier de la
Marche, she became thus proficient in drawing, painting, vocal, and
instrumental music. In the meantime, the political ambitions of the
French monarchy had shifted in their focus, and in 1491, Charles re-
pudiated Margaret and married Anne of Brittany. Five years later,
the deeply humiliated young woman entered into a new alliance with
a Spanish prince, Don Juan of Castile. This marriage was even more
short-lived, for less than a year later, in 1497, the frail Juan died as his
bride was awaiting their first child. Once again, new dynastic alliances
were contemplated, and in 1501, Margaret took as her third husband
Philibert le Beau, the heir to the Duchy of Savoy. Although a happy
one, this too was fated to be a very brief union, for Philibert died in
1504 as a result of a hunting accident. Thereafter, until her own
death in 1530, Margaret remained alone at the head of her domains,
governing them with a steady and authoritative hand.

Following the death of Philibert, his body was transported to Brou,
the location of an old Benedictine priory adjoining Bourg-en-Bresse,
and buried there near his father and mother, Philip of Bresse and
Margaret of Bourbon.[12] The widowed duchess also decided to erect a
convent on the site, in fulfillment, apparently, of a vow made by
Philibert's mother twenty-four years earlier, which had not yet been
carried out and whose neglect was perhaps taken as a cause of the re-
cent tragedy. In the place of the Benedictines, however, steps were
taken to install there Augustinian hermits of the Congregation of St.
Nicholas of Tolentino, possibly, as has been suggested, because
Philibert died on that saint's feast day. A contract was signed on
March 31, 1505, for the construction, by local masons, of conventual
buildings and a church with two tombs for Philibert and for his
mother.[13] A year later, the initial rather modest plan was made some-
what more elaborate and a new agreement drawn up, again with local
artisans.[14] Lemaire's name is first encountered in connection with the
building projects of Brou in 1506 when he was sent to Rome to assist

[12] The history of the building of Brou is treated very thoroughly by Bruchet, *Mar-
guerite d'Autriche*, 143ff., with a comprehensive catalogue of the documents (Appendix
I, 187ff.). A more summary account is found in V. Nodet, *L'église de Brou*, Petites Mono-
graphies des grands Edifices, Paris, 1928.

[13] Bruchet, *Marguerite d'Autriche*, 188-89, no. 3. [14] Ibid,. 189-90, no. 4.

in the negotiations leading to the removal of the old parish and the establishment of the Augustinian monastery, instituted through a Bull of Julius II dated July 16 in that year.[15] On August 28, 1506, Margaret was at Brou officially to lay the cornerstone of the convent buildings, whose walls stood in a completed state at Christmas of the following year.[16]

Five additional years were required to bring the entire work on these residential quarters to an end. In 1509, however, the project assumed a wholly new significance, when Margaret, through her will, decided to make the church of Brou the site of her own tomb.[17] Although she simultaneously ordered that the church and two tombs already commissioned be completed "according to specified plans," new schemes altogether beyond the limited horizons of the Bressan artisans heretofore entrusted with the work were soon unfolded. Lemaire figures prominently in this broadening of ambitions. He is described in 1509 as *soliciteur* of the constructions of Brou, a title which seems to define some loose supervisory function. We find him in frequent correspondence with Margaret and members of her governing council about the progress of the work, acting as her intermediary in negotiations with the parties involved, and more unexpectedly, taking a hand in the purchase of marble, a task which he did not perform to complete satisfaction, as his superiors were eventually to remind him.[18] One might expect, too, that through his literary and historical interests, he was able to furnish a kind of programmatic orientation for the planned monuments and their setting.

Before his involvement with the Brou projects, Lemaire wrote several works which he dedicated to Margaret. His first *Epître de l'amant vert*, composed in 1505, is a conventional lament by the poet whose unrequited love drives him to the grave. In the now familiar formula, the object of his longing is thus apostrophized:[19]

> T'ay ie desplu, ô chef d'oeuvre parfait?
> Ay-ie noncé chose qui face à taire. . . .

In the same year, Lemaire completed his *Couronne margaritique*, probably his best-known work. The author here mourns Philibert le Beau, whose days were wrongfully ended by Death and Misfortune.[20]

[15] Ibid., 156.

[16] Ibid., 191, no. 7.

[17] Ibid., 192, no. 10.

[18] Ibid., 199, no. 33, and 219, no. 72.

[19] *Oeuvres complètes*, III, 4.

[20] Ibid., IV, 35-36.

Las, si la Mort plaine d'austerité,
L'eust peu souffrir tendre à maturité,
Quel grand chef d'oeuvre en nature on eust veu!
Car il estoit pourveu
D'amour, de loyauté,
De sens, d'honneur, et d'extreme beauté.

But as in the case of the *Temple d'honneur* for the Duke of Bourbon, the lament for the defunct prince soon turns into a panegyric for his surviving widow. Prudence and Fortitude are sent to console her and through their assistance, the agents of death are consigned to hell. To celebrate this victory, Virtue decides to offer Margaret a beautiful "triumphal and permanent" crown. It is to be made by Merit, the excellent goldsmith of her brother, King Honor. Merit, we learn, is already busy at this time making two diadems, "grands chefs d'oeuvre exquis," for Margaret's two departed husbands. In his workshop are employed the great artists of Antiquity, among them Polyclitus, Phidias, Lysippus, and Myron. One of the miniatures in the manuscript of the *Couronne margaritique* in Vienna, thought by some scholars to be Lemaire's dedication copy, shows these mighty artisans absorbed in their task.[21]

For Margaret's own crown, Virtue has called into her presence ten of her most beautiful nymphs. Standing in a circle, each wearing a precious stone on her forehead, they represent the live model (*vif pourtraict*) which Merit is to follow. This is the subject of another miniature in the Vienna manuscript (Fig. 12). Ten of the outstanding learned men the world has known have been invited to make orations on the symbolical correspondences between the stones and the ten Virtues, each designated by a letter in Margaret's name. Lemaire's invention on this latter point is clearly indebted to the literature of Me-

[21] Vienna, Osterreichische Nationalbibliothek, Cod. 3441, fol. 32verso. According to a note (fol. 1recto), the manuscript was given by Margaret to her brother Philip in 1505. See F. Unterkircher, *Manuscrits et livres imprimés concernant l'histoire des Pays-Bas, 1475-1600*, ex. cat., Brussels, Bibliothèque Royale Albert Ier, 1962, 54-55, no. 83; and for the question of the authorship of the miniatures, E. Duverger and D. Duverger Van de Velde, "Jean Lemaire de Belges en de Schilderkunst: Een Bijdrage," *Jaarboek van het koninklijk Museum voor Schone Kunsten, Antwerpen*, 1967, 46. On the other hand, in the most recent attempt to deal with the codex (O. Pächt and D. Thoss, *Die illuminierten Handschriften und Inkunabeln der Österreichischen Nationalbibliothek: Französische Schule*, II, Vienna, 1977, 87-91), the authors hold that it does not constitute Lemaire's presentation copy.

dieval lapidaries, but there is a novel twist in his exposition. For him, each gem and its corresponding virtue embodies only one of the crown's qualities. The excellence of the work—and of Margaret— resides in a judicious blend of the best traits of every part. The famous story of Zeuxis' painting of the fair Helen is now told, for her beauty "was a masterpiece surpassing all feminine comeliness in the world,"[22] and its depiction similarly required a choice and combination of the most attractive features of five beautiful young women. Such a process of selection and synthesis, too, we are led to infer, is the proper working method of rhetorical praise as practiced by Lemaire himself: the writer picks the finest flowers from the literature of the past and combines them into a handsome bouquet of his own making.

The outline of the *Couronne margaritique* resembles that of the panegyric for Pierre de Bourbon closely, and the conception of the *chef d'oeuvre* which it manifests likewise does not depart from that encountered in the earlier work. First, the hero, in the now conventional fashion, is understood to be a masterpiece. Second, the poet elaborates a grandiose scheme for a monument in his patron's honor, a monument in this instance actually presented as the work of an artist, but once again, a literary fiction rather than a concrete object. Lemaire's writings are suffused with an intense and firsthand experience of the charged, extravagant side of the late Flamboyant Gothic confronting the Italian Renaissance. The loving enumeration of precious stones, of intricately crafted structures bearing statuary, armorial shields, and luxuriant foliage evoke in the reader's mind works of such contemporaries as Van Orley or Mabuse, both of whom were also active in the service of Margaret. It cannot be an accident that the writings of Lemaire are so conspicuous for their references to outstanding artists of the time. In this respect, they have served even those historians impatient with his literary style.

The inception of Lemaire's involvement with the Brou project was accompanied by the appearance on the same scene of another sizable figure, eager to display his talents. Jean de Paris, or Perréal, occupies a large if problematic place in the French cultural picture of the decades around 1500.[23] Engineer, alchemist, illuminator, but primarily

[22] *Oeuvres complètes*, IV, 152.

[23] On Perréal, see A. Vernet, "Jean Perréal, poète et alchimiste," *Bibliothèque d'Humanisme et Renaissance*, III, 1943, 214-52; P. Pradel, "Les autographes de Jean Perréal," *Bibliothèque de l'Ecole des Chartes*, CXXI, 1963, 132-86; and P. Jodogne, "Etudes sur Jean Perréal," *Studi Francesi*, IX, 1965, 83-86. An important discovery has made it pos-

designer of civic and royal spectacles, Perréal is first documented in a professional capacity in Lyon where he executed decorations for the ceremonial entries of St. François de Paul (1483), the Cardinal de Bourbon (1485) and Charles VIII (1490). In 1509, we find him in Italy, taking part in the campaign of Louis XII against the Venetians. It was upon his return to Lyon, in November of the same year that, from his own testimony, he found Lemaire and received from him the commission for the design of the Brou tombs. Some designs (*patrons*), he claims to have heard, had already been prepared, but the duchess, desirous of something more worthy of memory, had turned to him for help.

The inadequacy of the existing plans for the tombs which Perréal deplored were the work of one Thibaut Landry, or Thibaut de Salins, to whom payments are recorded for labor on the monument of Philibert.[24] Nothing is known of his art beyond the insults which Perréal heaps on it. The name points to a talent of regional origin, most likely a conventional Gothic artisan like those who executed the modest but attractive decorative sculpture in the cloisters of the Brou monastery: an accomplished hand, though innocent of the classicizing and humanistic ambitions which Perréal's outlook and experience required. For Thibaut, Perréal proposed to substitute "ung bon ouvrier et excellent desciple du nomme Michel Colombe," as like the former, we are told, as gold is to lead.[25] In Colombe, by 1509, near the end of a long and productive career, we have unquestionably a figure of another magnitude, who might well be considered the ablest French sculptor of his time.[26]

It seems likely that Perréal delivered the *pourtraicts* of the Brou tombs in 1510, when Margaret ordered payments to be made to him.[27] But nothing of a practical nature seems to have been immediately done. In April of the same year, the duchess was considering an invitation to work on the monuments to yet another artist, the Florentine sculptor Pietro Torrigiano, in Flanders after the completion of his work on the tomb of Henry VII in Westminster.[28] Somewhat later

sible, after much tendentious speculation, to define his style as a painter: Ch. Sterling, "Une peinture certaine de Perréal enfin retrouvée," *L'Oeuil*, nos. 103-104, 1963, 2ff.

[24] Bruchet, *Marguerite d'Autriche*, 158 and 198, nos. 29 and 30.

[25] Ibid., 219, no. 72.

[26] Vitry, *Michel Colombe et la sculpture française*, 337ff.; and P. Pradel, *Michel Colombe*, Paris, 1935.

[27] Bruchet, *Marguerite d'Autriche*, 157 and 196-97, no. 25.

[28] Ibid., 194, no. 16.

still, Margaret, having accepted Perréal's designs, settled on Colombe
for the preparation of models, though the final execution of the work
in stone was to be left in the hands of Thibaut.[29] At the beginning of
1511, Perréal was busy with the selection of the stone to be used, and
we have from him an evaluation of the respective merits of marble
and alabaster, in which there occurs a revealing acknowledgment of
the prestige of the latter material, based on its use in the tombs of the
Dukes of Burgundy at Champmol.[30] The documents for the year
1511 indeed show Lemaire, Perréal, and with them, more reluctantly,
Colombe, at the peak of their exertions in the affairs of Brou. It was
also in this context that the idea of the masterpiece as an artistic
achievement of the highest order passed from the stage of a literary
fiction into the realm of concrete ambition.

The matter is first broached by Perréal himself in his already men-
tioned letter of January 4, 1511, addressed to Louis Barangier,
Margaret's secretary and close adviser. Sure of himself as always, out-
spoken, even contentious, the writer's purpose is to impress on his
correspondent, for whom the conflicts between personalities and ar-
tistic philosophies on the Brou *chantier* may well have seemed as
obscure as they were bothersome, his larger view of what the monu-
ment should be. True, the minister is told, the purchase of the stone
for the projected tombs had been expensive, but the final price could
go much higher to a sum far exceeding that initially allotted by the
duchess! That is because the nature of the monument, as it is con-
ceived by Perréal, demands it. Barangier should go to Dijon to see
what has been done in this line at Champmol. White marble for the
effigies of the defunct should be obtained in Genoa, and black marble
in Liège. That is what Perréal specified for the tomb of Duke Francis
II of Brittany in Nantes, of which he is sending Barangier the design
so that he may judge for himself. Now follows news of Perréal's con-
tacts with Colombe in order to induce him to work on the Brou
monuments, and information—precious for our knowledge of this
project—concerning the collaboration of the two men and assistants
on the Nantes tomb. To come to the point: great works require large

[29] Ibid., 196-97, nos. 22 and 25.

[30] Ibid., 202-203, nos. 40 and 41. The Champmol tombs are also mentioned by
Lemaire (199-200, no. 35). Another indication of interest in Champmol at this time is a
reproduction of Sluter's Well of Moses made in 1508 for the hospital of Dijon (P.
Quarré, *Mémoires de la Commission des Antiquités de la Côte d'Or*, XXVI, 1963-69, 113, and
XXIX, 1974-75, 164). According to the same author, a drawing of the monument was
also sent in 1601 by the monks of Champmol to the Carthusians of Scala Coeli of Evora
in Portugal.

means and "grans ouvriers," and the unfortunate Thibaut, here again denigrated, is not one of them; for what Perréal has in mind, in his own words, is to realize a *chef d'oeuvre*.[31]

Taken in isolation, the word might seem only a casual boast, but as will soon become apparent, this is not the case. We possess a letter by Lemaire to Margaret written some ten months later, on November 22, 1511, in Tours, where Lemaire had journeyed to persuade Colombe to lend his assistance to the realization of the Brou projects and to negotiate with him the terms of a contract. Colombe's age—he was, in Lemaire's estimation, some eighty years old—and his frail health were the chief obstacles to his effective cooperation. Nevertheless, the duchess was assured by her emissary that she would have from this eminent master, in the tomb of Philibert, "ung des plus grandz chiefz d'euvre qu'il fit oncques en sa vie."[32] In order to complete the work, Colombe requested until Easter, but Lemaire promised to do his best to bring his labors to an end within three months. Shortly thereafter, on December 3, 1511, Colombe together with his three nephews, the sculptor Guillaume Regnault, the master mason Bastien François, and the illuminator François Colombe, entered into a formal contract with Margaret through her agent. He was to provide before Easter of the following year a model in clay of the tomb of Duke Philibert following the design of Perréal. François Colombe and Bastien François were to prepare for the duchess two drawings of the monument, one showing it as seen from above and the other from the side. Bastien the mason was also to construct a base out of stone for the clay model. As for the latter, it was to be made by Colombe himself unassisted. The master further undertook, with the help of God, to make "ung chef d'oeuvre selon la possibilité de mon art et industrie."[33]

Perréal, Lemaire, and Colombe were thus united in their aim, which they boldly proclaimed to their patron. Colombe's embrace of the intention to elaborate a masterpiece, even though hedged in qualifying terms and hence more of a promise to do his best than an ironclad guarantee to deliver the unsurpassable, is the more remarkable since it is consigned to a document in due and legal form. Such a

[31] Bruchet, *Marguerite d'Autriche*, 203, no. 41. The full text is published in E.-L.-G. Charvet, *Jean Perréal, Clément Trie and Edouard Grand*, Lyon, 1874, 62.

[32] Bruchet, *Marguerite d'Autriche*, 211-12, no. 62.

[33] Ibid., 212-15, no. 64. The full text of the contract is published in Vitry, *Michel Colombe*, 487-90, and has been included in the anthology of W. Stechow, *Northern Renaissance Art, 1400-1600*, Sources and Documents in the History of Art, ed. H. W. Janson, Englewood Cliffs, N.J., 1966, 146-50.

statement of intention is, so far as I have been able to ascertain, without parallel among artists' contracts. Although witnessed by a notary, it seems probable that Lemaire was responsible for the actual wording of the agreement, for as we have seen, *chef d'oeuvre* was a term much in vogue with him, while we have no knowledge that it had any currency at all with Colombe, unless his earlier collaboration with Perréal on the ducal tomb in Nantes should be credited with some significance in this context. After the conclusion of the contract, Lemaire obtained from Colombe a supplementary commitment of his energies to the Brou enterprise. In addition to the execution of the model, he agreed to model personally ten figures of Virtues which were to be positioned around Philibert's tomb.[34] But delays, occasioned by the aged sculptor's infirmity, were encountered and, if the clay model of the monument could be expedited from Tours toward the middle of May of the year 1512, Colombe also had to inform the duchess on the 27th of the same month that he had not yet been able to finish the ten Virtues.[35] Furthermore, work would keep him busy until late in the fall, and nothing could be done during the winter. In the meantime, however, and before Colombe could carry out his plans, the situation at Brou had drastically changed, and his participation was no longer required.

Even before the end of the year 1511, Lemaire's fortunes at the court had suffered a serious reversal, and by February 1512, he had left Margaret's service to offer his talents to Anne of Brittany, the queen of France, Perréal's own position had become equally difficult. Argumentative as always, he had also broken with Lemaire, in whom he now professed to see an incompetent and an "inventeur de menteries."[36] In August 1512, a new man, Loys van Boghem (or Bodeghem), a master mason from Brussels, appeared on the scene at Margaret's request to report on the state of affairs at Brou.[37] In the middle of the following year, he was put in full charge of the building of the church, and his arrival also signaled an entirely new departure so far as the design of the tombs was concerned. These were eventually entrusted to Jan van Roome (or Jean de Bruxelles), an artist chiefly known as a designer of tapestries.[38] Conrat Meyt of Worms

[34] Bruchet, *Marguerite d'Autriche*, 214.

[35] Ibid., *Preuves*, 388-89, LXII, and 222, no. 80.

[36] Ibid., 226, no. 92. [37] Ibid., 225, no. 88.

[38] On this artist see, most recently, the studies by E. Dhanens: "Jan van Roome, alias van Brussel, schilder," *Gentse Bijdragen tot de Kunstgeschiednis*, XI, 1945-48, 41-146, 60ff. (for the Brou projects), and 136-37 (for the documents); and "L'importance du peintre

was commissioned to carve the monumental statuary, including the funerary effigies, while other sculptors were assigned the architectural framework of the monuments and the carving of lesser importance. These are the masters who impressed upon the structure and the tombs within the form they have retained, nearly unchanged, to the present day (Figs. 13 and 14).[39]

What of the projects of the team of Perréal, Lemaire, and Colombe? Our sources indicate that Margaret turned over to Van Boghem the design and model (*patron et pourtraict*) of the church, which must undoubtedly have been the scheme devised by Perréal. For P. Pradel, it is inconceivable that she did not also show the new supervisor of the work the plans and models received from Colombe's atelier in Tours.[40] The fact that the tomb of Philibert as finally executed by Meyt and his colleagues incorporates a series of ten Virtues suggests that at least some of the ideas of the men formerly in charge were maintained by their successors. In one respect, that which specifically interests us here, there was a clear continuity. The agreement made by the duchess and Van Boghem in 1513, which presumably set forth in detail what was expected from him, has apparently not survived. But a letter from Barangier to Margaret written before November 15, 1512, following Van Boghem's initial visit to inspect the work at Brou, reports on the findings and recommendations of the master mason. It contains, among other points, a suggestion by Van Boghem that the site of the church to be built be moved fifteen to twenty feet from the monastery in order to avoid an obstruction of the view by the monks' dormitory and to make possible the construction of more beautiful chapels and a sacristy on the sides of the sanctuary. In particular, Van Boghem has in mind to erect for Margaret a private oratory directly accessible from her apartments by means of a passage over the *jubé* from which her tomb would be visible from above. For this chapel, he has lofty aims, and through Barangier, these are registered in the now familiar words: the work will be a masterpiece.[41]

Jean van Roome, dit de Bruxelles," *Tapisseries bruxelloises de la Pré-Renaissance*, ex. cat., Brussels, Musées Royaux d'Art et d'Histoire, 1976, 231-38.

[39] On the Brou tombs, see J. Duverger, "Vlaamsche beeldhouwers te Brou," *Oud Holland*, XLVII, 1930, 1-27; and, most recently, G. von der Osten and H. Vey, *Painting and Sculpture in Germany and the Netherlands, 1500-1600*, Harmondsworth, 1969, 238-39.

[40] Pradel, *Michel Colombe*, 65-66.

[41] Bruchet, *Marguerite d'Autriche*, 227, no. 95. Van Boghem hopes to build a chapel "qui sera ung chief d'oeuvre et pourrez descendre par dessubs le jubilé . . . en vostre chapelle, de laquelle pourrez veoir par dessubs vostre sepulture au grand haulte."

Unlike the men whom he supplanted at Brou, Van Boghem was to have the chance to fulfill his plan. What we know of him suggests a figure of determination and energy, whose efficacy in the management of a large building enterprise must have been warmly appreciated by his employers after the diffuse and inconclusive maneuvers of Lemaire and Perréal. Perhaps, too, as has been speculated, Perréal's projects might have been too Italianate for the taste of the duchess and her circle, moving her to turn, as a matter of conscious artistic policy, to exponents of the Flemish tradition. Van Boghem is thought to have been born in Brussels around 1470. Nothing is known of his training and professional activity before he came to Brou, but in 1516 he was asked to complete the *Broodhuys* (or *Maison du Roi*) on the Grand'Place in Brussels, following the plans of Antoine Keldermans. A number of other projects in Brussels and Bruges are credited to him, and he is believed also to be responsible for the reconstruction of Notre-Dame at Bourg-en-Bresse after the collapse of that church in 1514.[42] After his appointment at Brou, Van Boghem was to devote most of his time to the direction of the *chantier* there, though he secured from his patron the right to make two visits annually to the northern provinces in order to attend to his other affairs. Margaret for this purpose provided him with a horse, agreed to pay his ransom should he be sequestered on the way, and offered, on learning that his absence was the cause of delays in the progress of the work, to pay him a handsome bonus should he consent to limit himself to a single journey away from Brou each year.[43]

Soon after his arrival, work on the church began in earnest. By July 19, 1513, Van Boghem informed Margaret that the old buildings on the site had been demolished and that the digging of foundations for the new edifice was about to begin.[44] Thereafter, the duchess received frequent reports on the state of the project from her advisory council; from Chivillard, a financial agent who had been appointed to oversee the management of expenditures on the building; or from Van Boghem himself. Thus, near the end of October 1515, the piers and the outer walls of the body of the church with their windows had risen

[42] On Van Boghem, see the entry by H. Hymans in Thieme-Becker, *Allgemeines Lexikon*, IV, 1910, 165-66; L. Finot, "Louis van Boghem, architecte de Brou," *Réunion de la Société des Beaux-Arts*, XII, 1888, 187ff.; and F. de Mely, "Le Livre d'Heures de l'architecte Louis van Boghem au Séminaire de Bruges," *Les arts anciens de Flandre*, VI, 1912-13, 1-9.

[43] Bruchet, *Marguerite d'Autriche*, 229, nos. 103-104; 232, no. 116.

[44] Ibid., 230, no. 107.

to a height of twenty-two feet and those of the choir were still more advanced. Margaret's private chapel, together with a large part of its sculptural decoration was said to be "presque toute taillée."[45] Van Boghem had originally foreseen the completion of the entire work within a period of five years, but owing at least in part to changes in the program and other difficulties, this goal could not be met. At the end of July 1522, vaulting of the choir and transept was completed, the steeple was nearing the height of the nave, and the three tombs were well advanced. Van Boghem's report of July 14, 1528, indicates that at the time, the vaulting of the nave was in progress, after the completion of the eastern parts of the edifice. Only the upper part of the façade, the *jubé*, and incidental elements of construction and decoration were still to be attended to.[46] In February of the following year, the impatient Margaret found it expedient to conclude a curious wager with Van Boghem by which she promised to make a special payment of five hundred pounds to him should he be able to complete the balance of the work in the course of the following thirty months.[47] On March 22, 1532, the church was officially consecrated. It was too late, however, for Margaret's own use and delight, for she had died fifteen months earlier, on December 1, 1530, following a prosaic household accident.

The chapel on which Van Boghem promised to lavish special care is located on the northern side of the monks' choir. To it is attached a smaller room, located off axis on its northwestern side, which is the private oratory of the duchess (Fig. 15). The ensemble conforms faithfully enough to the specifications given by the master mason as reported in Barangier's letter of the fall of 1512 to the duchess. Graphic representations of the building as a whole and, it is likely, of the chapel, existed as well. These had been given over to the paymaster Chivillard, who was to assure himself that they were followed. The design of the chapel with its adjacent oratory, and their location on the plan of the church, fulfill certain functional prerequisites or programmatic inclinations which may be reasonably supposed to have been conveyed to the architect. The latter's principal concerns, of course, were defined at the outset by the nature of the institution. The church was to be a princely mausoleum, with an appropriate sanctuary space to enable a monastic congregation to celebrate mass and offer special prayers for the deceased. The three tombs at Brou were installed in a row immediately to the east of the two bays which com-

[45] Ibid., 233, no. 122, and *Preuves*, LXXI.
[46] Ibid., 169 and 246-47, no. 159. [47] Ibid., 248-49, no. 166.

prise the monks' choir. Unlike the tombs of the Burgundian princes at Champmol—a celebrated and well-nigh unavoidable point of reference for the Brou builders—Margaret's monument and those of her kin each present a different design. Philibert's free-standing tomb is situated in the middle, while that of his mother, Margaret of Bourbon, is in the form of an *enfeu* located along the southern partition wall, opposite. The tomb of Margaret of Austria is the northern pendant of this ensemble. Distinguished by its open-canopied superstructure, it is surrounded by an open space on three sides and extends the northern partition wall of the choir to its eastern extremity. The tomb also separates the central sanctuary area from the chapel along its northern side, which houses the imposing altar of the Seven Joys of the Virgin.[48] But the open canopy of the tomb acts more as a transparent screen than as a wall, opening the central space to the view from the contiguous room and also from Margaret's oratory which is situated immediately to the west. This feature of the design has its justification in the novel element of the program, introduced when the patron decided to alter the original project and elected to be buried at Brou side by side with her husband and his mother, who alone were initially to be interred there. The duchess at this time was still a young woman, and there was every reason to expect that the family mausoleum would be completed in good time. Thus, an oratory where she could perform her devotions and witness the services when she was at Brou became a practical necessity. Van Boghem's undertaking of 1512 to arrange for a direct connection between the chapel and her apartments meets one of the exigencies of this situation, and the itinerary provided entirely above ground-level recalls a long-established tradition in princely chapels. More intriguing is the basis of the architect's perception that a particular merit of his scheme would be to offer Margaret a view of her tomb from above as she was proceeding to prayer. The underlying thought, perhaps, fastens on the monument as a kind of *momento mori*, whose contemplation from an elevated position might offer the privileged viewer a metaphor, as it were, of future release from the bonds of mortality.

The oratory of the duchess, reached from a raised passageway by a staircase, is a rectangular room covered with a stellar ribbed vault. It houses only two architectural elements of note: a fireplace built into the wall on its northern side which would have softened for the

[48] M. Fransolet, "Le retable des Sept-Joies de l'église St.-Nicolas de Tolentin à Brou," *Oud Holland*, XLVIII, 1931, 36ff.

room's occupant the discomforts of cold and humid days, and an arched window pierced into the eastern wall, through which the adjacent chapel and apsidal space beyond came into view. In order to give this opening maximum value, it is cut into the wall on an oblique path and the inner face of the arch is therefore wider along the sides than at the top. The application of multiple parallel moldings and other ornament to the complex curvature of the arch thus involved a virtuoso display of stereometric precision (Fig. 15), which by itself lends to this part of the construction a singular interest.

The chapel proper, to the east, is square in plan. It is illuminated on its northern and eastern sides by windows with stained glass, but the imposing Assumption of the Virgin in the north has no counterpart in the east, where the opening of the wall is limited to the upper part of the space. Below, there is blank masonry, in front of which stands the monumental marble altar of the Seven Joys of the Virgin. The lower walls of the chapel are lined with a white marble revetment of shallow arcaded niches chiseled with utmost delicacy and a profusion of ingenious ornamental devices, among which is the recurrent monogram of Margaret and Philibert tied by stylized knots. Under this revetment, there is a bench of black marble, a more obdurate material sparingly used elsewhere in the chapel in an effective counterpoint with the lighter stone. The vaults are appropriately impressive in their ornate refinement. The configuration of the ribs takes the form of two concentric four-pointed stars, connected at their points by formerets and intersected horizontally and vertically by ridge ribs. At thirteen points where these ribs meet, there are elaborate pendant bosses with painted armorial shields of the ducal couple.

How well Van Boghem succeeded in his announced intention to accomplish in the building of the chapel a *chef d'oeuvre* is a question that everyone must answer to his or her own satisfaction. At Brou itself, the matter was not left in doubt. A poem written by a certain Antoine de Saix which could formerly be seen inscribed in the sanctuary to the right of the altar enumerates the Antique Marvels of the World, all of them surpassed, it is said, by "l'oeuvre parfaite de Marguerite."[49] The understandable contribution of local pride and political considerations of this text necessarily reduces its value as an indication of wider opinion on the building. It is also true that the site of the monument away from the major axes of circulation, and especially the political

[49] The poem, dated 1531, is published in S. Guichenon, *Histoire de Bresse et de Bugey*, Lyon, 1650, 28.

consequences of Margaret's death, led Brou back to the comparative obscurity from which it had briefly emerged during her reign. Nonetheless, there is good evidence that the monument was highly regarded by contemporaries and that it continued to inspire admiring comments even after its underlying esthetic had fallen into disfavor. The circumstances surrounding the construction of the church are recorded at some length in Guillaume Paradin's *Chronicle of Savoy*, first published in 1552 and later reissued in somewhat more ample form. Paradin calls it "the most superb and triumphant edifice and the most pleasant structure (for a Gothic work) which can be seen in Europe. Among churches, it can be counted among the miracles of beauty on which the eye can now feast. . . ." King Francis I, according to the same author, had been full of admiration for it, exclaiming on the occasion of a visit to Brou that "he had never seen a sanctuary of such excellence."[50] Brantôme (1527-1614) in his *Dames galantes* calls the church "one of the most beautiful and superb edifices in Christendom."[51] More surprisingly, perhaps, in the heyday of the Grand Siècle, we read in J. A. Piganiol de la Force that "the most skillful architects have often gone out of their way to examine this masterpiece."[52]

If the merit of a monument in the eyes of posterity can be made the object of a detached assessment, we must recognize at the same time that the criteria established for this purpose are themselves inseparable from their historical context. Were those of Margaret and of her builders identical to those of Brantôme, Piganiol, or, for that matter, our own? Although the construction of Brou is remarkably well documented in its material aspects, the intentions of the builders and of the patron in formal terms, and in particular the significance which the notion of *chef d'oeuvre* had for them, are far from clear. One is necessarily struck by the fact that it is the artists themselves—Perréal, Colombe, Van Boghem—who offer to make *chefs d'oeuvre*. Evidently they did not regard this as a wild boast but as a practical aim whose accomplishment would not have to await the assent of an untold number of generations. Or rather, not yet under the sway of historical relativism, they could feel confident that their judgment of artistic quality would be shared by the future. This absence of an historical perspective and the unself-conscious view that masterpieces could

[50] Bruchet, *Marguerite d'Autriche*, 437ff., and *Preuves*, XCIX.

[51] Brantôme, *Dames galantes*, Paris, 1787, III, 176-77.

[52] J. A. Piganiol de la Force, *Nouvelle description de la France*, Amsterdam, 1719, III, 221.

emerge from an artist's workshop by design, as exceptional but pre-
dictable results of careful calculation and expertise, retains something
of the older artisanal quality of the term. In concert with this must be
weighed the role in the unfolding of the plans of Brou of ideas of
literary derivation, articulated at Margaret's court by Lemaire and
Perréal. Here we find the duchess portrayed as a new Artemisia of
Caria, rivaling and surpassing the Marvels of Antiquity, the unargu-
able *chefs d'oeuvre* of the world. By the early stages of the sixteenth
century, artisans had long been making masterpieces, and the idea of
rivaling the achievements of the Ancients was nothing new. But the
association of the two concerns seems to me to constitute the salient
and original feature of Brou.[53]

Perréal's initial announcement of his desire to accomplish a mas-
terpiece at Brou was, as we have seen, soon followed by similar decla-
rations by Lemaire, Colombe, and Van Boghem. Eventually, the work
was "officially" so recognized through the display of the poem of An-
toine de Saix. Are all these writings independent of one another and
the striking reiteration of the same intention simply a coincidence?
This must be regarded as unlikely, if for no other reason than the
novelty of the idea itself. Was Perréal's example then merely followed
by the others? This, too, would seem improbable, for Lemaire himself
had long before made conspicuous usage of the word "masterpiece"
in poetic compositions, and it was he who had earlier urged Anne de
Beaujeu to "excogiter quelque très haut chef d'oeuvre miraculeux en
nature et surpassant tout autre" after the model of the Mausoleum of
Hallicarnassus.[54] It might be pointed out, further, that while Perréal,
Lemaire, and Colombe had in mind as their masterpiece the tomb of
Philibert, Van Boghem's *chef d'oeuvre* was to be an architectural space,
Margaret's chapel. One is thus led to ask whether a major factor in the

[53] The theme of the "new Artemisia" later proved applicable to other early widowed
princesses, among them Catherine de Médicis and Anne d'Autriche. For Catherine, the
Paris apothecary Nicolas Houel composed his vast *Suite d'Artémise*, for which Antoine
Caron and others provided drawings (*L'Ecole de Fontainebleau*, ex. cat., Paris, Grand
Palais, 1972, 357-63, with older bibliography). The *Chapelle des Valois* which Primaticcio
designed as a mausoleum for Henry II at Saint-Denis was a monument of world-marvel
class, which proved difficult to complete. The historian Etienne Pasquier noted that
Catherine proceeded "avec une depense pareille à celle des roys d'Egypte en leur
mausolées," while Dom Jacques Doublet in his history of the abbey church (1625)
thought the monument imitated the Pantheon (A. de Boislisle, "La sépulture des Valois
à Saint-Denis," *Mémoires de la Société de l'Histoire de Paris et de l'Ile-de-France*, III, 1877,
241-92).

[54] *Oeuvres complètes*, IV, 224.

transformation of Lemaire's literary program into a practical under-taking was not the duchess herself. Such an assumption would well account for the common thread which runs through the declarations of the men engaged on the Brou project, and it would be consistent as well with Margaret's combination of hardheaded realism and artistic interest—the latter well documented through her albums of poetry and music and her outstanding collection of books and paintings.[55] Lemaire's fanciful verbal constructions, in which others might see only graceful courtly allegories, must have struck her, in light of the extraordinary events of her own life, as having profound personal significance, crystallizing her resolve to give them concrete form.

[55] M. Françon, *Albums poétiques de Marguerite d'Autriche*, Paris, 1934; M. Michelant, "Inventaire des vaisselles, joyaux, tapisseries, peintures, manuscrits . . . de Marguerite d'Autriche, régente et gouvernante des Pays-Bas, dressé en son palais de Malines le 9 juillet 1523," *Compte-Rendu des séances de la Commission royale d'histoire ou recueil de ses bulletins*, Brussels, Académie Royale des Sciences, 3e série, XII, 1871, 5-78, 83-136.

IV

MASTERPIECES OF
THE FRENCH RENAISSANCE

At the beginning of the sixteenth century, the concept of masterpiece united several strands of meaning. Artisans, as before, made *chefs d'oeuvre* as exhibitions of skill before guild juries, and in ordinary speech this is how the word must have been understood. Yet the notion of God as the supreme master had made it possible to think of the *chef d'oeuvre* as an accomplishment of the highest order rather than as a routine technical exploit. The characterization of works of art held to be masterpieces was bound to reflect this elevation of the status of the term, but the vocabulary of praise not unexpectedly retained a workshop flavor. Monuments enjoying high esteem are said to be "artistement elabourés," "faicts par artifice admirable," or "d'une belle besogne." The sheer size of the work overwhelms the writer, or the fact that it appears as if suspended in midair, or in the case of a group of figures, that it is carved from a single piece of material. Artistic quality does not present itself, as it now does to us, as an issue separate from practical accomplishment. Rather, skill, finesse, virtuosity, are themselves synonymous with high merit.

We have also seen that mastery in its most accomplished manifestation was seen to approach the marvelous. The eventual equation of marvel and masterpiece recognized not only in the works of God, but in certain rare achievements of man, a kind of transcendental mastery no longer tied to the fulfillment of any professional obligation. The *mirabilia* of the Ancients were world or even universal masterpieces. Most of them were architectural wonders, though Phidias' statue of Zeus at Olympia and the bronze Colossus of Rhodes illustrated the potential of sculpture in the field of artistic miracles, again at the level of enormous scale and ingenuity.[1] The same hierarchy of values ob-

[1] On the Renaissance interest in colossal statues, see V. Bush, *The Colossal Sculpture of the Cinquecento* (Ph.D. Diss., Columbia, 1967), New York and London, 1976; and C.

tains within the choice of works which sixteenth-century writers came to designate as masterpieces: monuments of architecture primarily, sculpture to a lesser degree, and painting, a less "difficult" art in the judgment of the time, not at all. Thus, if the conception of masterpiece has its ultimate roots in artisanal practice, its alliance with the idea of the artistic *merveille* was an indispensable event in its history.

The shift from the generalized and stereotypical to the topographically specific in depictions of architecture which took place in the later Middle Ages illuminates some significant aspects of this alliance, though it is a phenomenon too broadly faceted to be considered here in detail. It brought with it the development of the cityscape as a self-standing pictorial genre, illustrated after the middle of the fourteenth century in ever more precise views of Rome, Jerusalem, and, somewhat later, Paris, Venice, Florence, and Cologne. Around 1460, Guillaume Revel, herald-at-arms of King Charles VII of France, compiled a record of towns in Auvergne controlled by Duke Pierre of Bourbon as feudal possessions, each being represented by a remarkably accurate view.[2] Hartman Schedel included depictions of the principal cities of western Europe in his World Chronicle of 1492, though the fulfillment of this vast ambition forced him to amplify his stock of views by the curious device of repeating the same one for several cities.[3] The painstakingly detailed architectural representations of the early Netherlandish masters seem to us truthful even where we cannot be sure that real monuments stand behind them. Individual structures of note came into the purview of precise representation. Mont-Saint-Michel and the castles of Duke Jean de Berry were depicted by the Limburg brothers, whose merging of calendrical and topographical illustration in the Duke's *Très Riches Heures* was revived over a century later in the hunting tapestries of the emperor Maximilian.[4] A

Seymour, *Michelangelo's David: A Search for Identity*, Pittsburgh, 1967 (Norton edition, New York, 1974), 33ff.

[2] G. Fournier, *Châteaux, villages et villes d'Auvergne au XVe siècle, d'après l'armorial de Guillaume Revel*, Geneva, 1973.

[3] E. H. Gombrich, *Art and Illusion*, London and New York, 1960, 68-69, 409.

[4] M. Meiss, *French Painting in the Time of Jean de Berry: The Limbourgs and Their Contemporaries*, New York, 1974, 201ff. Some recent attempts have been made to attribute at least some of these calendrical miniatures to a later master (L. Bellosi, "I Limbourg precursori di Van Eyck? Nuovi osservazioni cui 'Mesi di Chantilly,'" *Prospettiva*, I, 1975, 24-34; and E. König, "Le peintre de l'Octobre des Très Riches Heures du Duc de Berry," *Enluminure gothique*, Dossiers de l'archéologie, 1976, 96-123). For the Maximilian tapestries, see R.-A. d'Hulst, *Tapisseries flamandes du XIVe au XVIIIe siècle*, Brussels, 1960, 171ff., no. 20.

room in Francis I's palace at Fontainebleau was decorated with views
of the kingdom's principal royal residences,[5] and the king paid a
Flemish painter, Jean Raf, who specialized in topographical depic-
tions, for having made a "pourtraict" of London and a map of the
principal cities of England.[6]

In certain fifteenth-century depictions of architecture, this concern
for accuracy is accompanied by a dramatic increase in scale, decisively
shattering the conventional "dollhouse" effect conveyed by figures lo-
cated in or in front of comparatively diminutive structures. In Jan van
Eyck's famous silverpoint drawing of St. Barbara in Antwerp, the
tower in which the saint is to be immured is a truly monumental build-
ing, whose height and bulk are underscored by a number of devices.
It is set at some distance from the frontal plane of the picture, and
reveals its size to the viewer through the enormous disproportion be-
tween the seated saint in the foreground and the diminutive work-
men busy around its base. The setting of the building in a kind of hol-
low extends its spatial thrust, and the fact that it is shown still under
construction, with laborers raising and setting stones near the upper
border of the drawing invites the inference that the confines of the
scene will soon prove too small to accommodate it.[7] Another pioneer-
ing image of colossal architecture, perhaps inspired by an Eyckian
model, is found among the miniatures added by Jean Fouquet to an
older copy of Flavius Josephus' *Antiquités judaiques*, once owned by
Duke Jean de Berry. Here we see Solomon standing on the balcony of
his palace supervising the construction of the Temple of Jerusalem
(Fig. 16).[8] The building is a Gothic cathedral, like Van Eyck's tower,
still only partially completed. The structure is aggressively cast on an
angle into an extremely shallow space delimited left and right by
buildings that are wholly overshadowed by its height and bulk. Unlike
the drawing of the Flemish master, where the building at least nomi-
nally remains subsidiary to the figure of the saint in the foreground,

[5] Pierre Dan, *Le tresor des merveilles de la Maison royale de Fontainebleau*, Paris, 1642, 153.

[6] L. de Laborde, *La renaissance des arts à la cour de France* (Paris, 1855), reprint, Burt Franklin, New York, n.d., II, 919-20.

[7] E. Panofsky, *Early Netherlandish Painting*, Cambridge, 1964, 185ff.; M. Meiss, " 'Highlands' in the Lowlands: Jan van Eyck, the Master of Flemalle and the Franco-Italian Tradition," *Gazette des Beaux-Arts*, LXVII, 1961, 273-314.

[8] Paris, Bibl. Nat. fr. 247, fol. 163; and P. Durrieu, *Les antiquités judaiques et le peintre Jean Fouquet*, Paris, 1908. A copy from the end of the fifteenth century is found in Geneva, Codex Bodmer 181, fol. 161 (F. Vielliard, *Manuscrits français du moyen âge*, Bibliotheca Bodmeriana, II, Cologny and Geneva, 1975, 126-28).

Fouquet's miniature makes architecture its main subject, the gesticulating Solomon manifesting no more than a very modest presence in the composition.

Fouquet's miniature and its Flemish antecedent can be seen as the source of two distinct types of architectural depiction. Already in the work of one of the French painter's followers, Jean Colombe, there is a turn toward the fantastic, an inclination which is further developed in sixteenth-century representations of the Tower of Babel in northern European art, beginning with the illustration in the Grimani Breviary and best known through the striking versions of the subject by Peter Brueghel (Fig. 17).[9] The building now easily dwarfs every other feature of the countryside, disappearing into the clouds at its summit, and visible as a whole only from a fair distance. Brueghel and northern Mannerists after him give the tower the appearance of an Antique monument, though at least arguably modified by Romanesque elements, taking as their point of departure the Roman Colosseum. However, in the decomposition of the grandiose structure into a multiplicity of arched members enclosing voids, and in the infinite and picturesque variety of detail, the conception of the late Gothic architectural wonder is still active. A series of engravings of the Seven Wonders of the World, after drawings by Maerten van Heemskerck, show a similar mixture of antiquarian precision and panoramic, grandly scaled fantasy, with buildings in a hybrid style commanding large vistas on a Lilliputian world (Fig. 11).

A second extension of architectural portraiture led away from Biblical or anecdotal reference and to an interest in the depiction of the outstanding monuments of the age. Here, fantasy is understandably minimized and the elements of objective characterization given greater stress. In France, where this kind of activity enjoyed a remarkably early flowering, the views of ancient and Renaissance monuments of Rome by Etienne Dupérac (ca. 1525-1604) and the engravings of admired French and Italian buildings by J. Androuet du Cerceau the Elder (ca. 1520-1584) are important documents of the genre. The combination of native and Italian interests expresses well the dual orientation of French culture toward the middle of the sixteenth century. The ancient Roman monuments and the new realizations of Bramante and Michelangelo commended themselves to enlightened tastes. But under Henry II, the excellence of French language and art as fully equal to the respected Latin models became a

[9] H. Minkowski, *Aus dem Nebel der Vergangenheit steigt der Turm zu Babel*, Berlin, 1960.

topical issue. Du Cerceau's collection in two volumes of the *Plus excellents bastiments de France* (1576-79), whose publication the king seems to have encouraged, is very likely related to these concerns.[10] It offers views of the principal palaces and outstanding residences of the kingdom, all of them buildings of then very recent origin. Yet Du Cerceau did not neglect older monuments in the Gothic style, some of which were to be included in a third volume of the *Bastiments* that was never completed, and we possess engravings of such Medieval structures as the Great Hall of the royal palace on the Cité island erected in the time of Philip the Fair and of Charles V's Bastille and Castle of Vincennes. According to Etienne Pasquier, who quotes him in his remarkable history of the French nation (1560), he was particularly impressed by the Sainte-Chapelle, which he regarded as "the boldest building in the modern (i.e., Gothic) manner."[11] We have thus in his work a kind of embryonic national topography, foreshadowing the more ambitious efforts in this direction undertaken in the seventeenth century by Claude Chastillon in France, Matthäus Merian in the lands of the German empire, and less systematically for England, in the engravings of Wenceslas Hollar.

The rise of the cityscape and of the architectural portrait is inseparable as a cultural phenomenon from the sixteenth-century development on a broad scale of urban history. Rome, the first city in the Latin world, was also the only city of Medieval Europe to have inspired a sustained historiography.[12] The precocious civic consciousness of Italian city-states in the later Middle Ages nurtured an early flowering of local histories like Bonvesin della Riva's description of Milan, Giovanni da Nono's history of Padua, and Giovanni Villani's chronicle of Florence.[13] In France, at a later moment in time, the position of Paris came to rival that of Rome, with Guillebert de Metz in the fifteenth, Gilles Corrozet in the sixteenth, and Pierre Bonfons, Germain Brice, and Jacques du Breul in the first half of the seventeenth

[10] H. von Geymüller, *Les du Cerceau: Leur vie et leur oeuvre*, Paris, 1887.

[11] E. Pasquier, *Recherches de la France*, Paris, 1667, 362: "La Saincte Chappelle de Paris fut bastie par le Roy sainct Louys, d'une architecture admirable telle que nous pouvons voir. I'ai autresfois ouy dire à Maistre Jacques Androuet, dit du Cerceau, l'un des plus grands architectes qui se soient jamais trouvez en la France, qu'entre tous les bastiments faits à la moderne, il n'y en avoit point de plus hardy que celuy-là."

[12] G. Tellenbach, "Die Stadt Rom im Sicht ausländischer Zeitgenossen (800-1200)," *Saeculum*, XXLV, 1973, 1-40; and R. Valentini and G. Zucchetti, *Codice topografico della Città de Roma*, Rome, 1940-53.

[13] J. K. Hyde, "Medieval Descriptions of Cities," *Bulletin of the John Rylands Library*, 48, 1965-66, 308-38 and, for a list of the source material, 338-40.

century only the most conspicuous names among the city's historians.[14] Other French cities became the object of historical study in the same period, and in André Duchesne's *Antiquités et recherches des villes, chasteaux et places les plus remarquables de toute la France*, first published in 1609 and repeatedly reprinted, the towns and fortified places in the entire country were collectively surveyed.

This literature is most diverse in its scope and quality, and it does not lend itself to simple characterization. The writers show the greatest interest in demonstrating the antiquity of their city and thus, as a rule, begin with the treatment of classical sources. These are quarried and indeed sometimes tormented out of all recognition for the testimony which they might give on behalf of a heroic founder or glorious early history; and in line with their basic purpose our writers are unusually attentive to monuments, inscriptions, and artifacts of all kinds of ancient origin found on their native ground. The story is carried forward in a generally more economical fashion for the Middle Ages, with an enumeration of churches and, in the secular sphere, city gates, bridges, and outstanding princely or aristocratic residences. For churches, the institutional affiliation is noted, along with the number and constitution of the clergy. Generally, reference is made to the possession of an outstanding relic or a famous image, and particular attention is paid to the tombs of significant persons, whose epitaphs are often transcribed *in extenso*. In their response to formal qualities of works of art, the urban historians are seldom very profound or original. Extraordinary size, costly materials, technical and craftsmanly virtuosity earn their praise, which is not infrequently couched as an echo of general opinion rather than given as a personal judgment. Indeed, this opinion may turn out to have been borrowed from an older source which the writer has consulted for most of his information. Local patriotism is always a potent ingredient, contributing where this suited the purpose, to a noteworthy benevolence in regard to styles in disfavor within the more advanced currents of taste. The laws of the genre lead the writer to interpret the topography of his own city as an ensemble on a reduced scale of the great Roman model, with its own witnesses of ancient and later greatness and, dominating the whole, its own *mirabilia*.

Adrien de la Morlière's *Antiquitez, histoires, et choses les plus remarqu-*

[14] A.J.V. Leroux de Lincy, *Paris et ses historiens aux XIVe et XVe siècles,* Histoire générale de Paris—Collection de Documents, Paris, 1867; and M. Dumolin, "Notes sur les vieux guides de Paris," *Mémoires de la Société de l'histoire de Paris et de l'Ile-de-France*, XLVII, 1924, 109-85.

ables de la ville d'Amiens, first published in 1622, and several times re-printed, is a fine example of this kind of literature. It begins, characteristically enough, with an "Ode Panégyrique," in which it is claimed that "Amiens was already all-powerful some two thousand years ago under Julius Caesar," and goes on to allude to the existence of colonies of the city in Asia Minor in the time of Alexander the Great. The author in succeeding chapters describes Amiens' geographic setting and enumerates the occasions when great princes sojourned in the town. We hear, further, about the early saints of the city, the counts and royal administrators, the privileges which it enjoyed and the nature of its governance. The treatment of the churches and monasteries of Amiens rightly enough begins with the cathedral (Fig. 18), of which La Morlière was a canon. Whatever this may have contributed to his outlook, his description of the edifice is, given its date, remarkably thorough and sympathetic. "Truly," we read, "it would be impossible to encounter a masterpiece of greater boldness, nor one more difficult to represent than this church. Books give us some descriptions of the most superb structures of ancient times, but here, no pen would be adequate for the task, and it would be necessary to have on hand every sort of plan and engraved rendering in order to show the towers, the stairs, the portals, the flying buttresses and compound shafts, not to mention its many other members and beautiful details."[15] In La Morlière's praise of the edifice, a major role is taken by the enumeration of the measurements of different parts, which in this vast structure could well be presumed to speak for themselves. Sheer size, however, is not for him a criterion of quality. If the cathedral measures one hundred and thirty-two feet from the base of the nave piers to the summit of the vaults, this "it has in common with a fair number of buildings of this kind. Yet the proportions are more satisfactory than anywhere else." In the relation between the upper windows, the galleries, and the vaults, there is "beautiful order and ap-

[15] A. de la Morlière, *Les antiquitez, histoires et choses plus remarquables de la ville d'Amiens* (1622), Paris, 1627, 82-83. The high standing of Amiens Cathedral is recorded also in Belleforest's *Cosmographie universelle*, Paris, 1575, 381, and still at the beginning of the eighteenth century by the two traveling Benedictines, Martène and Durand, who write: "L'église cathédrale est un chef d'oeuvre accompli, on ne peut rien voir de plus parfait, ni de plus beau, et dans tout le royaume, il n'y en à aucune qui lui puisse disputer" (*Voyage littéraire de deux Religieux Bénédictins de la Congrégation de Saint-Maur*, Paris, 1717, I, 171). On the reputation of Amiens and other Medieval monuments at this time, see also A. Rostand, "La documentation iconographique des 'Monuments de la Monarchie Françoise' de Bernard de Montfaucon," *Bulletin de la Société de l'histoire de l'art français*, 1932, 107 and 140.

propriate symmetry." As might be expected in an author of the early seventeenth century, Gothic architecture is seen through classicizing eyes, but it is also true that in the light of the mannered complexity of certain late Medieval and Renaissance structures, Amiens Cathedral and the moment of High Gothic art which it represents could with some justification be interpreted in this way.

The history of Normandy's principal city was written by Noël Taillepied, whose *Recueil des antiquitez et singularitez de la ville de Rouen* first appeared in 1587 and was frequently reissued until it was superseded in 1668 by François Farin's more weighty *Histoire de la ville de Rouen*. The monument singled out for special praise by these authors is not the cathedral but the equally imposing abbey church of St. Ouen. Taillepied calls it, as it was in his time, "one of the most beautiful works in the world for the boldness of its architecture, realized by two architects as if by envy of one another."[16] The story is given more fully by Farin and is also found in Dom Pommeraye's history of the abbey of St. Ouen published in 1662.[17] The present church of St. Ouen was begun under Abbot Jean Roussel, called Marc d'Argent, who ruled between 1303 and 1339. At his death, the choir was finished, but the transept and the nave were just begun. Building activity slowed down markedly thereafter because of the effects of the Hundred Years' War. The transept was completed by the master mason Alexandre de Berneval, first signaled in 1422, and by his son Colin, who replaced him at his death in 1441.[18] Berneval's tomb slab can still be seen in the chapel of St. Agnes on the northern side of the choir (Fig. 19). It is a double tomb on which he is shown in company with a second architect standing at his right, who is without an identifying inscription. It is very probable that the story of the rivalry between the two men, found in Taillepied and his successors, was inspired by this monument. According to these writers, Berneval constructed one of the rose windows of the transept, whereupon the second figure, qual-

[16] F. N. Taillepied, *Recueil des antiquitez et singularitez de la ville de Rouen*, Rouen, 1587, reprinted by the Société des Bibliophiles Normands, Rouen, 1901, 60-61.

[17] J.-F. Pommeraye, *Histoire de l'abbaye royale de Saint-Ouen*, Rouen 1662, 196f.; and F. Farin, *Histoire de la ville de Rouen*, Rouen, 1668, III, 3.

[18] For the building history of Saint-Ouen, see the studies by A. Masson, "Eglise Saint-Ouen," *Congrès archéologique*, 1926, 102-26, and *L'église abbatiale Saint-Ouen de Rouen*, Petites Monographies des grands Edifices, Paris, 1927; and that by J. Lafond, *Les vitraux de l'église de Saint-Ouen de Rouen*, I, 1970, *Corpus Vitrearum Medii Aevii*, 14ff. The story of the rivalry of the two masters and the alleged murder of Colin was dealt a fatal blow by J. Quicherat, "Documents inédits sur la construction de Saint-Ouen de Rouen," *Bibliothèque de l'Ecole des Chartes,* 3rd Series, III, 1852, 473ff.

ified by them as his servant or apprentice, undertook to surpass his
work in the rose of the opposite transept arm. He succeeded so well in
this that his master murdered him in a jealous rage. For this, he was
executed, but the monks of St. Ouen, whom he had well served, ob-
tained his body and gave the two men a common burial in the church.

When and under what circumstances this story originated is as yet
unclear. Pommeraye states that he found it "in certain ancient manu-
scripts of the abbey and library of M. Bigot,"[19] and it was already
known to Taillepied. Both Pommeraye and Farin before him add that
the two roses were completed in 1439. The latter calls them "master-
pieces which one cannot contemplate without admiration," and the
former thought well enough of them to reproduce them by means of
engravings in his book. The tomb itself must have attracted its own
share of attention. Judging by the symbolic animals below the feet of
the two architects—a dog under Berneval and a lion under his
anonymous companion—the carver modeled his work on the conven-
tional tomb type for a married couple. Perhaps the monument was
commissioned by Berneval's son Colin for himself and for his father,
though we should not be surprised that it was not interpreted in this
way, since such a double architect's tomb still seems wholly excep-
tional. Exceptional, too, is the active characterization of the figures,
who do not, as is customary, merely display the attributes of their
trade, but actually employ them as if at work. Both hold compasses
which they demonstratively point toward panels or sheets with archi-
tectural drawings. That they might be engaged in a contest was prob-
ably not an altogether unreasonable inference to draw. The projects
which are illustrated in these drawings differ. Berneval's alone is a
rose window, of which a pie-shaped section is shown, while his col-
league's, largely obliterated by the erosion of the stone, is a compound
Gothic pier drawn in section. But a drawing made for Roger de Gaig-
nières between the years 1670 and 1715 shows this difference to have
been willfully or otherwise overlooked, likely under the influence of
the story of the architects' rivalry (Fig. 20).[20] The design of Berneval's
window is fairly similar to the existing rose of the south transept of St.
Ouen (Fig. 21), which would justify not only the attribution of that
work to the older master but would also support the conclusion that
this was a labor in which he took particular pride. The rose of the

[19] Emery Bigot (1626-1689) was a Rouen collector and bibliophile (see M. Prevost
and R. d'Amat, *Dictionnaire de biographie française*, 1954, VI, 444).

[20] J. Adhémar, "Les tombeaux de la collection Gaignières: Dessins d'archéologie du
XVIIe siècle," *Gazette des Beaux-Arts*, LXXXVIII, 1976, 6, no. 1124.

north transept has an unusual and very different design (Fig. 22), incorporating a great five-pointed star. It is also, arguably, a more brilliant achievement—or so, at least, it was viewed in Renaissance Rouen. If the theme of rivalry was thus suggested by a misreading of the double tomb, its substance was furnished by the contrasting perfection of the two roses.[21]

La Morlière and the Rouen historians cite as a source of inspiration for their own efforts the history of Paris of Gilles Corrozet, whose *Antiquitez* was first published in 1550. Its success is attested by a number of subsequent editions and amplified versions by continuators well into the first half of the seventeenth century. Foremost on Corrozet's list of great Parisian monuments is the cathedral of Notre-Dame (Fig. 23), which he calls "the only marvel in France for its scale and design."[22] This favorable opinion was partly based on the author's belief, apparently widely shared and still found in Victor Hugo's *Notre-Dame de Paris* that the edifice had been erected on *pilotis* over the waters of the Seine. But Corrozet also gives an enthusiastic account of various aspects of the structure, concluding with a striking impression of the upper parts: "the entire roof line is sustained by flying buttresses, upon which, in part, there are square and triangular pyramids with effigies of the kings of France and other personages who are within and above. To be brief, it is the largest and most well-built spectacle in the Christian world."[23]

Among the continuators of Corrozet and other writers after him, there appears a further argument for the excellence of Notre-Dame. It is founded on the opinion of Robert Ceneau, bishop of Avranches, who in his *Gallica historica* (1557) compared the church to the Temple of Diana at Ephesus and found that it overshadowed that world marvel "in length, width, height and structure."[24] For another historian of the city, André Thévet (d. 1590), the towers of Notre-Dame were reminiscent of another of the ancient marvels of the world, the "two highest pyramids in Egypt."[25] Beginning with Jacques du Breul's *An-*

[21] Contrasting roses of "floral" and stellar design are also found in the transepts of the cathedral of Rouen and elsewhere in Normandy, at Sées.

[22] G. Corrozet, *Les antiquitez, chronicques et singularitez de Paris*, Paris, 1586, 60. On this author, see M. Dumolin, "Notes sur les vieux guides de Paris," *Bulletin de la Société de l'histoire de Paris et de l'Ile-de-France*, 1920, 209ff.

[23] Corrozet, *Antiquitez*, 60; for Victor Hugo's citation, see J. Mallion, *Victor Hugo et l'art architectural*, Paris, 1962, 67-68.

[24] *Roberti Coenalis . . . Gallica historica*, Paris, 1557, bk. II, per. III, fol. 130.

[25] A. Thévet, *Cosmographie universelle*, Paris, 1575. The description of Paris is reprinted with the title *La grande et excellente cité de Paris* in *Collection des anciennes descrip-*

tiquitez de la ville de Paris (1595), the crucifix of the *jubé* above the entrance of the choir is singled out as a masterpiece: "The great crucifix which is above the door of the choir, together with the cross, are made of one piece, and the base in the form of an arch of another single piece. They are two masterpieces of carving and sculpture."[26] The *jubé* of Notre-Dame was executed in the first quarter of the fourteenth century by Pierre de Chelles and Jean Ravy. It consisted of five gabled arcades surmounted by a gallery. Scenes of the Passion of Christ, fragments of which are still extant, decorated the spandrels. The work was damaged in the religious troubles of the sixteenth century and largely dismantled in the middle of the seventeenth to make way for a new choir screen. However, a drawing made in 1708 by Robert de Cotte shows that the central crucifix of the Gothic *jubé* and its supporting arcade praised by Du Breul and his immediate followers had been saved from destruction and incorporated into the seventeenth-century design (Fig. 24). The drawing is too small in scale and imprecise in detail to make it possible to assess the esthetic merit of the work, though it does at least register its basic configuration and helps us to understand the technical achievement so highly esteemed by the critics.[27] The crucifix, which must have been made of wood, had trilobed extremities and a kneeling angel on each arm. The flanking Virgin and St. John stood on high pinnacles adjoining the gable. The latter was pierced by a rose and crowned a trilobed arch.

Corrozet and other Renaissance historians of Paris also had a very high opinion of the Sainte-Chapelle (Fig. 25). The former seems to allude to the judgment of Du Cerceau, quoted earlier, when he remarks that the building is, "in the view of architects, the boldest work on this side of the Alps." This is "because it contains two perfect churches, an upper chapel and a lower one, in which there is not a single column or support, outside of those surrounding the edifice on the exterior. These are so high and straight, so slender and fine that it would seem that it could not resist the smallest injury from the elements. . . . "[28] The chronicler Belleforest, writing in 1575, similarly

tions de Paris, no. 5, ed. V. Dufour, Paris, 1881, 16-17. Thévet also calls Paris (p. 3) a "miracle de l'univers."

[26] Jacques du Breul, *Les antiquitez de la ville de Paris* (1595), Paris, 1640, 7.

[27] M. Aubert, "Les trois jubés de Notre-Dame de Paris," *Revue de l'art*, XLIII, 1923, 105-18, and "Les dates de la clôture du choeur de Notre-Dame de Paris," *Mélanges Emile Bertaux*, Paris, 1924, 20-26; and D. Gillerman, "The Cloture of the Cathedral of Notre-Dame: Problems of Reconstruction," *Gesta*, XIV/1, 1975, 41-53.

[28] Corrozet, *Antiquitez*, 75.

praises the structure "which is held to be as admirable an edifice as one could see, large and solid in volume, yet borne by supports which would seem incapable of sustaining such a great weight."[29]

With the passage of time, new monuments appeared on the scene, adding to the number of recognized *chefs d'oeuvre*. In Amiens, La Morlière so designated not only the cathedral but its elaborately carved early sixteenth-century wooden choir stalls,[30] while Farin in Rouen cites the historiated wooden doors of St. Maclou, sometimes attributed to Jean Goujon.[31] In Paris, a new masterpiece was acclaimed in Philibert de L'Orme's great spiral staircase of the Tuileries palace. Begun around 1564 for Catherine de Médicis and only completed after the architect's death in 1570, it could be recorded only by Corrozet's successors. It is singled out for high praise in a dispatch of the Venetian ambassador Lippomano, dated 1577, and thereafter regularly acclaimed as a masterpiece in the histories and guidebooks of the city. Du Breul writes that "the spiral staircase of this beautiful palace, suspended in the air and without a newel of any kind to support the steps, is the most beautiful masterpiece of architecture and one of the boldest that can be seen in France."[32] In Michel de la Rochemaillet's *Théâtre de la ville de Paris* (1556), we read that the work is "one of the most admirable staircases of the world, oval in shape, and in the middle of this oval, there is another which is entirely hollow. Thus, the spiraling steps are supported only on one side, with nothing to hold them up on the other."[33] Sauval's monumental *Histoire et recherches de la ville de Paris* (1724) is unbounded in its admiration: "This marvellous masterpiece has inspired a quantity of fables which I shall spare the reader. All I can say is that if this staircase had been erected in a century further removed from our own, we

[29] F. de Belleforest, *Cosmographie universelle*, Paris, 1575, 204; and Dufour, *Collection des anciennes descriptions*, no. 7, 1882, 222. Belleforest's work is an amplified version of Sebastian Münster's *Cosmographia universalis*, 1544.

[30] La Morlière, *Antiquitez*, 83: "Les chaires du choeur, chef d'oeuvre ou plutost miracle de sculpture et de menuiserie. . . ." On these celebrated stalls, begun in 1508 and finished in 1522 at the earliest, see A. Boinet, *La cathédrale d'Amiens*, Petites Monographies des grands Edifices, Paris, 1926, 94-104.

[31] Farin, *Histoire*, II, 87: "Les portes de ce Temple sont des Chefs d'oeuvre, et leur sculpture qui represente divers mystères de nostre religion, surprend les curieux qui avouent qu'ils n'ont jamais rien vu de plus beau." On the authorship of the doors of Saint-Maclou, see P. du Colombier, *Jean Goujon*, Paris, 1949, 32ff.

[32] Du Breul, *Antiquitez*, 671.

[33] M. de la Rochemaillet, *Théâtre de la ville de Paris*, Paris, 1642, in *Collection des anciennes descriptions*, no. 3, 1880, 29.

would have come to believe that the builder had been a magician or a fairy."[34]

The Tuileries palace, considerably altered after 1664 by Le Vau, was destroyed by fire during the Paris Commune. The original scheme is preserved in drawings by Du Cerceau who, as Sir Anthony Blunt has suggested, must himself have contributed ideas of his own to the project. De L'Orme's famous staircase was situated at the center of the western wings of the palace. Although there is some uncertainty concerning some aspects of the design, its major features are known. The staircase was enclosed in a rectangular space. At ground level, there were three adjoining flights of curving steps, separated from each other by a low wall, an idea which recalls the arrangement of the stairs in Michelangelo's vestibule of the Laurenziana library in Florence. At an intermediate level, the lateral flights terminated and the central section alone continued upward. It was an oval, some twenty-seven feet wide and equipped with a bronze balustrade beyond which was the oval void of roughly equal width. The upward path of the stairs was interrupted by landings where doorways gave access to rooms on each side.[35] As we have seen, it is this oval staircase, open in the middle and seemingly without any support, which aroused the enthusiasm of the critics. De L'Orme's mastery was demonstrated here in a theme much at home in French late Medieval and Renaissance architecture, with such illustrious creations as the staircases of the castles of Blois and Chambord at hand. In Paris itself, the spiral staircase of the church of the Bernardins had been singled out by the fifteenth-century historian of the city Guillebert de Metz as another *tour-de-force* of this kind, "a marvellous *vis* with a double flight of steps, so that those who are ascending or descending one set of stairs do not know where those using the other are."[36]

The rebuilding of the Louvre palace initiated by Francis I and continued by his successors was duly recorded by the Paris historians. Corrozet notes that Francis began the construction of a great hall "in

[34] H. Sauval, *Histoire et recherches de la ville de Paris*, Paris, 1724, II, 54, reprinted in A. Blunt, *Philibert de l'Orme*, London, 1958, Appendix B.

[35] Blunt, *Philibert de l'Orme*, 91ff. The monument was reproduced in an engraving by the Marots, which now appears to be lost. It is mentioned in the catalogue of the works of Jean Marot found in F. le Comte, *Cabinet des singularitez d'architecture, peinture, sculpture et graveure*, Paris, 1699, I, 40: "Elevation du milieu de la face du Palais des Thuilleries, qui est accompagnée d'un escalier en ovalle vuide, et l'une des merveille de l'Architecture, qui a été bati du Regne de Catherine de Médicis, et conduit par Philibert de Lormes."

[36] Leroux de Lincy, *Paris et ses historiens*, 167.

the antique manner, the most excellent according to the art of architecture ever seen."[37] The monument stood high in the esteem of later writers as well, though the supreme accolade was accorded to it only in time, as the structure grew more imposing through different building campaigns and especially after the addition of Perrault's colonnaded block (1667-70) closing the square to the east. That the edifice might be a masterpiece was then discovered to be consistent with its supposed etymology. Louvre was understood to mean *l'oeuvre*, and this deduction pointed to the true significance of the work. Isaac of Bourges, an author who is thought to have flourished in the first half of the eighteenth century, represents this point of view: "This admirable edifice, to which the name Louvre has been given—a name whose true explanation is at the same time a high compliment, since it signifies a work of the greatest excellence or *chef d'oeuvre*—is of the palaces of Paris and even of the entire universe the largest, the most beautiful and the most magnificent."[38]

With the Louvre and the Tuileries, the palace of Fontainebleau has a secure place among late Renaissance architectural marvels. Belleforest in his *Cosmographie universelle* (1575) speaks of it as follows: "In the Gatinais is found the magnificent dwelling, superb castle and royal palace, the seat and pleasure ground of the French kings. Once in a ruinous state, it was restored in our time by the great king Francis I, who, having assembled the most excellent master architects in all of Europe, built this masterpiece as rare as can be seen in all of Gaul."[39] Pierre Dan, the head of a small community of Trinitarian monks installed by Francis in the chapel of the chateau, had little difficulty in compiling a substantial anthology of similar sentiments for his *Trésor des merveilles* (1642), the first history of the monument. A sonnet by François Malherbe (1607), one of the numerous poetic compositions inspired by the palace, its gardens, and the famous neighboring forest, opens with these verses:

> Beaux et grands bâtiments d'eternelle structure
> Superbe de matière, et d'ouvrages divers,
> Où le plus digne roi qui soit en l'univers
> Au miracle de l'art fait céder la nature.[40]

[37] Corrozet, *Antiquitez*, 160.

[38] Isaac de Bourges, *Description des monuments de Paris*, in *Collection des anciennes descriptions*, no. I, 1878, 26. Antoine du Mont Royal, *Les glorieuses antiquitez de Paris*, in *Collections des anciennes descriptions*, no. 2, 1879, 6, similarly says: "Le Louvre fut ainsi nommé, comme si on voulut dire: L'Oeuvre par excellence et en sa perfection."

[39] Belleforest, *Cosmographie universelle*, I, 333.

[40] Malherbe, *Oeuvres*, ed. A. Adam, Paris, 1971, 82.

The name *Merveille* has long designated the handsome multi-storied structure rising on the northern side of the church of Mont-Saint-Michel, and housing the cloister, refectory, wine cellar, almonry, and other communal spaces of the abbey (Figs. 26 and 27). It is generally agreed that the *Merveille* consists of two distinct wings connected to one another, both largely erected in the first third of the thirteenth century. How long it has borne its present name has not yet been determined, though the building is already so labeled on a topographical view of Mont-Saint-Michel dated 1705.[41] It would seem most probable, in view of the history of interest in architectural marvels as sketched on the preceding pages, that the *Merveille* acquired its name in the course of the later Middle Ages or the Renaissance. However this may be, the fame of this part of the monastic complex no more than epitomizes the reputation of the monument as a whole (Fig. 26). For indeed, the extraordinary setting, the brilliant conception of the architecture, the religious and political role which the monastery played, taken in combination, make this as nearly a universal marvel as there is. Guillaume de Saint-Pair's *Roman du Mont-Saint-Michel*, near the end of the twelfth century, sets the tone for a chorus of later voices. Approaching the goal of their voyage, his pilgrims

> Veient le mont et le mostier
> Molt se prenent a merveiller.[42]

The popularity of the archangel's shrine was enhanced in the later Middle Ages through its heroic resistance to English onslaughts in the course of the Hundred Years' War. Michael almost became a national saint in France, ordering Joan of Arc, in her own words, to rise to her king's rescue. Louis XI created a knightly order under his patronage. Encouraged by a succession of papal grants of indulgences, pilgrims came to the *Mont* in ever greater numbers. The architecture of the monastery received through various additions and alterations the form which it presents today. Under the influential Cardinal d'Estouteville, abbot from 1446 to 1483, the old Romanesque choir of the church was pulled down and replaced by the present most impressive

[41] P. Gout, *Le Mont-Saint-Michel: Histoire de l'abbaye et de la ville: Etude archéologique et architecturale des monuments*, Paris, 1910, II, 461ff. The print of 1705 by Nicolas de Fer is reproduced in vol. I, 289, fig. 176. For the constructions which constitute the *Merveille*, see also M. Nortier, "La construction de la Merveille," *Annales du Mont-Saint-Michel*, 1965, no. 1, 10-14, and no. 2, 35-38.

[42] Guillaume de Saint-Pair, *Roman du Mont-Saint-Michel*, ed. P. Redlich, Ausgabe und Abhandlungen, Marburg, 1894, vs. 728-29.

Flamboyant Gothic sanctuary, itself termed in one of our sources the *grand oeuvre*.[43] Fr. Feuardent (1604), Dom Jean Huynes (1640), and Thomas Le Roy (1647) wrote the earliest histories of Mont-Saint-Michel. Institutional rather than urban history, their work is more concerned with the record of events, benefactions, and miracles connected with the monastery than with the description and praise of local curiosities. Thus, there is no attempt on their part to justify the pre-eminence of the monument in terms of formal or technical criteria. The word "marvel" retains for them a literal, supernatural sense, largely synonymous with miracle and embracing both natural and man-made features in a single perception. An acute personal impression was recorded by a seventeenth-century visitor to the mount, Dubuisson-Aubenay, whom its winding streets reminded "of the Tower of Babel, as it is represented in engravings" (Figs. 17 and 26).[44]

Not all writers of urban history discovered masterpieces on their doorstep. While a local poet professed to see in the cathedral of Orléans the eighth wonder of the world,[45] no monument of Lyon, a larger and culturally richer city, with an imposing historiography, received such lofty praise. The topography of the city and the interests of its historians are concurring factors in this comparative reticence. From Guillaume Paradin (1573) to Jacobus Spon (1675), the Lyonnais authors devoted much effort to the investigation of the city's ancient remains and inscriptions. Here, as in southern France more generally, the material evidence of this ancient past loomed more prominently than in the north. Gothic architecture made a conversely less overwhelming mark on the landscape, or else it was neutralized by the prestige of older remnants. The Lyon historians praise the Place Bellecour, the old Hôtel de Ville, the cathedral of St. Jean and especially its astronomical clock,[46] but this matter is quickly dispatched and entirely overshadowed by their catalogue of Roman antiquities. But for all the wealth of these, the city boasted no really outstanding

[43] See Dom J. Laporte, "Le crépuscule de l'ancien monachisme au Mont-Saint-Michel," *Millénaire du Mont-Saint-Michel*, Paris, 1967, I, 211ff.

[44] Dubuisson-Aubenay, *Itinéraire*, 33: "Entrés que vous estes, tout à l'heure vous montez par une rue tournoyante comme les escaliers de la tour de Babel représentée ès taille douces."

[45] Fr. le Maire, *Antiquitez et choses mémorables de l'église et diocèse d'Orléans*, Orléans, 1645, 40-41, quoting from the poem *Aurelia* (1615) by Raoul Boutrays (Botereius) which is cited in full at the end of the volume.

[46] See, for example, J. Spon, *Recherches des antiquités et curiosités de la ville de Lyon*, Lyon, 1675, 23; and A. Ungerer, *Les horloges astronomiques et monumentales les plus remarquables de l'Antiquité jusqu'à nos jours*, Strasbourg, 1921, 106ff.

monument of masterpiece stature. Nicolas Chorier, the historian of Vienne a short distance to the south, might well have had this situation in mind when he concluded his remarks on the cathedral of St. Maurice in his city with the statement that it was the only edifice "capable of being the ornament of this province and taking for it the place of several marvels."[47]

In Provence and Languedoc, by contrast, the monuments of Antiquity could assert their excellence in nearly uncontested fashion. Jean Poldo d'Albenas, the author of a history of Nîmes, published in 1560, gives enthusiastic descriptions of the Maison Carrée, the amphitheater, the Fontaine de Diane (*nympheum*), and other Roman structures in the town. However, the "great marvel of the world" for him is the Pont du Gard, taken, according to the now familiar formula, to have been the work of demons or magicians rather than ordinary mortals.[48] The bridge was also the subject of a laudatory epigram by the noted reformer Theodore de Bèze (1519-1605), and it is cited with high acclaim in Sebastian Münster's *Cosmography*, as well as in the two earliest national topographies of France, Duchesne's *Antiquités et recherches* and the *Itinerarium Galliae* (1612) of Iodocus Sincerus (Zinzerling).[49] Thereafter, the work never failed to inspire admiring comment.

In 1585, the royal engineer Louis de Foix entered into a contract to reconstruct the lighthouse of Cordouan, on a small island off the Atlantic coast near the estuary of the Gironde (Fig. 28). As set forth by the late R. Crozet, the building history of this famous work—*pharum praenobilis*, as Sincerus calls it—encompassed two stages.[50] The first

[47] N. Chorier, *Les recherches du Sieur Chorier sur les antiquitez de la ville de Vienne*, Lyon, 1659, 176. An earlier historian of Vienne singled out a doorway and passage cut into a buttress on the north side of the cathedral in order to provide access to the cloister as "un oeuvre de Maistre fort hardy, et comme un chef d'oeuvre" (J. Lelièvre, *Histoire de l'antiquité et saincteté de la cité de Vienne en la Gaule celtique*, Vienne, 1625, 227). An old proverb of southern France designates four marvels in the region: the steeple of Rodez Cathedral, the portal of Conques, the cathedral of Albi, and the steeple of that at Mende (J. Bousquet, "Le clocher de Rodez, oeuvre complète ou inachevée? Sa place dans l'évolution des types architecturaux," *Actes du 96e Congrès National des Sociétés Savantes*, Paris, 1976, II, 267-68).

[48] J. Poldo d'Albenas, *Discours historial de l'antique et illustre cité de Nismes*, Lyon, 1560, n.p.

[49] The poem of Bèze in which the bridge is called "hinc stupendum illud humanae industriae opus Pontus Gardius" is quoted by Sincerus, *Itinerarium Galliae*, Amsterdam, 1655, 126-27, though I have not found it in the edition *Theodori Bezae Vezelii Poemata*, Lyon, 1757.

[50] R. Crozet, "Le phare de Cordouan," *Bulletin monumental*, 1955, 153-71.

campaign, much hindered by a shortage of funds and the unrest of the times, accomplished the building of the powerful foundations and the first story of the tower. In 1594, the architect concluded a new agreement which called for the notable enlargement and enrichment of the design. This second scheme is known to us through a recently discovered drawing in Stockholm and an engraving by Claude Chastillon, who in 1606, after the death of Louis de Foix, was called upon to complete the structure. Exposed to severe climatic conditions, the tower required extensive repairs in the late eighteenth century, when the upper part was reconstructed, gaining its present, more severely neoclassical silhouette. The two lower stories of Louis de Foix's second project containing three superimposed rooms have been preserved with relatively little change. The dome of the third-story chapel with its projecting gabled dormers surmounted by obelisk-like pinnacles is encased in masonry of the later remodeling, but the interior has survived more or less intact. The conception of the edifice and many of its features have no parallel in their time in France and show that the builder was familiar with developments of architectural design in Italy, most notably certain late projects of Michelangelo and Vignola.[51] It is possible that he became acquainted with the style of these two masters through some connection with the building of the Escorial, for he is known to have been in the service of King Philip II of Spain in the 1560s, when the plans for the highly Italianate monastic complex and pantheon were being formulated.

Above the entrance of the chapel, below a bust of Louis de Foix, there is an inscription in which the lighthouse is successively compared to each of the seven marvels of the world and found to outshine them all. It seems likely that the author of these verses had in mind not only the formal and technical achievement represented by the monument, but a reference to the lighthouse of Alexandria, one of the ancient world marvels. Jacques-Auguste de Thou in his *Histoire universelle* (1623) and several other writers of the first half of the seventeenth century explicitly make this comparison. For Léon Godefroy, who visited the structure in 1638, it is "reputed the eighth wonder of the world, or even the seventh instead of the lighthouse of Alexandria." Claude Pellot, Colbert's uncle, calls it "the most beautiful masterpiece of architecture in France."[52]

The role of the crown in the building of the Cordouan lighthouse

[51] J. Guillaume, "Le phare de Cordouan, 'Merveille du Monde' et monument monarchique," *Revue de l'art*, 8, 1970, 33-52.

[52] Crozet, "Phare," 161.

has led to the suggestion that the structure embodies a profound political message and was specifically intended to glorify the memory of the martyred king Henry IV.[53] It is well to recall, however, that the portrayal of a prince as a patron of *mirabilia* was no longer a novel idea at this time. It is already implicit in the accounts of the seven marvels upon which Lemaire, as we have seen, elaborated the theme of the "new" Artemisia. If the monument of Hallicarnassus and the Pyramids were royal mausolea, in Semiramis' Hanging Gardens (fortifications) of Babylon, in the Colossus of Rhodes, and the Lighthouse of Alexandria, a prince was shown acquiring renown as a patron of stupendous public works. Henry's vast urbanistic schemes in Paris—the Pont Neuf, the Place Royale, and the Place des Nations—show clearly enough that this is where his inclinations lay.

By the middle of the seventeenth century, "masterpiece" had gained acceptance in France as a superlative term applicable to outstanding monuments of architecture and, less commonly, of sculpture. A dictionary of the French language published in Paris in 1621 lists two Latin equivalents and thus registers the entry of the term into elevated speech. For *chef d'oeuvre*, the translation *canon artis* is given. *Faire chef d'oeuvre* is translated *tirocinium facere*.[54] The two entries have different connotations, reflecting the double meaning acquired by the word. *Canon artis*, suggesting rule, measure, model, comes close to the exemplary sense of masterpiece, whose unfolding in the later Middle Ages we have traced. *Tirocinium*, which may be defined as "the first beginning of anything, the first trial, attempt or essay," represents the older meaning connected with artisanal practice and perpetuated in this sphere within the fabric of guild regulations. The expression "chef d'oeuvre d'architecture" in some of our citations, with its suggestion of mastery circumscribed within a given professional activity, still bears the mark of this older usage. On the other hand, the expression cannot, in context, be taken literally to refer to an artisanal exercise, and the display of mastery here involved is unambiguously that of the newer, canonical variety.

[53] Guillaume, "Phare," 50ff.
[54] *Thresor de la langue française, tant ancienne que moderne*, Paris, 1621, 118.

V

CHEF D'OEUVRE AND MASTERPIECE

We have thus far written of *chef d'oeuvre* and "masterpiece" as if they were interchangeable terms. Their early history, however, does not unfold in wholly parallel lines, as a comparison between French and English versions of the same text will show. In 1559, John Calvin published the definitive Latin version of his *Institutio Christianae religionis*. In the first part of this capital work, Calvin considers the means by which man can have knowledge of God's existence. The spectacle of the creation is for him a convincing demonstration of the divine purpose. For we need not cast more than a glance at this great and noble work ("amplissimam vero hanc et pulcherrimam machinam") to be overwhelmed by the infinite abundance of light emanating from it.[1] One year after the Latin edition, Calvin published his own French translation of the *Institutio*. Here, the divine labor is called "ce beau chef d'oeuvre du monde universel."[2] But in the English version, made by an anonymous translator from the Latin original and published in 1578, the words are "this most large and beautiful frame."[3] A similar pattern is found in the different versions of Agrippa of Nettesheim's treatise in praise of women, mentioned above. Agrippa's argument that woman is the most perfect among the works of God ("omnium operum Dei perfectissimum") is rendered in the French translation of

[1] J. Calvin, *Institutio Christianae religionis*, Geneva, 1559, 10.

[2] J. Calvin, *Institutions de la religion chrétienne* (Geneva, 1560), reprint, Paris, 1957, Bibliothèque de textes philosophiques, ed. J.-D. Benoît, 52. Other references to man as the divine *chef d'oeuvre* in French writings of the sixteenth century are found in R. Bady, *L'homme et son "institution" de Montaigne à Bérulle, 1580-1625*, Annales de l'Université de Lyon, 3e série, fasc. 38, Paris, 1964, 110; and, among the sources cited by Sozzi, *La 'dignitas hominis,'* 183ff.

[3] J. Calvin, *The Institutions of the Christian Religion*, London, 1578, 7.

1578 as "la femme fut le dernier chef-d'oeuvre de Dieu."[4] The word "masterpiece" does not occur in an English version published in 1542, which adheres more closely to the Latin and speaks of woman as "the most perfect of all goddis workes, and of the same the very perfection."[5]

A third case of texts available to us in parallel French and English versions is represented by Guillaume Salluste du Bartas' long poem *Première Sepmaine ou Creation du Monde*, first printed in 1578. In the first seven sections, each of which is devoted to one of the days of Creation, the author draws the now familiar picture of the Lord as a great architect, whose work he compares to the building of a mighty palace. Unwilling to imitate some older world, the Creator proceeds much like Zeuxis in his painting of Helen of Troy:[6]

> Et choisissant par tout les choses les plus belles,
> Fait en un seul bastiment dessus trente modelles;
> Ains n'ayant rien qu'un Rien pour dessus luy mouler
> Un chef-d'oeuvre si beau, l'Eternel, sans aller
> Ravasser longuement, sans tressuer de peine
> Fit l'air, le ciel, la terre, et l'ondoyante plaine. . . .

In the corresponding lines of Josiah Sylvester's *Divine Weeks* (1605), the English translation of Du Bartas' poem, the word "masterpiece" is not mentioned.[7] But the situation is reversed in a later passage of the work dealing with the creation of man. Here, Du Bartas remarks in traditional fashion that God's earlier labors were only trial efforts for this final accomplishment, the highest of all.[8] This is how Sylvester renders these lines:

> All th'admirable Creatures made beforne
> Which Heaven and Earth and Ocean doo adorne,

[4] Agrippa of Nettesheim, *Opera*, II, 520-21, and *Traité de l'excellence de la femme*, Paris (Jean Poupy), 1578, 16. I did not have access to the earlier translations of the work listed in J. G. Th. Graesse, *Trésor des livres rares et précieux* . . . , Dresden, 1859, 45.

[5] *A Treatise of the Nobilitie and Excellencie of Womankynde, translated into Englyshe by David Clapham*, London (Th. Bertheletus), 1542, 97.

[6] *The Works of Guillaume de Salluste, Sieur du Bartas*, ed. U. T. Holmes, J. C. Lyons, and R. W. Linker, Chapel Hill, N.C., 1935, II, 201.

[7] *The Divine Weeks of Josiah Sylvester* (1605), London, 1611, 8-9.

[8] *Works of Du Bartas*, 393:

> Tant d'admirables corps dont le ciel se décore,
> Dont l'eau s'enorgueillit, dont la terre s'honore,
> Ne sont que coups d'essai comparez comme il faut
> A l'art industrieux d'un ouvrage si haut.

> Are but Essaies, compar'd in everie part,
> To this devinest Maister-Piece of Art.[9]

If we acknowledge that nothing more significant than the convenience of versification may in particular cases stand behind the choice of terms, the larger pattern is nevertheless reasonably clear. "Masterpiece" began its career later than its French equivalent, apparently making its initial appearance in the English vocabulary of praise not earlier than the beginning of the seventeenth century. Even after that time, it did not so readily displace the conventional accolades. The word, in any case, is not of French origin at all, but derives from the German *Meisterstück* or its Dutch equivalent.[10] Initially, *Meisterstück* was, like *chef d'oeuvre*, a term used to designate the project assigned to an apprentice or journeyman as a qualifying trial required for acceptance into a professional guild. In Germanic lands, this usage is recorded in guild statutes of the first half of the fourteenth century, although in these sources, the word "masterpiece" is not necessarily used. As in texts of this kind from other parts of Europe, it may be specified only that the candidate must give evidence of his proficiency in the presence of a master, that he must satisfactorily execute several tasks, "work well," or something similar. But *Meisterstück* or, more infrequently, *Meisterwerk* are well attested in documents of the fifteenth century and later.[11] As in France, the evolution of the practice seems to have become more widespread toward the end of the Middle Ages, and the projects assigned to aspiring masters ever more complicated. In 1685, the apprentice tailors of Stuttgart and Tübingen were asked to make as their masterpiece a long preacher's robe, a master or doctor's robe, a student's costume (in the latest fashion for a knight), a comedy or ballet costume, a *livrée* (for a domestic servant), "an Italian and Hungarian costume," and a pair of wide knee breeches.[12]

Such requirements could easily be seen as vexatious and were especially resented by artists, increasingly conscious in the sixteenth century of the humanistic basis of their calling. In his *Schilderboek* (1604), Carel van Mander comments caustically on the ignorance and

[9] *Divine Weeks*, 207.

[10] *Oxford English Dictionary*, IV, 1933, q.v. "masterpiece." According to Trübener's *Deutsches Wörterbuch*, IV, 1943, 60, "masterpiece" is likely "one of the earliest English words borrowed from German still in use."

[11] R. Wissell, *Des alten Handwerks Recht und Gewonheit*, II, 1ff.; H. Huth, *Künstler und Werkstatt der Spätgotik*, Augsburg, 1925 (reprint, Darmstadt, 1967), 89, nn. 17-19; and J. and W. Grimm, *Deutsches Wörterbuch*, XVI, Leipzig, 1885, 1981-82.

[12] Wissell, *Alten Handwerks Recht*, 9.

obstructionist tactics of the guilds, "the shameful laws and narrow rules" which the most estimable painters of his day had to contend with. The noble art of painting was degraded, he contended, when masterpieces "have to be produced in the same fashion as the works of cabinet makers, tailors and other tradesmen." Peter Vlerick (1559-81), a painter of Courtrai and one of Van Mander's teachers, who had moved to Tournai in the hope of establishing himself there, was asked by the local painters' guild to prove his worth by executing a "test piece" (*proefstuk*). It was a *Massacre of the Innocents*, done in watercolor on canvas, a technique which Vlerick made a specialty. As Van Mander describes it, it was "a fine composition. In the foreground, a building with a melee of soldiers and women with children; in the background, a vista of a town with a market scene and a pleasant group of houses and people." But the dean of the guild and his fellow "daubers" were left unmoved, and they looked upon the work "as if it were a millstone." It took the intervention of the bishop of Tournai to enable Vlerick to gain acceptance into their membership.[13]

In England, the masterpiece requirement is found in documents of the sixteenth century and tended to become generalized thereafter. For the London weavers, ordinances of 1589 and 1594 state, "Everie man in our Guild shall make a proofe of his workmanshipp before he be admitted a Master."[14] The words "proof," "proof-piece" (after the Dutch *proefstuk*), or "maisterstick" (after *Meisterstück* or *Meesterstuk*) are sometimes encountered in place of "masterpiece." According to the by-laws of the London company of joiners, dated 1572, "every man [is] to make his proof piece."[15] In Aberdeen, the guild of hammer-

[13] *Het Schilder-Boek van Carel van Mander*, ed. A. F. Mirande and G. S. Overdiep, Amsterdam, 1943, 341ff. On Vlerick, of whose hand nothing seems to remain, see Thieme-Becker, *Allgemeines Lexikon*, XXXIV, 460-61. The case bears some resemblance to that of Peter Vischer the Younger, whose monument of Frederick the Wise (1527) in the chapel of Wittenberg Castle was accepted as the artist's masterpiece by the Nuremberg City Council in place of a more traditional trial piece. In order to pacify the guild of copper and bronze casters, however, it was ruled that this decision should not constitute a precedent. See Th. Hampe, ed., *Nürnberger Ratsverlässe über Kunst und Künstler im Zeitalter der Spätgotik und Renaissance, 1449, 1474-1618*, Quellenschriften für Kunstgeschichte und Kunstechnik des Mittelalters und der Neuzeit, XI-XII, Vienna, 1904, 235-36, no. 1563; and H. Stafski, *Der jüngere Peter Vischer*, Nuremberg, 1962, 41-43.

[14] F. Consitt, *The London Weavers' Company*, Oxford, 1933, 311. On London guild organization generally, see G. Unwin, *The Gilds and Companies of London*, London, 1938, 264ff.

[15] H. L. Phillips, *Annals of the Worshipful Company of Joiners of the City of London*, London, 1915, 8.

men, comprising the locksmiths, pewterers, cutlers, and metal work-
ers, required that "whasomever myndes to come in amongst the saidis
craft to be frieman amongst them sall mak and present two pieces of
work for his maisterstick sufficiently made and wrocht according to
that calling he myndis to lyve be."[16] The London goldsmiths insti-
tuted the masterpiece in 1607, accompanying their action with a care-
fully reasoned statement of purpose. Perceiving the practice of their
art to have greatly declined in quality, they blame this on an excessive
subdivision of labor which leads some artisans to cast only bottles,
others to make only spoons, or to confine themselves to only one op-
eration, such as polishing, chasing, or engraving. Thus, now, "very
few workmen are able to finish and perfect a piece of plate singularly,
with all the garnishings and parts thereof, without the help of many
and several hands." Because of their deficiency, they are forced to
turn for help to "sundry inferior handy crafts" like those of pewter-
ers, founders, and turners, "to the great scandal and disgrace of this
Mystery." Every man, it is argued, ought to be able to begin and finish
his own work himself, as in times past. To remedy this situation, the
guild masters decree that no one shall be allowed to set up shop and
conduct business until he has completed "a piece of work commonly
called a masterpiece."[17]

In the process of their promotion to the rank of superlatives, *Meis-
terstück* and "masterpiece" encountered rivals of French or Latinate
origin. The German *Hauptwerk* (or *Hauptarbeit*), which has remained
in use, is nearly synonymous with *Meisterstück* and a literal equivalent
of *chef d'oeuvre*. Luther employed it in an arresting formulation: "The
Incarnation of Christ is the masterpiece [*Hauptwerk*] among God's
works."[18] In England, we find the expression "chief" or "chiefest
work," as in an inscription in the London church of St. Mary le Bow,
which saluted Queen Elizabeth I with the words: "Earth's Joy, Eng-

[16] E. Bain, *Merchant and Craft Guilds: A History of the Aberdeen Incorporated Trades*,
Aberdeen, 1887, 204.

[17] W. S. Prideaux, *Memorials of the Goldsmiths' Company*, London, 1896, II, 363. The
relation of mastery and mystery indicated by this text points to the magic dimensions of
superlative skill. On this idea, see the study of G. Scholem, "The Idea of the Golem" in
On the Kabbalah and Its Symbolism, New York, 1965, 165ff.

[18] Cited by the Grimms, *Deutsches Wörterbuch*, XIV, 2, 638: "menschwerdung Christi is
das heubtwerk aller werk gottes." In spite of the expert assistance of Prof. Stephen E.
Ozment of Yale University and of Dr. Heiko Jürgens (Institut für Spätmittelalter und
Reformation, Tübingen), I was unable to locate the exact source of this sentence in
Luther's works. Along the same lines might be mentioned the title of one of the Jesuit
Etienne Binet's works, *Le chef d'oeuvre de Dieu, ou les souveraines perfections de la Sainte
Vierge*, Rouen, 1620.

land's Gem, World's Wonder, Nature's Chief."[19] The French and English dictionary of Claude de Sainliens (Hollyband) issued in an edition printed in London in 1593 gives for the phrase "faire un chef d'oeuvre" two translations, one roughly reflecting the Latin side, the other the German: "to make a principall piece of worke, to make a maisters piece."[20] Beyond the diversity of linguistic origin, each of these definitions is also invested with a different shade of meaning. The second concerns the practical exercise of artisanal guilds, while in the first, a looser and more general range of achievement would seem to be suggested. In the dictionaries of a later date, "masterpiece" ascends more decisively the terminological summit of praise. A work issued in 1713 calls it "A most exact piece of Workmanship in any Art,"[21] but the curious entry in Dyche and Pardon's *New General English Dictionary* is hard to surpass: "Anything that it is too difficult for a person to do."[22]

There is another aspect of *Meisterstück*/masterpiece that differs from the French counterpart. The intimate connection of the term *chef d'oeuvre* with the architectural marvel which we have discerned in sixteenth-century France seems to have been unparalleled in English- and German-speaking lands. English writers began to speak of masterpieces of art later than their French colleagues, and when they ultimately did so, they had in mind painting and sculpture rather than architecture—a significant departure from the hierarchy of value illustrated in the preceding chapter and one which will occupy us at greater length below. Thus, is a letter dated 1613, Sir Dudley Carleton, the English ambassador in Venice, refers to a painting by Domenico Tintoretto as a "masterpiece."[23] The now obsolete variant

[19] Recorded in a number of guidebooks, among them Th. Delaune, *Angliae Metropolis, or the Present State of London*, London, 1690, 28. In the French translation offered in the *Guide de l'Angleterre ou relation curieuse du voyage de M. de B . . .* , Amsterdam, 1744, 279, this is rendered "La joie de la Terre, le Joyau de l'Angleterre, la Merveille du Monde, le Chef d'oeuvre de la Nature." In a poem presented to Queen Elizabeth on New Year's Day, 1594, "A Pleasant Conceite" (J. Nichols, *The Progresses and Public Processions of Queen Elizabeth*, London, 1823, III, 234), I note the same expression:

> North-hampton first, the Painter tooke in hand,
> As cheefest work, his pensil lately drew. . . .

[20] Hollyband, *A Dictionarie French and English*, London, 1593, q.v. "chef d'oeuvre."

[21] J. K., *A New English Dictionary, or a Compleat Collection of the Most Proper and Significant Words*, London, 1713, q.v. "master-piece."

[22] Th. Dyche and W. Pardon, *A New General English Dictionary*, London, 175-, q.v. "masterpiece."

[23] M.F.S. Hervey, *The Life, Correspondence and Collections of Thomas Howard, Earl of Arundel*, Cambridge, 1921, 142.

"masterprize" appears in a play published a few years earlier, applied to a composition by the renowned Ferrarese composer Girolamo Frescobaldi.[24] When the young John Evelyn visited Paris in 1644, the monuments which he admired were much the same as those praised in the city guidebooks, and the words used by him to describe them prove that he must have been acquainted with some specimen of this literature. About De l'Orme's Tuileries scheme, he writes that "[it] is a princely fabrique, especialy that incomparable winding stayres of stone, which hanging without support at the pozzo in the middle, together with the Cupola, I take to be as bold and noble a piece of Architecture as any in Europ of the kind."[25] The thought echoes the characterization of the work by Du Breul, but Evelyn, unlike the latter, avoids any talk of masterpiece. In Italy, however, some months later, Evelyn encountered several works on which he was willing to lavish such praise: the Medici Venus, Michelangelo's *Christ of Sorrows* in Santa Maria sopra Minerva in Rome, and Agrate's *St. Bartholomew* from the façade of the Duomo in Milan (Fig. 46).[26]

Nevertheless, as Evelyn's comments make quite clear, the English reticence on the subject of architectural masterpieces is not to be equated with lack of interest or enthusiasm for exceptional feats of building skill, and this holds true also for Germany. Only here, these remained marvels. In Germany, the most admired monument of this kind was unquestionably the tower of the cathedral of Strasbourg (Fig. 29). It was designed by Ulrich of Ensingen, at whose death in 1419 the octagonal lower story seems to have been completed. The spire was finished by his successor Johann Hueltz of Cologne in 1439.[27] Even as it was nearing completion, the noted humanist Aeneas Sylvius Piccolomini pronounced it to be perfect. Erasmus opined that there was nothing comparable in Europe or in Asia. In his guidebook of central European territories, Martin Zeiller (1632) speaks of it in the same vein as "the Eighth Wonder of the World, and very possibly the Seventh."[28] He and numerous other writers to comment on the structure note its height (142 m), which in their eyes

[24] Cited in the *Oxford English Dictionary*, after B. Barnes, *The Devil's Charter*, III, V, dated 1607 (reprint, Tudor Facsimile Texts, ed. J. S. Farmer, 1913).

[25] J. Evelyn, *Diary*, ed. E. S. de Beer, London, 1959, 59.

[26] Ibid., 151, 193, 241.

[27] H. Reinhardt, *La cathédrale de Strasbourg*, Paris, 1972.

[28] M. Zeiller, *Itinerarium Germaniae nov-antiquae: Teutsches Reyssbuch durch Hoch und Nieder Deutschland* . . . , Strasbourg, 1632, 213-14. This follows the pioneering history of the cathedral by Hosea Schadeus, *Summum Argentoratensem Templum*, Strasbourg, 1617, where the status of the monument as one of the world wonders is made the object of a

gave it an edge over other celebrated spires of late Medieval Europe like those of the cathedrals of Antwerp and Vienna. They cite with jubilation the spiraling staircases (*Schnecken*) daringly attached to four sides of the tower and "so artistically and transparently built that one could see (from the exterior) people climbing upward and descending in them." One of these staircases has two separate flights of steps, so that "two persons can go up at the same time and speak without seeing one another."[29]

Within the cathedral, another marvel awaited the visitor in the celebrated astronomical clock designed between 1570 and 1574 by a team of artisans led by the Swiss mathematician Conrad Dasypodius.[30] Following the mechanical clock constructed in the library of Padua by Giovanni de'Dondi in the middle of the fourteenth century, such complicated devices capable of displaying a variety of astronomical, horological, and calendrical calculations and combined in the most elaborate instances with automata came to enjoy a great vogue. The clock of Strasbourg, with those of Prague and Lyon, can probably be called the most eminent in the opinion of the time. Tobias Stimmer's engraving (Fig. 30) of his design for the case of the Strasbourg clock is an implausible if engaging piece of cabinetry, inventive and ingenious to an almost promiscuous degree, the final word on *Wunderwerk* sensibility.

Among England's miracles of art, Stonehenge occupies a special place. Straddling the line between the natural and the artificial wonder, it compels awe more than admiration, and the reigning ideal of mastery is manifested only in its colossal scale. It is a marvel, thus, which could be a masterpiece only in another age. So far as is known, the monument is mentioned for the first time around 1130 by Henry of Huntingdon, who cites it as one of four wonders which could be seen in the country. At Stonehenge, according to this author, "stones of an amazing size are set up in a manner of doorways, so that one door seems to be set on another. Nor can anyone guess by what means

scholastic proof *secundum quatuor causarum genera* (16-19). For Humanist attitudes toward the cathedral, see P. Frankl, *The Gothic*, Princeton, 1960, 246, 249-50, and 856-57.

[29] Zeiller, *Itinerarium Germaniae*, 214.

[30] On the clock, see Reinhardt, *Cathédrale de Strasbourg*, 197ff.; and A. and Th. Ungerer, *L'horloge astronomique de la cathédrale de Strasbourg*, Strasbourg, 1922. "Masterpiece" is once again encountered in a French work, F. J. Böhm, *Description nouvelle de la cathédrale de Strasbourg . . .*, Strasbourg, 1733, 59, where the clock is called "ce beau chef d'oeuvre." On the significance of these mechanical miracles more generally, see C. Cipolla, *European Culture and Overseas Expansion*, Harmondsworth, 1970, 113ff.; and D. de S. Price, *Science since Babylon*, New Haven, 1975, 25ff.

so many stones are raised so high, or why they were built there."[31] A few years later, Geoffrey of Monmouth included a more circumstantial account of the structure in his *Historia Regum Brittaniae*, answering these still now troublesome questions. Geoffrey saw it as a monument set up by Aurelius Ambrosius, king of the Britons, to commemorate his nobles slain by the Saxons. Aurelius was advised by Merlin the Magician to send for the Giants' Dance (*Chorea Gigantum*), a mountain in Ireland. But after the king failed in this superhuman task, Merlin himself with his own engines carried the huge stone blocks to Stonehenge, "thereby giving a manifestation of the superiority of art over brute force."[32] In Geoffrey's far-fetched story, the puzzling arrangement of stones acquired the personality of an historical artifact, graced with the familiar marks of extraordinary distinction: a royal patron and the assistance of occult powers.

Stonehenge stood high on the list of monumental curiosities in England. In his great topographical survey of the country, *Britannia* (1586), William Camden recorded that "Our countrie-men reckon this for one of our wonders and miracles" (Fig. 31). He lamented that the builders of such a notable work had been forgotten, while repeating, as the opinion accepted by some, Geoffrey of Monmouth's story identifying it as a mausoleum of the early Britons. Camden also called it "a huge and monstrous piece of work, such as Cicero termeth *insaniam constructionem*."[33] Inigo Jones, the "English Vitruvius," took him to task for this in a study of Stonehenge which in 1620, King James I asked him to undertake. For Jones, Stonehenge was too considerable a structure to have been carried out by the primitive Druids of Britons. It was a Roman monument, and far from being rude or uncouth, it was, between the capital and the northern confines of the

[31] *Henrici archidiaconi huntendunensis historia anglorum*, ed. Th. Arnold, Rolls Series, London, 1879, 11-12. The three other English marvels cited by Henry are of the natural kind: the powerful winds which hurl at a great distance matter from caves in a mountain called the Peak (Derbyshire); a great cavern at Cheddar-hole (Somersetshire); and the rain which in some parts of the country "is seen to gather about the tops of hills and forthwith fall on the plains."

[32] *Galfredi monumetensis historia britonum*, ed. J. A. Giles, Publications of the Caxton Society, I, London, 1844, 140-43. See on this S. Piggott, "The Sources of Geoffrey of Monmouth: II, The Stonehenge Story," *Antiquity*, XV, 1941, 305-19; and the account of R.J.C. Atkinson, *Stonehenge*, London, 1960. A thirteenth-century miniature (London, British Library, Egerton 3028, fol. 30) shows Brut the Trojan building Stonehenge (reproduced in B. Smalley, *Historians in the Middle Ages*, New York, 1974, 40).

[33] The citation is from the English version of Camden's work, *Britain*, London, 1610, 253. On the rise of an English topographical literature, see E. Moir, *The Discovery of Britain: The English Travellers, 1540-1840*, London, 1964.

Empire, that monument most conspicuous for its magnificence. If the rugged blocks of stone now strewn about the site failed to convey this fully, Jones argued, there were once much-admired Roman buildings which did not make a better impression in their present state. Jones reconstructed Stonehenge as a circular (hypaethral) temple. He ingeniously deduced that it could not have been a mausoleum, for as the Pyramids and the Mausoleum of Hallicarnassus showed, such structures "were always reall and solid piles; not airous, with frequent openings, and void spaces. . . . " The circular plan and the open view to the sky suggested to him that the monument was a temple to the god Coelus.[34]

These fanciful speculations were rejected in a vigorous pamphlet by the royal physician Walter Charleton, which appeared in 1663. In Charleton's view, the monument is not at all magnificent as the Ancients themselves understood this word, and the stone blocks are "rude, rough, craggy and difform among themselves and destitute of any great Art or Elegance in general disposition and construction." Nor was the transportation of the blocks to the site and their erection such a miraculous feat as to require the intervention of Merlin or the technical genius of the Romans, who along with the Egyptians and Greeks, had done bolder things. He argued that Stonehenge had been erected by the Danes during the reign of King Alfred (871-901), but perhaps desiring to counteract the deflationary aspect of his demonstration, he advanced the politically attractive idea that it was a "Court-Royal for the Election of Kings."[35] Charleton's work received a lengthy refutation by John Webb (1665), Jones' son-in-law, who had earlier brought out his eminent kinsman's treatise, for him the final and unanswerable word on these matters.[36]

Behind the very uneven arguments deployed on each side, many of which have long ago been overtaken by the progress of archaeological science, our authors are of one mind in seeking to preserve undiminished an essential core of the concept of the artistic wonder, challenged, as would seem to be inevitable, by the puzzling monument on the Salisbury Plain. For Jones and Webb, this effort of conservation was realized by a very strained reading of the evidence in favor of a Roman pedigree, for as Webb would have it, "Stonehenge was, and

[34] I. Jones, *The Most Notable Antiquity of Great Britain, vulgarly called Stone-Heng on Salisbury Plain*, London, 1655.

[35] W. Charleton, *Chorea gigantum, or the Most Famous Antiquity of Great Britain, vulgarly called Stone-Heng . . .* , London, 1663.

[36] J. Webb, *A Vindication of Stone-Heng Restored . . .* , London, 1665.

could be Founded by no other Nation than the Magnificent, Power-full, and great Masters of Art, and Order, the Romans. . . ."[37] Charleton's disagreement was provoked not only by his much more modest appraisal of the qualities of the work, but also by his view of the accomplishment of the Ancients, which was no less lofty than Webb's. For him, however, it was the gap between the ancient marvels and Stonehenge which stood forth most sharply, not the parallels.

Monuments less puzzling and more attuned to the expected in this sphere, the Chapel of Henry VII in Westminster and King's College Chapel in Cambridge were acclaimed as wonders by Renaissance observers with unrestrained admiration. The chapel of King's College was begun in 1446 with the laying of a foundation stone, but exhaustive research undertaken in the last century has shown that three building phases must be distinguished and that the structure as we know it today is largely the work of the final campaign datable after 1509, when Henry VII made a large donation toward its completion (Figs. 32 and 33).[38] It soon became known far and wide. Josua Maler, a Swiss theology student who saw it on a visit to Cambridge in 1551, wrote that "it has the reputation of being the most beautiful building in England."[39] For Camden, the chapel "may rightly be counted one of the fairest buildings in the whole world,"[40] and this opinion is also found in Paul Hentzner's *Itinerarium* (1612), probably the first serious travel guide for the country.[41] In 1654, John Evelyn found the chapel "altogether answerable to expectation, especially the roofe all of stone, which for the flatness of its laying and carving may I conceive vie with any in Christendome."[42] Thomas Fuller, in his *History of Cambridge* (1655), is equally enthusiastic about the structure "wherein the Stone-Work, Wood-Work and Glass-Work contend, which most deserve Admiration. Yet the first generally carrieth away the Credit (as being a Stone-Henge indeed) so geometrically contrived, that volu-

[37] Ibid., 232.

[38] C. H. Cooper, *Annals of Cambridge*, Cambridge, 1842, I, 198ff., contains the documents relating to the foundation of the chapel. For its history and architecture, see N. Pevsner, *Cambridgeshire*, Harmondsworth, 1954, 83ff.

[39] W.-D. Robson-Scott, *German Travellers in England, 1400-1800*, Oxford, 1953, 26.

[40] Camden, *Britain*, 487.

[41] P. Hentzner, *Itinerarium Germaniae, Galliae, Angliae, Italiae*, Nuremberg, 1612; my reference is to the section on England translated as *Paul Hentzner's Travels in England during the Reign of Queen Elizabeth*, London, 1797, 40. On the author, see Robson-Scott, *German Travellers*, 65-70.

[42] Evelyn, *Diary*, 352.

minous Stones mutually support themselves in the arched Roof, as if Art had made them forget Nature. . . ."[43]

The Chapel of Henry VII at the eastern end of Westminster Abbey was begun in 1502 and completed in 1519 (Figs. 34 and 35). More or less contemporaneous to the chapel in Cambridge and like it a high point of the Perpendicular Style in England, it was greeted by the antiquarian John Leland as *orbis miraculum*.[44] Camden and Francis Bacon are of the same mind and include in their praise of the structure Torrigiano's funerary monument of the king.[45] Hentzner remarks on its "splendor and elegance."[46] After the middle of the seventeenth century, however, the rising tide of classicism produced a division of opinion. Evelyn, in a work written in old age when his sympathies had evidently changed, criticized the "crinkle-crankle" effect of its ornate Gothic fabric and asked his readers to compare it to the sober elegance of Inigo Jones' Banqueting House and the buildings of Christopher Wren.[47] Wren's own comments on the edifice are more favorable, if tinged with irony.[48] But foreign travelers and guidebooks of England representative of a less self-consciously enlightened taste remained steadfast in their high esteem for it, occasionally decorating their observations with Leland's lofty phrase, the wonder of the world.

The English antiquarians commented favorably on other monuments of the Medieval past. Camden had warm praise for Lincoln Cathedral, particularly noting its facade: "Certes, as it is built, it is for all throughout not onely most sumptuously, but also passing beautifull, and that with rare and singular workmanship: but especially that fore front at the West end, which in a sort ravisheth and allureth the eyes of all that judiciously view it."[49] Leland and other writers were

[43] T. Fuller, *History of the University of Cambridge from the Conquest to the Year 1634* (1655), Cambridge and London, 1840, 151.

[44] Quoted by many writers, including Camden, *Britain*, 429; and Delaune, *Angliae metropolis*, 21. On the structure, see W. R. Lethaby, *Westminster Abbey and the Kings' Craftsmen*, London, 1906, 222ff.; and H. M. Colvin, *The History of the Kings' Works*, III, London, 1975, 210-22.

[45] Camden, *Britain*, 429. Bacon wrote that it was "one of the statelyest and Daintyest Monuments of Europe both for the Chapel and for the Sepulcher" (*The Works of Francis Bacon*, Philadelphia, 1850, I, 384).

[46] *Travels in England*, 16.

[47] Evelyn's opinion is found in his *Account of Architects and Architecture*, dated 1696, and printed at the end of his edition of R. Fréart de Chambray's *Parallel of the Ancient Architecture with the Modern*, London, 1753, 9-10.

[48] Wren, *Parentalia . . .*, London, 1750, 299. [49] Camden, *Britain*, 539.

partial to Salisbury Cathedral, which seems generally to have been regarded as the finest Gothic minster in England.[50] Justifying this view, the guidebooks offer the familiar encomium on elaboration and technical prowess, here overladen with numerological considerations. As the anonymous *England Described, or the Traveller's Companion* (1788) has it, "The doors and chapels equal the number of months in a year, the windows the days, and the pillars and pilasters the hours."[51] There is a striking evocation of the structure's transparent effect: "The outside is magnificent, there being no outside wall, but only butresses and windows." The famous chapter house, with its octagonal plan and vaults resting on a single column "is thought to be one of the greatest." The cloister is "one of the largest and most magnificent in England."[52]

London Bridge was one of the most impressive Medieval building achievements (Fig. 36) and inspired much admiring comment from sixteenth- and seventeenth-century authors. Constructed between 1176 and 1209 by a cleric of the city, Peter of Colechurch, it was a span of over nine hundred feet in stone over waters made treacherous by the Thames' sizable tidal fluctuations.[53] Taking an epigram of Sannazaro in praise of Venice as his model, James Howell began his *Londinopolis* (1657) with a poem, frequently quoted after him, celebrating the greatness of the work.[54] It ends with the lines

> Let the whole earth now all her *Wonder* Count
> This bridge of Wonders is the *Paramount*

The structure consisted of nineteen arches, one of them incorporating a drawbridge to permit the passage of ships. The roadway was lined on each side by houses with shops. Near the center stood a handsome chapel dedicated to St. Thomas Becket, and there were monumental gates near the London and Southwark sides. Between 1577 and 1579, the second of these, Drawbridge Gate, was elaborated

[50] *The Itinerary of John Leland*, ed. L. T. Smith, London, 1907, I, 267; D. Defoe, *A Tour through the Whole Island of Great Britain, 1724-26*, Harmondsworth, 1971, 195; and Anon., *A New Display of the Beauties of England*, London, 1787, III, 347.

[51] *England Described, or the Traveller's Companion*, London, 1788, 401.

[52] Ibid. [53] G. Home, *Old London Bridge*, London, 1931.

[54] J. Howell, *Londinopolis: An Historicall Discourse or Perlustration of the City of London*, London, 1657, frontis. and 20-23, where the author remarks of the bridge, "If the stupendious site, structure thereof be well considered, [it] may be said to be one of the Wonders of the World." Howell also calls it (399) "the Bridge of the World," a phrase which is found also in the anonymous *History of London Bridge from Its Foundation in the Year 994 . . .*, London, 1758.

into a fantastic, three-storied edifice with projecting turrets at the four corners and a rich encrustation of ornament, which became known as Nonesuch House. John Stow, in his admirable *Survey of London* (1598) called it "a beautifull and Chargeable peece of work," and its reputation was enhanced by the rumor that it had been built without the use of a single nail.[55]

The name of Nonesuch House on London Bridge recalls Henry VIII's palace of the same name, one of the most celebrated edifices of the English Renaissance. The building, begun in 1538, was erected on a royal estate occupied by the parish church of Cuddington (Surrey). The plan to build a matchless wonder, reminiscent of Margaret of Austria's project at Brou, existed from the start, since at the inception of construction, the site was recorded as the "Manor of Nonesuche otherwise Codingtonne."[56] Leland, the earliest author to mention the work, offers the Latin equivalent *Nulli Secunda*, and a couplet, often paraphrased after him:

> This, which no equal has in art or fame.
> Britons deservedly do Nonesuche name.[57]

Camden explains in greater detail: "Prince Henrie the Eighth, in a very healthfull place called Cuddington before, selected for his owne delight and ease and built with so great sumptuousnesse and rare workmanship, that it aspireth to the very top of ostentation for shew; so as a man may thinke, that all the skill of Architecture is this one peece of worke bestowed, and heaped up together. So many statues and lively images there are in every place, so many wonders of absolute workmanship, and workes seeming to contend with Roman Antiquities, that most worthily it may have, and maintaine still this name it hath of Nonesuch. . . ."[58]

The role of Nonsuch as royal residence was interrupted by the Civil War and never again resumed. It was eventually entrusted to private owners who, finding its upkeep too burdensome, began its demolition. By the end of the seventeenth century it had virtually disappeared, and before archaeological exploration of recent years, even its location was no longer known. Set in the midst of spacious gardens,

[55] J. Stow, *Survey of London* (1598), London and New York, 1965, 56.

[56] J. Dent, *The Quest for Nonsuch*, London, 1962, 35; and J. Summerson, *Architecture in Britain, 1530-1830*, Harmondsworth, 1970, 33-37.

[57] Dent, *Quest for Nonsuch*, 55. The couplet in the Latin version quoted by Dent is ascribed to Leland, though it does not appear in his published works.

[58] Camden, *Britain*, 287.

the structure was a rectangle divided into a pair of courts. A drawing made in 1568 by the Flemish artist Joris Hoefnagel (Fig. 37) shows us the much admired south front of the inner court. It is a long, low-slung block framed by a pair of octagonal towers, whose silhouette bears some resemblance to Francis I's Castle of Chambord. Yet the effect is less massive, with a strong persistence of the thin, planar articulation of Perpendicular Gothic. The wall was of a half-timbered construction, the spaces between the wooden membering being filled with stucco panels in relief and showing a profusion of figures, emblems, and ornaments of every kind. The timber framework was covered with a revetment of slate panels themselves elaborately carved. The official survey of the palace and estate made in 1650 also singles out the inner gatehouse connecting the two courts, which was equipped with a clock, chimes, and "six golden horoscopes," "of most excellent workmanship and a very speciall ornament to Nonsuch House." Further, it highly praises the battlements of wood covered with lead which crowned the buildings of the inner court on all sides, and the corner towers, whose exuberant and somewhat fantastic outline Hoefnagel recorded with care.[59]

The description of the kingdom found in Guy Miège's *The New State of England . . .* (1691) is much more summary than those of Leland and Camden since it is only a part of a work embracing also the political and social institutions of the country. Miège's list of architectural marvels is otherwise largely identical with that of his predecessors, though it likely reached a wider audience since a revised version of the text was published in French and German editions. In the French translation, issued in Amsterdam in 1708, the word masterpiece, all but absent from the vocabulary of praise of English topographical literature, is on the contrary introduced wherever opportune. Thus, Henry VII's chapel in Westminster, "an admirable artificial Work both within and without" in the English version, becomes "un chef d'oeuvre de l'Art" in the French text, and the passage devoted to the

[59] Dent, *Quest for Nonsuch*, 58, and 288. Thomas Platter, a German traveler, wrote of the monument as follows: "Nonsuch is a fine royal residence; it takes its name from its magnificence, for Nonsuch is equivalent to *non pareille*, without equal, for there is not its equal in England" (*Thomas Platter's Travels in England in 1599*, ed. C. Williams, London, 1937, 190). Hentzner (*Travels in England*, 58) speaks of it as built by the king "with an excess of magnificence and elegance, even to ostentation: one would imagine everything that architecture can perform to have been employed in this one work. There are everywhere so many statues that seem to breathe so many miracles of consummate art, so many casts that rival even the perfection of Roman antiquity, that it may well claim and justify the name of Nonsuch, being without equal. . . ."

chapel of Kings College in Cambridge is handled in the same way.[60] Much more unexpectedly, Miège calls *chefs d'oeuvre* two churches which once graced the monastery of Bury Saint Edmunds, described by him much more mildly in the English version, following an older author, as "very fine and of curious Artifice."[61]

Miège was a native of Lausanne in Switzerland and no doubt more attuned to French usage than his English predecessors in the field of topographical description. Perhaps on this account, the word "masterpiece" came to him more easily, and indeed it already appears in the original redaction of the *New State of England*, if only once. It is applied to the columnar monument erected by Sir Christopher Wren between 1671 and 1677 to commemorate the Great Fire of London (Fig. 38).[62] Although English and foreign observers alike had high regard for Wren's architecture, their warmest praise was generally reserved for other accomplishments, St. Paul's first and foremost, the Sheldonian Theater, or the Hospital at Greenwich. In the Monument, Wren intended with a great Doric shaft to rival the Roman columns of Trajan and Marcus Aurelius. In his original scheme, a statue of Charles II was to surmount the work, or else, a personification of London's grandeur and resurrection from the flames.[63] Miège must have had in mind beyond this political dimension of the undertaking the view of the Roman columns as *mirabilia*. A glowing commentary on Trajan's column had appeared in Fréart de Chambray's *Parallèle de l'architecture . . .* (1650), a work familiar to Wren in Evelyn's translation and perhaps to Miège, where the pillar is characterized as a "Masterpiece of the World."[64] Miège and other London guides noted the dimensions of Wren's Monument, which easily surpassed the height of the Roman columns. He was impressed by the circular staircase in black marble which enabled visitors to take advantage of the admirable view from the top. Daniel Defoe thought that the column outdid "all obelisks and pillars of the ancients," or at least those which he had seen.[65] Other writers could be more perfunctory in their praise, and

[60] G. Miège, *The New State of England*, London, 1691, 317, and *L'état présent de la Grande Bretagne*, Amsterdam, 1708, 216. On the author, see *Dictionary of National Biography*, XIII, 367.

[61] *Etat présent*, 34; *New State*, 205.

[62] *New State*, 291.

[63] On the Monument, see *Parentalia*, 321ff.; and N. Pevsner, *London*, The Buildings of England, I, Harmondsworth, 1975, 182.

[64] R. Fréart de Chambray, *Parallèle de l'architecture ancienne et moderne*, Paris, 1650, 88.

[65] Defoe, *A Tour*, 301.

the French critic Dézallier d'Argenville was to find its smoothness inferior to the sculpture-laden columns of Rome.[66]

Wren's St. Paul's, as should be expected, received much more extensive critical attention, most of it unqualified in its enthusiasm for the monument. The ultimate accolade was awarded to it again in a French text, J. Beeverell (or Borel)'s *Délices de la Grande Bretagne et de l'Irlande*, which appeared in 1707, four years before the official completion of the edifice. For this writer, it must be one of the wonders of the world. The vaults, in particular, are through their colossal scale and solidity "chefs d'oeuvre de l'Art" (Fig. 39).[67] Wren's accomplishment was a response to a challenge of exceptional proportions. The old cathedral which he was called upon to replace was a Norman building begun after 1097, though much remodeled in subsequent times. It had been one of the most imposing edifices in Europe in terms of scale, or as some authors, citing William of Malmesbury, were wont to say, "of such a capacity that it may seem sufficient to receive any number of people."[68] The Gothic steeple which rose over the crossing to a height of some six hundred feet was the tallest tower in western Europe and much esteemed for it. Before the Great Fire, Wren had proposed to dismantle the structure and replace it with a dome, but his plan was rejected because of opposition from admirers of the old work. When the catastrophe of 1666 forced a complete reconstruction of the mounument, the steeple was not forgotten, and Wren had to take its height into account in designing his dome for, as he put it, "the old church having had before a very lofty spire of timber and lead, the World expected that the new work should not in this respect fall short of the old."[69] Old St. Paul's was remembered further for the elegant Corinthian portico which Inigo Jones had added to the west front between 1633 and 1640. With its enormous columns, it was unique north of the Alps, and Wren himself considered it "an entire and excellent Piece."[70]

It is well known that after all hope of repairing the Medieval

[66] A. N. Dézallier d'Argenville, *Vie des fameux architectes et sculpteurs*, Paris, 1788, I, 286.

[67] J. Beeverell, *Délices de la Grande Bretagne et d'Irlande*, Leiden, 1707, IV, 827. An English version appeared as *The Pleasures of London*, ed. W. H. Quarrell, London, 1940, 31.

[68] Delaune, *Angliae Metropolis*, 20, after William of Malmesbury, *De gestis pontificum anglorum* (Rolls Series, ed. N.E.S.A. Hamilton, Cambridge and London, 1870, 145): "Tanta criptae laxitas, tanta superioris aedis capacitas, ut quamlibet confertae multitudini videatur posse sufficere."

[69] *Parentalia*, 291. [70] Ibid., 277.

cathedral had been given up, Wren elaborated a sequence of projects whose style and character have inspired much scholarly discussion.[71] In his initial scheme, the architect sought to realize a suitably impressive monument, though within reasonable limitations. It was to be "of moderate Bulk, but good proportion," beautiful but not too large, and of manageable cost. As Wren himself tells us in the *Parentalia*, this design came under criticism from partisans of the Gothic style for its classicizing conception, and from others who thought it "not stately enough, and contended that, for the Honor of the Nation, and the City of London, it ought not to be exceeded in Magnificence by any Church in Europe."[72] The architect's answer to these objections was a second design in which St. Peter's in Rome was deliberately embraced as a model. The political and religious implications of this choice are evident enough. London was to claim its share of the succession of Empire, and its cathedral was to become, as a parallel to the Roman basilica, the principal shrine of Protestantism. This parallel was not of Wren's invention, but had already presented itself in connection with the old monument ruined by the fire. The London church was pointedly reported to have been the only cathedral to be dedicated to St. Paul and held by some to have been founded by the apostle himself. Edward Chamberlayne asserted in his *Angliae Notitia* that its length surpassed St. Peter's by twenty feet.[73] When the building was demolished, Wren thought that he had uncovered the foundations of the early Medieval cathedral of London built shortly after the end of the Diocletianic persecution, and he concluded that its plan had been derived from the old Roman basilicas of St. Peter and St. Paul.

The thought of a building of surpassing magnificence, we must add, was not foreign to the architect. Among his notes published in the *Parentalia* are reconstructions of world wonders of Antiquity, of Noah's Ark, and of the Temple of Solomon.[74] In Wren's time, St. Peter's in Rome could claim to be the chief modern realization in this line. In 1644, Evelyn described it as "that most stupendious and incomparable Basilicam, far surpassing any now extant in the World, and perhapps (Solomon's Temple excepted) any that was ever built."[75] For other authors, it was "the most finished piece in the world, " and

[71] V. Furst, *The Architecture of Sir Christopher Wren*, London, 1956, 24ff. and 96ff.; and Summerson, *Architecture in Britain*, 221ff.

[72] *Parentalia*, 282.

[73] E. Chamberlayne, *Angliae Notitia*, London, 1669, I, 194.

[74] *Parentalia*, 360 and 367ff.

[75] Evelyn, *Diary*, 135.

"for beauty, proportion and divers other things [to] excel all other Temples."[76]

Although Wren's accomplishment in the rebuilding of St. Paul's earned him high praise, its assessment was inevitably beset by paradox. A judgment, whatever its premises, had to involve a comparison with the model in Rome, and in view of the peerless standing of the latter, St. Paul's most favorable critics could do no better than to minimize whatever defects condemned it to second place. The *Parentalia* itself shows some vacillation in its appraisal of the monument. It is called, with obvious reference to the Roman work, "the second Church for Grandeur in Europe." But in another place, it is remarked in its favor that it was completed in the short span of thirty-five years by a single architect, while St. Peter's was in construction some one hundred and forty-five years and with no less than twelve men successively in charge.[77] Defoe's warm words come nearest, perhaps, to closing the qualitative gap between the two structures. For him, St. Paul's is inferior to St. Peter's only in the decoration of the interior, and for this, the austerity of Protestant piety is made responsible.[78] Yet even critics disposed to find fault with Wren's design do not judge it harshly. In the classicizing outlook which informs their perceptions, to be second best is to occupy an enviable place in relation to the cherished archetypes. The models of bygone heroism are no longer to be rivaled and surpassed by novel displays of ingenuity, but insofar as possible, integrally reincarnated.

Although the conceptual and stylistic gap which separates the seventeenth-century architectural marvels in England and on the Continent from their late Medieval counterparts might seem to us well nigh unbridgeable, concern for stylistic orthodoxy does not hold the same place in the topographical literature as it does in art theory. There is, in the former, a certain functional tolerance for the varieties of experience that would pass for lack of rigor in the latter. Hence, also, no clear break in sentiment or in expression manifests itself as one kind of overwhelming object replaces another on the historical stage. One may note, however, a narrowing of the geographic frame of reference. In their qualification of preeminence, our critics are apt no longer to refer to the world in its entirety, as their predecessors

[76] Chamberlayne, *Angliae Notitia*, 194; and R. Lassels, *An Italian Voyage, or a Compleat Journey through Italy*, London, 1698, II, 21.

[77] *Parentalia*, 293. [78] Defoe, *A Tour*, 303.

had done, but to the boundaries of Europe.[79] It is not, to be sure, that they have become less demanding. Rather, the canon of exemplars against which to measure any new effort seems to them optimally represented here. Rome is, of course, the principal attraction, although Paris is increasingly conspicuous on the map of telling architectural feats. But cosmographic and topographic writings signal marvels generously distributed over the Continent: the cathedral of Cologne, the Certosa di Pavia, and in Spain, the Escorial and the Palace of Charles V in Granada, among others.[80] The rise of the idea of Europe in the political and cultural consciousness of the late Renaissance constitutes the background of this shift of orientation. What other area is so "fortified with Castles, edified with Townes, crowned with Cities?" asks Samuel Purchas at the beginning of the seventeenth century. Learning and the arts having forsaken their seats in Greece, and in the continents of Africa and Asia, Europe is now their sole domain.[81] But the change in attitudes toward the great models of the past conveyed by Wren's Monument and St. Paul's was also a factor in this more restrictive view. These achievements presuppose a critical engagement, and thus a familiarity with their Roman and Renaissance prototypes that could only be obtained through study at close range. Mastery, demonstrated in surpassing skill, thus now implies measurement, comparison, theoretical reflection.

[79] Thus, W. Harrison (*The Description of England*, 1587, ed. G. Edelen, Ithaca, 1968, 69) speaks of the Divinity School in Oxford along with King's College Chapel in Cambridge and the Chapel of Henry VII at Westminster as the three most "notable piles within the compass of Europe." London Bridge, according to Delaune (*Angliae Metropolis*, 179), for its "admirable Workmanship, vastness of Foundation, for all Dimensions, for solid stately houses and Rich Shops built thereon, surpasseth all others in Europe. . . ." Evelyn (*Diary*, 59) takes the Tuileries staircase to be "as bold and noble a piece of architecture as any in Europe of any kind." See also the comment of Bacon on the Chapel of Henry VII in Westminster, n. 45, above.

[80] Zeiller, *Itinerarium Germaniae*, 464; and S. Münster, *Cosmographia universalis* (1544), Basel, 1628, 118. On the Certosa di Pavia, see the assessment of Commines, cited in A. Blunt, *Art and Architecture in France*, 1500-1700, Harmondsworth, 1970, 5.

[81] S. Purchas, *Purchas his Pilgrimes*, London, 1613 (Hakluyt Society, Extra Series), I, 1905, 248-49, cited by D. Hay, *Europe: The Emergence of an Idea*, Edinburgh, 1968, 120-21.

VI

THE CLASSIC
MASTERPIECE

When "masterpiece" came to signify in Dr. Johnson's words, "chief excellence," the word would seem to have entered into its present skin.[1] But definition is only one aspect of meaning. Excellence has variable esthetic and social dimensions, and the urge to single out its most conspicuous exponents is not everywhere and at all times the same. Certain developments of the seventeenth and eighteenth centuries must now be considered since they decisively affected the understanding of the concept. The ambition of artists, first in Italy, then in Northern Europe, to free themselves from the constraints of artisanal regulations and to gain recognition as equals of poets and men of science looms as the largest of these. Since the masterpiece requirement was the key element in the process of admission to the guild and thus, in principle at least, had to be satisfied as a condition to the licit exercise of a profession, it is to be expected that an attack on the guild system would involve a direct challenge to the validity of this test. To be sure, the nature of guild organization varied a great deal from place to place, and it had also developed serious internal stresses. In some towns, the exercise of the painters' art had been entirely freed from guild jurisdiction. Elsewhere, artists were sometimes exempted from the obligation to give formal proof of their skill and pay the required fee because of their eminent talent, or in compliance with the wishes of a princely protector. Already in the second half of the fourteenth century, the kings of France conferred masters' rights on chosen subjects as a personal favor dispensing them from any qualificatory obligation. This was done where it had become necessary to quickly revitalize the productive capacity of a town,[2] and it became a

[1] S. Johnson, *Dictionary of the English Language*, London, 1755, q.v. "masterpiece."
[2] In 1564, Charles IX issued an edict, confirmed several times thereafter, permitting

custom to do so on the occasion of royal births and marriages.[3] In 1608, under Henry IV, a group of artists were installed in the Louvre under exclusive royal patronage, thus liberating them from any attachment to the guild.[4] But there was much resistance to these changes from the corporate establishment, and in some instances a contrary movement toward stricter regulation took place.

The foundation of the Académie royale de peinture et de sculpture (1648) was a full-fledged challenge to the old system. Dedicated, as proclaimed in its motto *Libertas artibus restituta*, to the free exercise of the arts, the Academy dispensed instruction through appointed professors and admitted qualified practitioners to its ranks. The word *chef d'oeuvre*, associated with the ways of the old guilds, is prudishly avoided in the statutes, but the break with past procedures is clear enough. The Statutes of 1648 forbid the painters' guild to compel members of the Academy to become masters. An article evidently drafted with the traditional revelries of the artisans' guilds in mind, prohibits fasting, drunkenness, and debauchery on the occasion when new members were admitted.[5] For all this, the objection against the masterpiece was more a matter of symbolism than of substance: the *chef d'oeuvre* stood condemned not because it was objectionable as such, but because it respected no distinction between an elevated calling and the world of stainers and sign painters.[6] When the Academy

the mayor and *échevins* of Bourges to accept new masters without requiring the *chef d'oeuvre* in order to "repeupler ladite ville d'artisans" (J. Chenu, *Recueil des antiquitez et privilèges de la ville de Bourges* . . . , Paris, 1621, 156). In Venice, the plague of the years 1575-76 so decimated the population that the Senate decreed in 1577 that the ordinary requirements for the mastery, including the *prova*, as the masterpiece was there called, be suspended for three years (E. Favaro, *L'arte dei pittori in Venezia e i suoi statuti*, Università de Padova, Pubblicazioni della Facoltà di lettere e filosofia, LV, Bologna, 1975, 6of.).

[3] The painter Jean Goujon was made a master in 1615 on the occasion of the birth of Henrietta of France, a daughter of Henri IV and future spouse of Charles I of England (J. Guiffrey, *Artistes parisiens*, 98, no. 155). In 1629, Antoine le Nain received a similar dispensation (J. Guiffrey, "La maîtrise des peintres de Saint-Germain des Prez: Réceptions et visites," *Nouvelles archives de l'art français*, 1876, 102ff.; and J. Thuillier, "Documents pour servir à l'étude des frères Le Nain," *Bulletin de la Société de l'histoire de l'art français*, 1963, 164-66).

[4] J. Guiffrey, "Logement et artistes au Louvre . . . depuis 1608 jusqu 'en 1791," *Nouvelles archives de l'art français*, 1873, 1-221; and R. Crozet, *La vie artistique en France au XVIIe siècle*, Paris, 1953, 22ff.

[5] L. Aucoc, *Institut de France: Lois, statuts et réglements concernant les anciennes académies et l'Institut, de 1635 à 1889*, Paris, 1889, cix. On the history of the Academy, see L. Vitet, *L'Académie royale de peinture et de sculpture: Etude historique*, Paris, 1861.

[6] As A. Fontaine points out (*Les collections de l'Académie royale de peinture et de sculpture*, Paris, 1910, 1), the Academy, "malgré son horreur de la Maîtrise," did in the early years

spelled out its own requirements for membership, it instituted a test not much different from the masterpiece but without calling it so. A regulation of 1655, already included in the statutes of the older Academies of Florence and Rome, specifies that no one shall be admitted as a member until he has presented a painting or a work of sculpture for the approval of the company.[7] The work was to remain in its possession in perpetuity.

The procedure involved in the submission of the *morceau de réception* is described in connection with the candidacy in the same year of the sculptor Gaspar Marcy. Having applied for admission, he was asked to make a clay model in relief, within a period of three months, of Christ in half length as *Ecce Homo*, to be later executed in marble.[8] The minutes of the Academy's sessions furnish other details concerning this examination. Initially, the aspiring academician presented one of his works for consideration. If it was favorably received, he was given the subject of his demonstration piece and asked to make a preparatory drawing (*esquisse*) or, in the case of sculptors, a model. Some-

[7] Aucoc, *Lois, statuts et réglements*, cxxxii. The rival Académie de Saint-Luc maintained the masterpiece requirement (see Vitet, *Académie royale: Pièces justificatives*, 315). When its property was put up for sale in 1776, a selection of the best examples was made for acquisition by the royal collection. Among the paintings listed are Lebrun's *Martyrdom of St. John*, Le Sueur's *St. Paul Healing the Sick*, and Blanchard's *St. John on Patmos* (J. Guiffrey, *Histoire de l'Académie de Saint-Luc*, Archives de l'art français, Nouvelle période, IX, Paris, 1915, 124ff.). Whether Lebrun actually became a master is disputed. His biographer Guillet de Saint-Georges states that he gave his painting, now in the Parisian church of St.-Nicholas-du-Chardonnet, to the old guild of painters and sculptors "comme un don gratuit et sans engagement de réception dans le corps de maîtrise," but the critic Mariette affirms that he was admitted as a member (see *Charles Lebrun, 1619-1690*, ex. cat., Versailles, 1963, xxxiv). In the Roman Accademia di San Luca, the requirement of a qualificatory work is first stated in the *"Ordini stabilità"* of Taddeo Zuccaro in 1593 (M. Missirini, *Memorie per servire alla storia della Romana Accademia di S. Luca . . .*, Rome, 1823, 31-32). For the situation in Florence, see J. Cavalucci, *Notizie storiche intorno alla R. Accademia delle Arti del Disegno in Firenze*, Florence, 1873.

[8] *Procès-verbaux*, I, 106. Marcy presented first a sketch (122-23), then a model in plaster (124-25). He was finally admitted to membership in August 1657 after being reprimanded for failing to attend to the final version in marble (130, 134). A list of identifiable *morceaux de réception* has been published by Duvivier, Chennevières, Daudet, and Montaiglon, "Sujets des morceaux de réception des membres de l'ancienne Académie de peinture et de sculpture et gravure," *Archives de l'art français*, 1852-53, 353-91.

times both, or several drawings, were requested. After approval had been given to a project, the candidate was instructed to make a final version of a given size, which was presented for a definitive judgment by the company. The finished work became its property. Like their artisan colleagues, the members of the Academy were concerned about the integrity of these qualificatory trials. In the early years of its existence, two representatives of the company were thus customarily delegated to visit the candidate and observe him at work. In 1666, it was decreed that aspiring members "must show themselves and draw or model in the Academy in the presence of a professor before being given the subject of their trial piece."[9]

In England, the divorce between the handicraft conception of the artist and the more elevated ideal derived from the Italian Renaissance culminated in the foundation of the Royal Academy of Arts (1768). Like its older sisters on the Continent, it offered instruction based on the copy of ancient models and drawing of the human figure from life.[10] The provisions for admission of new members contained in the *Instrument of Foundation* approved by George III differ slightly but significantly from those of the French Academy. In London, the candidates were first elected to the company, though they did not receive their letters of admission until they had submitted for approval "a Picture, Bas-Relief or other specimen" of their ability, to become the property of the Academy. In practical terms, the Diploma Work, as it came to be called, was less a test than a ceremonial gesture, since the judges could easily satisfy themselves in advance of the performance by their choice of an outstanding talent. According to the standard history of the Academy, some newly elected members even sought to hasten the process of their admission by offering their most convenient work on hand, with the promise of substituting something better for it at a later time.[11] By comparison, the French *morceau de réception*, on whose successful completion the candidate's admission integrally depended, remained closer to the artisanal *chef d'oeuvre*.

[9] *Procès-verbaux*, I, 304: "Les aspirants seront tenus de désigner ou modeler à l'Académie, en présence du Professeur, et de faire voire sa figure, avant qu'il lui soit ordonné un sujet pour procéder à sa réception." In 1703, the Academy decreed that both the model and final project had to be executed on its premises (*Procès-verbaux*, III, 366-67).

[10] W. Sandby, *The History of the Royal Academy of Arts from Its Foundation in 1768 to the Present Time*, London, 1862; and J. E. Hodgson and F. A. Eaton, *The Royal Academy and Its Members*, London, 1905.

[11] Sandby, *Royal Academy*, II, 380-81. For a list of Diploma Works received by the Academy, see Hodgson and Eaton, *Royal Academy*, 370-76; and Sandby, *Royal Academy*, II, 405ff.

Ultimately, however, the old system encountered a more radical challenge: could artistic merit be justly measured at all on the basis of a single performance, inevitably caught in a network of contradictory stresses? If the candidate was unarguably qualified by talent and training, the additional hurdle of the masterpiece—by whatever name— would only confirm the obvious. If, on the other hand, his competence was in doubt, he might yet have a lucky day and get by or benefit from the misplaced indulgence or, worse, corruption of his peers. Such sentiments were not new, but they were probably brought into sharper relief when the artisanal ideal of technical mastery lost its preeminence through the rivalry of other, more theoretically inspired qualitative criteria. Another line of argument against the masterpiece, reflecting eighteenth-century economic ideas, is found in Diderot's *Encyclopédie*. If someone is inept, it is proposed here, he should not be prevented from exercising his trade. In the free play of competition, his true worth will soon become apparent to all and, as is right, he will ruin himself.[12] These debates have a familiar flavor, for it is fair to say that institutional efforts to subject professional activity in the arts to some form of expert licensing down to the present day have met with much the same criticism.

The rise of the academies was symptomatic, more importantly, of a fundamental reordering of the categories of esthetic labor into what has been called the modern system of the arts.[13] To the older, extremely diverse classifications succeeded the notion that painting, sculpture, architecture, music, and poetry (occasionally joined by theater and the dance) formed a coherent ensemble of activities clearly distinguishable from scientific or artisanal pursuits, which should be called the Fine Arts. If we consider the first three headings in this grouping, broadly designating the plastic or visual arts, we must take note of a substantial promotion of sculpture and painting from their earlier standing among the handicrafts. This promotion was the work of Alberti, Vasari, and other figures of Italian Renaissance historiog-

[12] Diderot, *Encyclopédie, ou Dictionnaire raisonné des sciences, des arts et des métiers . . . ,* Paris, 1751-65, III, 273, q.v. "chef d'oeuvre." It may be noted that in certain cases, the masterpiece was deemed insufficient by itself to assure the competence of the artisan and was supplemented by an examination. This was the situation in Bourges for goldsmiths and barbers—no doubt particularly sensitive occupations—whom it was necessary, after the *chef d'oeuvre*, to "examiner & interoger pour cognoistre leur suffisance et capacité" (Chenu, *Recueil des antiquitez . . . de Bourges*, 156).

[13] P. Kristeller, "The Modern System of the Arts," *Journal of the History of Ideas*, XII, 1951, 496-527, and XIII, 1952, 17-46, reprinted in the author's *Renaissance Thought: II, Papers on Humanism and the Arts*, New York, 1965, 163-227.

raphy, who successfully proclaimed the humanistic basis of the pictorial arts. It was a development which was bound to affect the choice of products of artistic industry admitted into the canon of superlative achievement. The earliest masterpieces of man, as we have seen, had been exclusively works of architecture. In sixteenth-century writings, there are occasional references to celebrated statues and paintings of Antiquity as masterpieces, or we hear of an admired work that it is the equal of Praxiteles' *chef d'oeuvre*.[14] Paradin, the historian of Lyon (1573) calls *chef d'oeuvre* a personification of death in the church of St. Paul of that city, said to have been painted by King René of Anjou.[15] But only after 1600, it would seem, was the term applied on a sustained basis to the works of contemporary painters, sculptors, and weavers.

This shift in focus is apparent in the notes of Evelyn's Italian journey and in Molière's poem in praise of Pierre Mignard's painting of the dome of the Val de Grace, in which the edifice is adjured to protect from the ravages of time:

> Le chef-d'oeuvre fameux de ses riches présents,
> Cet éclatant morceau de savante peinture. . . .[16]

Earlier, the antiquarian Blaise de Vigenère spoke of Germain Pilon as the greatest French sculptor of his time, pointing to the "infinite number of *chefs d'oeuvre* in marble, bronze, terra cotta, in high as well as in low relief" to be seen by that master.[17] Joachim Sandrart, the

[14] J. Aubery (*Les bains de Bourbon-Lancy et Larchambault*, Paris, 1604, 59) speaks of the figures of Adam and Eve in the porch of the Sainte-Chapelle at Bourbon-L'Archambault as "tout nuds, de pierre de grès, si artistement elaborées, que Praxitelle les eut advouées pour son chef d'oeuvre." Gabriel Cibber, who executed the reliefs at the base of Wren's Monument, is called "another Praxiteles" in E. Chamberlayne's *Angliae Notitia*, London, 1682.

[15] G. Paradin, *Histoire de Lyon*, Lyon, 1573 (reprint, Roanne, 1973), 275. See on this O. Pächt, "René d'Anjou—Studien II," *Jahrbuch der Kunsthistorischen Sammlungen in Wien*, LXXIII, 1977, 82. Jean Bodin, in a work published in 1568 (*La réponse de Jean Bodin à M. de Malestroit*, ed. H. Hauser, Paris, 1932, 19), speaks of a painting by Pierre Lescot at Fontainebleau "qui est un chef d'oeuvre admirable, que plusieurs ont parangonné aux tableaux d'Apelles. . . ." Lescot is known primarily for his work on the rebuilding of the Louvre, and no other references to his practice of painting exist. See on this point, P. du Colombier, *Jean Goujon*, Paris, 1949, 103.

[16] Molière, *Oeuvres*, Paris, 1818, VI, 401.

[17] B. de Vigenère, *Les images ou tableaux de platte peinture*, Paris, 1614, 855. Vigenère also calls masterpieces several of the ancient statues included in the *Decriptiones* of Callistratus, which is attached to his translation and commentary of Philostratus' *Imagines*. Antoine de Laval, *Des peintures convenables aux Basiliques et au Palais du Roy*, Paris, 1605, quoted by J. Thuillier, *Etudes d'art français offerts à Charles Sterling*, Paris, 1975, 196,

historian of German art, wrote in the life of the Flemish painter Michael Coxcie contained in his *Teutsche Academie* (1675), that the latter, after the completion of his apprenticeship, traveled to Rome where "he diligently copied the works of Raphael and other famous masterpieces."[18] The altered seventeenth-century perspective is perhaps best revealed in the literary activity of André Félibien, and notably in his *Entretiens*, first published as a complete collection in 1680. This remarkable work is a comprehensive history of art from Classical Antiquity to the writer's own time, giving, as might be expected, careful attention to the Italian Renaissance but also including in its purview the northern European Schools. There is a foretaste of our own encyclopedic surveys in the author's wide field of vision, which is governed by concentration on painting, implicitly elevated by him to preeminence in the hierarchy of the visual arts.

For Félibien, *chef d'oeuvre* was a comfortable word, which he did not invest with exaggerated emotions. In his view of things, there are first of all the masterpieces of ancient Greek sculpture. Of these, there was no fixed nomenclature, though Félibien was inclined to estimate their number as no more than fifty.[19] The Abbé Dubos held that all had likely survived, since the Romans, superior to the Greeks in statecraft but beholden to them in every other sphere, had taken pains to transport these works to Rome or to copy them.[20] Among these monuments, however, some stood out as authoritative achievements of the highest order. Félibien mentions as choice examples the Medici Venus, the Laocoön, and the Farnese Hercules, works whose critical standing was nearly unrivaled in his time. The group of statues which, with the Laocoön, had been installed in Bramante's Belvedere Court in the Vatican figure in other writers' lists of favorites, most notably the Apollo, the Hercules Torso, and the Sleeping Ariadne (Fig. 40).[21] Casts and all manner of copies constitute the visible aura of this elevation to canonical status.[22]

speaks of the paintings in the Ulysses Gallery at Fontainebleau and of Homer's poem which inspired them as "deux chefs d'oeuvre parfaits."

[18] J. Sandrart, *Academie der Bau-, Bild-und Mahlerey-Künste von 1675*, ed. A. Peltzer, Munich, 1925, 125.

[19] A. Félibien, *Entretiens sur la vie et les ouvrages des plus excellents peintres anciens et modernes*, Paris, 1666-88, I, 88.

[20] J. B. Dubos, *Réflexions sur la poésie et sur la peinture*, Paris, 1770, I, 385.

[21] H. H. Brummer, *The Statue Court in the Vatican Belvedere*, Stockholm, 1970.

[22] See H. Ladendorf, *Antikenstudium und Antikenkopie*, Abhandlungen der Sächsischen Akademie der Wissenschaften zu Leipzig, Philologisch-historische Klasse, 46, no. 2, Berlin, 1958, with extensive bibliography; and on early copies of the Vatican antiques,

The statue of Venus is mentioned for the first time in 1550 and was acquired in Rome by Cardinal Fernando de' Medici in 1584 for his villa on Monte Pincio. Sometime thereafter, its anonymity was dissipated through the addition of a spurious inscription calling it the work of a little-known Greek master Kleomenes. Notwithstanding, the more prestigious name of Phidias was soon advanced, on the dubious evidence of a passage in Pliny. Until its fame was eclipsed in the early years of the nineteenth century, the statue was cited in the most rapturous terms by numberless writers.[23] Montesquieu, who saw it in Florence where it had been removed in 1677, summarizes, not without a touch of irony, the significance of the work in contemporary eyes: "Since this statue embodies the correct rules, everything which is identical in its proportions to it is good, while that which departs from it is bad. Thus, one cannot contemplate and describe it too much"; and in conclusion, "This statue is not the model of Venus, but of beauty, and to describe it is to say how a woman must be, and how she must be represented."[24]

If the Medici Venus represented the ideal of feminine beauty, the Hercules Farnese was thought to be the embodiment of manly strength. The statue of the weary hero, bearing the signature of the Athenian sculptor Glykon, was discovered in the Thermae of Caracalla between 1540 and 1549, and until its transfer to Naples in 1790, displayed with other ancient marbles in the courtyard of the Roman palace from which it takes its name.[25] Like other classic mas-

S. Pressouyre, "Les fontes du Primatice à Fontainebleau," *Bulletin monumental*, 1969, 223-39.

[23] A. Michaelis, "Zur Geschichte des Schleifers in Florenz und der Mediceischen Venus," *Archäologische Zeitung*, XXXVIII, 1880, 1-17, and "Die älteste Kunde von der Mediceischen Venus," *Zeitschrift für bildende Kunst*, New Series, 1, 1889-90, 297-301. Evelyn (*Diary*, 151) wrote that "the Venus is without parallel, being a masterpiece . . . certainly nothing in sculpture ever approached this miracle of art." On the statue within the context of ancient art, see M. Bieber, *The Sculpture of the Hellenistic Age*, New York, 1955, 20, 26, and 98; and W. Amelung, *Führer durch den Antiken in Florenz*, Munich, 1897, 46ff., no. 67. J. R. Hale, "Art and Audience: The Medici Venus, 1750-1850," *Italian Studies*, XXXI, 1976, 37-58, deals with its later reputation.

[24] Montesquieu, *Oeuvres complètes*, Paris, 1964, 355-56. See also J. Ehrard, *Montesquieu: Critique d'art*, Paris, 1965.

[25] Th. von Frimmel, "Zu den Nachbildung des Herakles Farnese in der Malerei," *Studien und Skizzen zur Gemäldekunde*, 3, 1917/18, 142-54. Jonathan Richardson comments that the statue "is so Famous, and so well known, and of which there are so many Prints and Drawings . . . that it needs no farther Description" (*An Account of Some of the Statues, Bas-Reliefs and Pictures in Italy*, London, 1722, 130-31). Bellori saw in the work a masculine counterpart of the Medici Venus (*L'Idea del pittore, dello schultore e dell'ar-*

terpieces, it could be compared to an icon, inspiring copies, adaptations, and an appropriate hagiographic embellishment. Michelangelo, having attempted to restore the statue, is said to have abandoned the task and destroyed his work, exclaiming that he could not even supply the missing fingers. The execution of the missing legs and left hand was in fact carried out by Guglielmo della Porta. His performance, it is said, was so highly esteemed that when the original limbs were discovered near the Villa Borghese in 1560, it was decided to leave the additions in place.[26] Until the rise of modern scholarship, which has concluded that the statue reflects a lost original by Lysippus, Glykon's star stood high in the firmament of the great masters. The words of Horace (*Epist.* I, 1, 30) concerning "unconquered Glykon's strength of limb" must refer to a renowned athlete but were taken to characterize the virile and muscular manner of our sculptor as it is exhibited in the Hercules Farnese. For Winckelmann, this was the point of departure for Michelangelo, Algardi, and Schlüter's art and formed a contrast with the "youthful and feminine" tendency represented by Bernini and Duquesnoy.[27]

The Laocoön was discovered in 1506 and immediately hailed by qualified opinion as the greatest work of art left to us by the Ancients. In this instance, Pliny's own unambiguous words could be cited in support of this judgment.[28] Félibien devoted his third *Conférence* to the Academy (1667) to the work, and noted this concordance of ancient and modern views.[29] Winckelmann considered it "a supreme standard for art," and it stands, more surprisingly perhaps, as the illustration of his famous declaration: "The most telling quality of the Greek masterpieces, in summary, consists of a noble simplicity and calm grandeur, in the general stance as well as in the expression."[30] In

chitetto . . . , Rome, 1672, cited by E. Panofsky, *Idea: A Concept in Art Theory*, New York, 1968, 163), and the same point is made by Dryden in the preface of his translation of C. A. du Fresnoy, *The Art of Painting*, London, 1716, x. For the authorship of the statue, see Bieber, *Hellenistic Age*, 37; and F. J. Johnson, *Lysippos*, Durham, N.C., 1927, 196ff.

[26] For the anecdote concerning Michelangelo, see F. de Navenne, *Rome: Le Palais Farnese et les Farnese*, Paris, n.d., 446ff.

[27] J. Winckelmann, *Kleine Schriften, Vorreden, Entwürfe*, ed. W. Rehn, Berlin, 1968, 70.

[28] Pliny, *Hist. Nat.*, XXXVI, 37. R. Förster, "Laokoön im Mittelalter und in der Renaissance," *Jahrbuch der Preussischen Kunstsammlung*, XXVII, 1906, 149-78; M. Bieber, *Laocoon: The Influence of the Group since Its Rediscovery*, New York, 1942; and M. Winner, "Zum Nachleben des Laokoon in der Renaissance," *Jahrbuch der Berliner Museen*, XVI, 1974, 83-121.

[29] Félibien, *Conférences de l'Académie royale de peinture et de sculpture pendant l'année 1667*, Paris, 1668 (reprint, Geneva, 1973), 31.

[30] Winckelmann, *Kleine Schriften*, 43.

the case of the Laocoön, the body of commentary is not only very ample, but goes beyond conventional praise to a searching consideration of the nature of the work itself and of its implications for art and criticism alike. Why is the high priest in his mortal struggle represented in the nude rather than in sacerdotal robes? Why, in spite of the consummate skill of the three Rhodian masters, are the two sons implausibly smaller than their father? In the portrayal of suffering, how should the claims of expressive distortion be measured against those of truth and decorum? In his lecture, Félibien remarks further on the characterization of the Laocoön: it is not so overpowering a figure as the Hercules Farnese since it is that of a priest, while the proportions differ from those of the Apollo Belvedere, who is a god. Yet our critic discerns in the writhing body no ordinary mortal but one of "high birth and particular merit," an appropriate paradigm, we must suppose, for a learned assembly under royal protection.[31]

A second theater of high mastery was located by the seventeenth- and eighteenth-century authors in the art of the High Renaissance. Among the works of Leonardo, the *Last Supper* enjoyed the greatest esteem. Michelangelo's *Last Judgment* in the Sistine Chapel was generally considered to be his most impressive achievement. But the most sizable and exemplary body of masterpieces was attributed to Raphael and his School. For Félibien and many other critics, the painter's *chef d'oeuvre* was the *Transfiguration*, which could be seen in San Pietro in Montorio (Fig. 41).[32] The painting had been commissioned by Cardinal Giuliano de'Medici for his cathedral in Narbonne, but after the master's death was given by the patron to San Pietro in his memory. A copy of the painting, Vasari states, made by three of Raphael's pupils, Luca Penni, Giulio Romano, and Perino del Vaga, was unsuccessfully "sought in France."[33] These circumstances were woven into different historiographical configurations. That the painting was originally destined for a French city is mentioned in nearly obligatory fashion, and the king himself is credited with having recognized its merits. Papillon de la Ferté's outline of art history (1776) has it that the king himself commissioned it.[34] The death of Raphael before the work could be completed and its exhibition at the painter's bier, related by Vasari, made a deep impression. It seemed to suggest an idea of great prom-

[31] Félibien, *Conférences*, 33.

[32] Félibien, *Entretiens*, I, 245. For the painting, see L. Düssler, *Raffael: Kritisches Verzeichnis der Gemälde, Wandbilder und Bilderteppiche*, Munich, 1966, 67, no. 119.

[33] Vasari, *Vite*, ed. G. Milanesi, IV, 646.

[34] D.P.J. Papillon de la Ferté, *Extrait de différents ouvrages sur la vie des peintres*, Paris, 1776 (reprint, Geneva, 1972), I, 39.

ise for the future, the masterpiece as the ultimate accomplishment of an artist, the final synthesis of a "late phase." Oskar Fischel, one of Raphael's modern biographers, sensed in the painting the artist's premonition that his life was drawing to an end. In the *Transfiguration*, he thought, we have his Requiem.[35]

Not everyone held the painting in such high esteem. Roger de Piles considered the artist's masterpiece to be the *St. John in the Desert*—presumably the painting now in the Louvre, which is regarded as a workshop copy.[36] Sir Joshua Reynolds thought that the Vatican frescoes and the tapestry cartoons in Hampton Court represented the master's most significant works.[37] Winckelmann's greatest enthusiasm was reserved for the Sistine Madonna, a work which, following its arrival in Dresden in 1754, may be said to have inaugurated the painter's celebrity in Germany.[38] Among Raphael's followers, Giulio Romano's *Palazzo del Tè* frescoes in Mantua were sometimes given the same high praise as his teacher's art. But these differences of opinion were easily overshadowed by general agreement on the exemplary value of the painter's achievement as a whole. Raphael constitutes a novel event in our account, a figure whose works were, to be sure, not all of equal merit, yet all in all, of such surpassing excellence that the determination of the best had to be made at the most rarified level. In the collective judgment, the notion of masterpiece as the supreme achievement lost ground before the image of the great artist as a purveyor of masterpieces *en série*, a "formgiver" whose major statements established the models against which future effort would be measured.

What of the course of events after Raphael's death? According to Reynolds, the state of art had since then materially declined, and aside from some guarded praise for the painting of Titian, no new peaks could be signaled. Félibien, on the other hand, not only had a more favorable opinion of the Venetian master, calling his paintings in the royal collection "autant de chefs d'oeuvre," but he also adhered

[35] O. Fischel, *Raphael*, London, 1964, 278. See also H. Lüthgens, *Raffaels Transfiguration in der Kunstliteratur der letzten vier Jahrhunderte*, Diss., Göttingen, 1929.

[36] R. de Piles, *Abrégé de la vie des peintres*, Paris, 1715, 173. On this painting, see Düssler, *Raffael*, 58, no. 100.

[37] J. Reynolds, *Discourses on Art*, ed. R. Wark, San Marino, 1959, 78-79, 81, 216, and 238.

[38] See M. Ebhardt, *Die Deutung der Werke Raffaels in der deutschen Kunstliteratur von Klassizismus und Romantik*, Studien zur Deutschen Kunstgeschichte, 351, Baden-Baden, 1972, 55ff.; and M. Putscher, *Raphaels Sixtinische Madonna: Das Werk und seine Wirkung*, Tübingen, 1955, 136ff.

to the more positive view that the heritage of Raphael had been res-
cued by the Carracci and their associates at the end of the sixteenth
century from two major heretical tendencies which threatened to en-
gulf it, the esoteric artificialities of Mannerism and the naturalistic ex-
cesses attributed to Caravaggio.[39] A new dispensation of masterpieces
was thus at hand. Its genial instigator was Poussin, whose *Eliezer and
Rebecca* (Fig. 42) and *Fall of the Manna* are singled out for special
praise and lengthy analysis. Of the former, Félibien's well-meaning
fictional interlocutor Pymandre is moved to say that "it would only be
necessary to well imitate this work to make a second masterpiece."
Concerning the *Manna*, Poussin is lauded for having modeled his
figures after famous examples of ancient statuary, for these "master-
pieces of art . . . seemed to him much more deserving of imitation
than ill-shaped men and women such as they are. . . ."[40]

The Ancients, Raphael, and Poussin are milestones which mark out
a recognizable path on the landscape of artistic values, but the *Entre-
tiens* in the designation of masterpieces is not exclusively committed to
a single line. Van Dyck's *Crucifixion* for the Franciscans of Dender-
monde is said to be admired as a priceless *chef d'oeuvre*.[41] The text
seems implicitly to encourage the view that every artist, whatever his
stylistic orientation and relative merit, was by definition the author of
a masterpiece. Thus, Quentin Metsys' is said to have been his *Descent
from the Cross* painted for the Confraternity of carpenters and joiners
of Antwerp.[42] Sébastien Bourdon, we are told, worked to the utmost
of his ability to ensure that the gallery which he painted for the Prési-
dent de Bretonvillers would be his supreme work.[43] It is evident that
this is only a recasting in more up-to-date terms of the artisanal posi-
tion: the masterpiece is and can only be a single performance, but it is
the best in an artist's career rather than the first. Félibien is even more
accommodating when he speaks without further qualification of the
paintings in the king's *Grand Cabinet* as the *chefs d'oeuvre* of the great
masters. They are beautiful in different ways, the merits of one com-

[39] Félibien, *Entretiens*, I, 659. [40] Ibid., II, 429.

[41] Ibid., II, 226. The painting is now in the church of St. Mary in Dendermonde. See
E. Dhanens, *Inventaris van het Kunstpatrimonium van Ostlanderen: IV, Dendermonde*, Ghent,
1961, 122, no. 250, with earlier bibliography.

[42] Félibien, *Entretiens*, I, 544. For the painting, see H. Brising, *Quinten Metsys: Essai sur
l'origine de l'Italianisme dans l'art des Pays-Bas*, Uppsala, 1909, 69ff.

[43] Félibien, *Entretiens*, II, 530; and C. Ponsonhailhe, *Sébastien Bourdon: Sa vie, son
oeuvre*, Paris, 1883, 230ff. A description of this work is found in Guillet de Saint-
Georges' *Life of Bourdon*, in *Mémoires inédits sur la vie et les ouvrages des membres de
l'Académie royale de peinture et de sculpture*, Paris, 1854, I, 95ff.

plementing those of another in marvelous concert. For art is such a vast thing that no man can by himself command its every part.[44]

The other branches of the Fine Arts had their masterpieces, too. In the field of architecture, once their exclusive province, the Maison Carrée in Nîmes, the Colosseum, and the Pantheon in Rome were often singled out for high praise. In Alexander Pope's *Essay on Criticism*, there is an encomium on the rotunda which is at the same time a striking esthetic credo:

> In Wit, as Nature, what affects our hearts
> Is not th'exactness of peculiar parts;
> 'Tis not a lip, or eye, we beauty call,
> But the joint force and full result of all.
> Thus when we view some well-proportion'd dome
> (The world's just wonder, and ev'n thine, O Rome!)
> No single parts unequally surprize,
> All comes united to th'admiring eyes
> No monstrous height, or breadth, or length appear;
> The Whole at once is bold, and regular.[45]

As in the case of the pictorial arts, another recension of *chefs d'oeuvre* had come to complement or rival the old. For Addison, St. Peter's is to modern what the Pantheon was to ancient architecture.[46] Mansart's Val de Grace and Château of Maisons, Perrault's Louvre Colonnade and Observatory are other buildings of newer times which were called masterpieces in seventeenth- and eighteenth-century criticism.[47] Poetry, now a sister art, entered the lists with Homer as its loftiest champion, and Virgil's stately and measured voice supreme among the Romans.[48] The Ancients had their counterparts among the Mod-

[44] Félibien, *Entretiens*, II, 3.

[45] *The Works of Alexander Pope*, ed. W. Warburton, London, 1751, I, 166-67.

[46] J. Addison, *Remarks on Several Parts of Italy* (1701), in *The Works of the Right Honorable Joseph Addison*, ed. R. Hurd, London, 1875, I, 418.

[47] C. Perrault, *Parallèle des anciens et modernes en ce qui regarde les arts et les sciences*, Paris, 1688, 70-71, 251-252. Among the works of Mansart, Félibien awards the highest accolade to the now destroyed chapel of Fresnes (*Entretiens*, I, 22), while Piganiol de la Force (*Nouvelle description de la France*, Amsterdam, 1719, II, 134) notes in connection with the church of the Visitation in the Rue Saint-Antoine that "quelques uns en regardent l'extérieur . . . comme un petit chef d'oeuvre, d'autres pensent autrement."

[48] Vigenère, *Images ou tableaux de platte peinture*, 521, writes of "ces deux excellents chefs d'oeuvre de l'Iliade et de l'Odyssée," while Jonathan Richardson calls Homer "this great, this ONLY man . . ." (*An Essay on the Theory of Painting*, London, 1725, 71). On the position of Homer, see N. Hepp, *Homère en France au XVIIe siècle*, Diss., Strasbourg, 1968; and Th. Bleicher, *Homer in der deutschen Literatur (1450-1740): Zur Rezeption der Antike und zur Poetologie der Neuzeit*, Stuttgart, 1972.

erns. Milton was hailed as another Homer. Molière, the new Terence, had in his *Tartuffe* and *Misanthrope* written masterpieces of comedy. Boileau was a new Horace, and Voltaire was held by some of his admirers to be another Seneca. On the other hand, La Fontaine's Fables, like Le Nôtre's gardens, inspired appreciative comment because they seemed to initiate new genres in which there were no ancient models.

Musicians faced special difficulties, it was thought, because they "had not such perfect models before them, as Antiquity furnished to poets in the dramatic works of Sophocles, Euripides and Terence, or the epic poems of Homer and Virgil."[49] Hence, what masterpieces there were had to be of more recent vintage. Probably the first composer to have been surrounded with the critical regard announcing a great master was Palestrina (1524-1594). Charles Burney calls him "the Homer of the most Ancient Music that has been preserved," a characterization that combines deep reverence for a founding father with the imputation of an awesome but not wholly "correct" style.[50] Yet the influence of Palestrina's music was of necessity limited to choral composition for the Catholic service, and other important figures in the history of music like Guillaume Dufay, Josquin des Prés, or Orlandus Lassus, admired as they might be from a distance, were too remote in their style from the musical ideals of the seventeenth and eighteenth centuries to impose their standard. There was, thus, in the history of music, no pantheon of universal *chefs d'oeuvre* comparable in its continued significance to the works of the Ancients and of Raphael. In consequence, the pattern of critical acclaim is far less predictable and subject to a much greater degree than in the other arts to the pressures of doctrinal or national pride. In England, Purcell was regarded as the greatest native composer and his reputation was eventually to be surpassed only by that of Handel.[51] In France, the Abbé Bourdelot in his pioneering history of music (1715) praised as *chefs d'oeuvre* a work by the sixteenth-century composer Claude Lejeune, and in a collective way, the best cantatas of French composers of his time.[52] But the context of his judgments brings out their

[49] C. Burney, *A General History of Music*, London, 1776-89, III, 234.

[50] Ibid., 185. A more sustained cult of Palestrina seems to have developed in the nineteenth century. See, for example, Hugo's poem "Que la musique date du XVIe siècle," in *Les rayons et les ombres*, no. XXXV (V. Hugo, *Oeuvres poétiques complètes*, Paris, 1961, 260); and later, Pfitzner's opera *Palestrina* (1917).

[51] On Handel's renown, see K. H. Darenberg, "Georg Friedrich Händel im Spiegel englischer Stimmen des 18. Jahrhunderts," *Archiv für Kulturgeschichte*, XLI, 1959, 133-65.

[52] P. Bourdelot, *Histoire de la musique et de ses effets*, Paris, 1715, 25, 219, and 301.

apologetic intention. He wished to counter the more immoderate partisans of Italian music by showing that the French side, too, had its merits. The figure of Lully plays a key role in this somewhat tedious quarrel, and his admirers saluted his works as masterpieces allying the best of Italian principles to the special qualities of French taste. The age of the great classics of music, which would speak to the human family at large, had not yet arrived, as Bourdelot himself seems to have realized in this interesting observation: "It is maintained by the most celebrated practitioners of the art that no musician can reach the highest perfection, since music, being an infinite science, daily reveals new possibilities for improvement."[53]

The hierarchy of genres in each of the Fine Arts is naturally reflected in the elaboration of a canon of authoritative works. In the realm of painting, the truly universal masterpieces belong to the category of historical subjects, recognized as the highest. But landscape, still-life, or genre, though they were specialties of a lower order, have a validity of their own and are endowed, too, with normative exemplars. It was another tenet of doctrine that the major schools of painting each had its own sphere of primacy. The Florentines excelled in drawing and composition, the Venetians in color, and Parma boasted of Correggio's luminous grace. Here were other potential voices for Félibien's concert of masterpieces. In theory, at least, the number of masterpieces could be infinitely enlarged in this way, with ever new categories brought forth, each harboring its own unsurpassable standard. Beyond the multiplicity of imaginable stellar performances of every kind, however, there would remain a more restrictive canon of *chefs d'oeuvre*, the pantheon of Raphael's works and of the ancient masters. The disposition toward inflation or restriction was a matter of individual taste and temperament but was also related to one's larger view of the course of artistic progress. Reynolds held a generally pessimistic opinion of the developments since Raphael's death and was thus parsimonious in his bestowal of praise. The diffuse meliorative sentiment which drew support from Newton's discoveries and looked toward a continued improvement of man's prospects led others to a more positive appreciation of new achievements. Charles Perrault, who championed his era against the partisans of the superiority of the Ancients, had no difficulty in finding masterpieces close at hand. Girardon's *Apollo* and other outstanding statues in the gardens of Versailles await only a little wear and tear, he slyly pro-

[53] Ibid., 34.

poses, before the most ardent admirers of ancient art will recognize their superlative merit, while in the realm of painting, Lebrun's *Alexander in the Tent of Darius* not only ranks with the greatest achievements of the past but surpasses them.[54] Voltaire thought most impressive the work of the medalists of the Grand Siècle, and calling attention to the large collection of die stamps in the Louvre, noted with no particular show of emotion: "There are more than two million of them and most of them are masterpieces."[55]

Perrault's conception of the masterpiece, represented also by other proponents of the modern side in the all too famous *Querelle*, has an arresting evolutionary perspective. For him, masterpieces come closest to realizing the idea of perfection, but only within a limited span of time. The paintings of Zeuxis and Apelles were regarded by the Ancients as worthy of the highest admiration, and they were the best that could then be achieved. But the ability to paint grapes so convincingly that birds will be fooled into pecking them does not strike him—in this, he is perhaps unjust—as so remarkable a feat. Since then, in any case, the state of art has progressed as the succeeding times have been able to build on the foundation of earlier achievements. Even Raphael, much as he may be prized, ignored the soft gradation of light and atmospheric effects of aerial perspective which artists mastered only after him. There are many people, he reports, who think that Jean Goujon's Fountain of the Innocents is the most beautiful work of architecture and sculpture in France, and this was once true. "But the beautiful works which have appeared since then, the Val de Grace, the façade of the Louvre, the Arc de Triomphe and the marvels of Versailles have now rendered this opinion not only false but ridiculous as well."[56] This relative notion of judgment is shared also by Voltaire, who remarks that Tristan l'Hermite's play *Marianne* (1636) was so successful that it took more than one tragedy by Corneille to make people forget it. "There are still some nations," he notes, "where very mediocre works pass for mas-

[54] C. Perrault, *Parallèle* 220ff.; and the poem "Le siècle de Louis le Grand" contained in the same volume, 13-14.

[55] Voltaire, *Le siècle de Louis XIV*, ed. A. Rebelliou and M. Marion, Paris, 1894, 596.

[56] Perrault, *Parallèle*, 70-71. The triumphal arch here mentioned is Claude Perrault's project for a monument to be set up in the Faubourg Saint-Antoine, of which a model was approved by the king in 1670. The actual construction was never finished, and in 1716 what had been done was demolished. See on this work A. Braham and P. Smith, *François Mansart*, London, 1873, I, 270; and W. Herrmann, *The Theory of Claude Perrault*, London, 1973, 85ff. and pl. 17.

terpieces, because no genius has appeared who has surpassed them."[57]

Yet the evolutionary process which leads to the increasing number and quality of masterpieces is not continuous. There are privileged times, marked by their exceptional fecundity. Voltaire held that there were four centuries in the history of the world, which "for anyone who thinks, and what is rarer, for anyone who has good taste" are all that really count. These great periods were, first, those of Philip and Alexander (or of Pericles), when the likes of Demosthenes, Aristotle, Plato, Apelles, Phidias, and Praxiteles flourished; second, of Caesar and Augustus, famed for the achievements of Lucretius, Cicero, Titus Livius, Virgil, Horace, Ovid, Varro, and Vitruvius. The third great century began with the taking of Constantinople by the Turks, leading to the rise of Italy, personified by the Medici, to the front rank; and the fourth was the age of Louis XIV, when France came to set the standard for the rest of the world. After the death of the monarch, decline set in as if productive energies needed a rest from the surfeit of masterpieces.[58] The awareness that such periods of outstanding achievement had been few in number over the history of mankind and that they had come and gone fueled speculation regarding the causes and conditions which might account for them. The role of an enlightened ruler figures prominently in these conjectures:

Les Siecles, il est vray, sont entre eux differens;
Il en fut d'éclairez, il en fut d'ignorans,
Mais [. . .] le regne heureux d'un excelent Monarque
Fut toujours de leur prix et la cause et la marque.[59]

Alexander's esteem and patronage of Apelles acquired an exemplary significance,[60] and Augustus was hailed as the standard-bearer of Latin literary excellence. From this interpretation, English critics developed the theme of an Augustan age with reference to the reign of Charles II and his successors, illustrated by the works of Dryden, Pope, and their contemporaries.[61] It was allowed, however, that these high moments resulted from a convergence of factors, and could

[57] Voltaire, *Siècle de Louis XIV*, 834. [58] Ibid., 583.

[59] Perrault, *Siècle de Louis le Grand*, 22.

[60] R. W. Kennedy, "Apelles Redivivus," *Essays in Memory of Karl Lehmann*, New York, 1964, 16off.; and M. Winner, *Die Quellen der Pictura-Allegorien im gemalten Bildergalerien des 17. Jahrhunderts zu Antwerpen*, Diss., Cologne, 1957, 3ff.

[61] J. W. Johnson, "The Meaning of 'Augustan,'" *Journal of the History of Ideas*, XIX, 1958, 507ff.

occur only after a certain qualitative eminence had been reached. The *chef d'oeuvre* was thus more than a matter of personal ability. One had to be born at the right time.

The historical consciousness which recognized that the achievement of an appreciation of greatness involved a collective experience that was always redefining itself might well have found it difficult to maintain its confidence in the existence of objective norms valid for all times. Yet, in fact, Voltaire and Perrault before him take this position for granted. That the works of l'Hermite or Goujon were once acclaimed as masterpieces is understandable and even defensible for them in light of the standards which prevailed, but it is nonetheless a faulty judgment. The disagreement between Ancients and Moderns was a matter of degree rather than of kind. The superiority of one or the other according to different opinions still left room for a sincere admiration of the losing side, and writers who voiced their preference for one did not thereby lose their respect for the other. Nevertheless, acquiescing in the view that history colored the artistic enterprise as well as its assessment was bound to undermine the basis of firm esthetic judgment. This was well recognized by Boileau in his refutation of Perrault's arguments for the modern position. How could one be sure, he argued, that praise did not spring from interested motives or plain fascination with novelty? The cathedrals of the Middle Ages were once admired, too—so one would think—and this proved how far self-deception could go. Boileau proposed as the solution to the dilemma the test of time. Only the approbation given by posterity can convince us of the true foundation of merit, and the longer this approbation has been maintained, the more unassailable it is.[62]

Although Boileau's intention was to demonstrate that the Ancients alone could claim a secure place at the summit of the hierarchy of human achievement, his argument contains a more generally applicable premise. Given the variety of tastes and the ups and downs of fashion, our views on what is of permanent worth among the artifacts of culture must be ratified by a jury removed from the inducements and pressures of the moment. But this is not solely to guard against the risk of error. Permanence itself and universality, in an admittedly narrower definition than we would now accept, are attributes of the *chef d'oeuvre*. As Hume declares, "The same Homer who pleased Athens and Rome two thousand years ago, is still admired at Paris and

[62] N. Boileau, *Réflexions critiques*, in *Oeuvres complètes*, ed. A. Adam, Bibliothèque de la Pléiade, Paris, 1966, 523ff.

at London. All the changes of climate, government, religion, and language have not been able to obscure his glory. Authority or prejudice may give temporary vogue to a bad poet or orator; but his reputation will never be durable or general. When his compositions are examined by posterity or foreigners, the enchantment is dissipated, and his faults appear in their true colors. On the contrary, a real genius, the longer his works endure, and the more they are spread, the more sincere is the admiration which he meets with."[63] It is apparent that the writer not only wishes to impress us with the longevity of Homer's fame as an historical fact, but to give us good reason to expect that this lofty reputation will continue endlessly into the future. To be sure, most readers, even those profoundly sympathetic with this position, would not wish to wait for two thousand years the verdict of posterity. For them, there is a strategy of presumptive immortality. A century or two may suffice, but we not infrequently have to be satisfied only with the conviction that the future will share our enthusiasm or rectify a gross error. Diderot, who believed that his contemporaries did not sufficiently prize the works of Richardson, admonished the centuries to pass rapidly, so that this slight could be repaired.[64]

The timelessness of masterpieces is for Hume complemented by their ready acceptance across spatial and linguistic boundaries. Racine makes the same point in his praise of Corneille upon the latter's reception into the French Academy in 1685: "The stage still reverberates from the applause provoked on their first performance by the *Cid, Cinna* and *Pompey*, these masterpieces since then given in so many theaters, translated into so many languages, which will live forever on the tongues of men."[65] Reynolds declares even more forcefully: "To distinguish how much has a solid foundation, we may have recourse to the same proof by which some hold that wit ought to be tried whether it preserves itself when translated. That wit is false which can subsist only in one language; and that picture which pleases only an age or one nation, owes its reception to some local or accidental asso-

[63] D. Hume, *Of the Standards of Taste*, in *The Philosophical Works of David Hume*, Edinburgh, 1826, 1966, 523ff.

[64] Diderot, *Eloge de Richardson*, in *Oeuvres esthétiques*, ed. P. Vernière, Classiques Garnier, Paris, 1959, 47. Diderot's ideas on posterity's role as the arbiter of genuine merit are set forth at greater length in his correspondence with the sculptor Falconet. See *Diderot et Falconet: Le pour et le contre: Correspondance polémique sur le respect de la postérité . . .* , ed. Y. Benot, Paris, 1958.

[65] J. Racine, *Discours prononcé à l'Académie Française à la réception de MM. de Corneille et de Bergeret* (1685), in *Oeuvres complètes*, ed. R. Picard, Bibliothèque de la Pléiade, Paris, 1960, 345.

ciation of ideas."[66] Hence, the importance of the traveler's report, the engraved copy, the transposition from one instrumental setting into another, which bring the work to a wider public and at the same time make manifest its claim to universality. The relative nature of judgment which is expressed in the view that the masterpieces of one era may be demoted to a lesser status in the eye of the next was also instrumental in this process of diffusion across cultural and social barriers. For it lies in the nature of the argument that as each of us is exposed to a more authoritative embodiment of perfection and instructed, if necessary, on its qualities, we will reject the old favorites and embrace the new as the basis of our critical standards. It is thus our ability to appeal to the existence of such a summit of art which guarantees the validity of our opinions and saves them from the imputation of prejudice or mere caprice. Behind every poem, monument, or musical composition, there is a firm foundation of value represented by the masterpiece of the genre, and it is by comparing the individual creation to this ideal exemplar that we determine its correct place on the scale of merit.

Through such an exercise of discrimination, taste, which requires the assistance of sound judgment, is enhanced. This is a subject on which the literature of the period is particularly expansive.[67] The old maxim *De gustibus*, it is held in these writings, is both true and false. It describes well enough the multiplicity of opinions available on every subject that sensation may engage. But taste is not truly a matter of personal preference, for it would be folly to maintain that there is no difference between genius and routine talent, between a Raphael or a Milton, and one of their uninspired followers. The conviction that taste is anchored on firm principles, and the simultaneous recognition that these principles inform the judgment of many persons either inadequately or not at all presented a contradiction which had to be resolved in one or two ways. Either "all sentiment is right" and its options should not be contested, or judgment should be improved in order to bring it into conformity with principle. Such a betterment of taste held out for its proponents the hope of a more pervasive rule of

[66] Reynolds, *Discourses*, 134. Ingres, in the same spirit, could later suggest that the great masterpieces of painting should be copied in a permanent material, like the enameled earthenware of the Della Robbias (*Ecrits sur l'art*, ed. R. Cogniat, Paris, 1947, 30).

[67] See the article and bibliography by G. Tonelli in the *Dictionary of the History of Ideas*, ed. P. Wiener, New York, 1973, IV, 353-57; and J. Dobai, *Die Kunstliteratur des Klassizismus und der Romantik in England: I, 1700-1750*, Bern, 1974, 108, and *II, 1750-1790*, Bern, 1975, 103ff.

reason. Some saw in it a beneficial effect on moral conduct. Alexander
Gerard, who in 1755 won the first prize for his *Essay on Taste* in a
competition sponsored by an Edinburgh learned society, concluded
that "Vice is often promoted by taste ill-formed or wrong applied: let
taste be rendered correct and just, [and] vice will be almost extin-
guished; for our opinions of things will be, in most cases, true and to
their natures."[68]

Such a correction of ungoverned taste by exposure to and reflection
upon man's great and universally recognized works was one of the
expected dividends of foreign travel. The guidebooks made available
to voyagers a nomenclature of the appropriate monuments and a few
remarks, in most cases, assessing their principal merits.[69] The infor-
mation, often culled from the *Lives* of Vasari and Bellori and rear-
ranged in a rough topographic sequence, acquainted the reader with
the name of the artist and the title of the work. He is assured that it is
"a rare piece," "a noble performance," that master's outstanding
achievement, or the best of its kind. These opinions are not necessar-
ily ascribed to anyone in particular, and appear rather to report some
timeless general consensus. The aim, clearly, is not to persuade
afresh, but to inform on what has already been decided beyond ap-
peal. But the appreciative endorsement of highly qualified authorities
was sometimes noted. Ariosto is said to have admired the paintings of
Dosso Dossi.[70] Poussin is recorded to have judged the best three paint-
ings in Rome to be Raphael's *Transfiguration*, followed by Daniele da
Volterra's *Descent from the Cross*, and in third place, Domenichino's
Death of St. Jerome.[71] In all likelihood, the most prolific source of en-
dorsements was Michelangelo. He contributed substantially to
Ghiberti's fame by calling his Florentine Baptistry doors the Gates of
Paradise. He is said to have highly esteemed Gentile da Fabriano, to
have spoken warmly of Muziano's *Resurrection of Lazarus* in the Roman
church of Santa Maria Maggiore, and to have called *sposa* (for its
beauty) Santa Maria Novella in Florence.[72] The barest entries in this
literature of travel are nothing more than lists of artists: this place, we
hear, is distinguished by the presence of a Garofalo, a Veronese, or

[68] A. Gerard, *An Essay on Taste* . . . , London, 1759, 203.

[69] For Italy, see the comprehensive work of L. Schudt, *Italienreisen im 17. und 18.
Jahrhundert*, Veröffentlichungen der Bibliotheca Hertziana, Vienna, 1959, which gives
exhaustive attention to the guidebook literature; see also Dobai, *Kunstliteratur*, I, 867ff.
and 911ff., and II, 1305ff. and 1358ff., for the English material.

[70] P. Monier, *Histoire des arts*, Paris, 1968, 282.

[71] Papillon de la Ferté, *Vie des peintres*, I, 303. [72] Monier, *Histoire*, 296.

another Tintoretto, the name alone being offered as a sufficient token of the interest of the painting. The more important monuments receive more extended characterization. A celebrated painting impresses the writer as miraculously lifelike, with the paint scarcely distinguishable from flesh. He has heard that a well-known prince has offered a fabulous sum of money for it. Stories which document the singular effect of the work are advanced. Edward Wright (1722) has heard that Dürer's woodcut of Adam and Eve was executed by the artist with a penknife while he was allegedly in prison. As a result, he won his freedom.[73] The painter Francia is said to have died of pain—and in another version of the story, of joy—on seeing Raphael's *St. Cecilia* when it arrived in Bologna.[74] Parmigianino was trapped by soldiers bent on plunder and destruction during the Sack of Rome at the hands of Charles V's troops. Such was his art, however, that they were pacified and took him under their protection.[75]

In the face of this vast accumulation of treasures, the traveler had to be alert and discriminating. "It is not enough," Henry Peacham's manual (1622) warns the reader, "for an ingenuous gentleman to behold these [works of art] with a vulgar eye, but he must be able to distinguish them and tell who they are and what they be."[76] He must therefore know the essentials of iconographic conventions, how to distinguish the representations of the ancient gods through their gestures and attributes. Familiarity with images on coins, with their explanatory inscriptions, is recommended for this purpose, and an acquaintance with history and poetry considered a precious asset. If this expertise is not available, the would-be gentleman is advised to view the monuments in the company of a *Cicerone*, or at the very least, equip himself with an authoritative guidebook. These strictures, though they would broaden and enlighten, also convey a threat. The acquisition of taste has a social dimension, and those to whom the finer perceptions are denied suffer ridicule and loss of standing. The anxieties to which the traveler is exposed are well brought out in the passage of this literature devoted to the problem of copies. The existence of different versions of the same work, of pastiches or adapta-

[73] E. Wright, *Some Observations Made in Travelling through France, Italy* . . . , London, 1730, I, 57. The story reflects Dürer's fame in the handling of wood as a graphic medium and at the same time the reputation of his burin engraving of *Adam and Eve*.

[74] R. and M. Wittkower, *Born under Saturn*, London, 1963, 286; and R. Graham "Lives of the Painters," in Du Fresnoy, *The Art of Painting*, 216.

[75] Graham, "Lives," 308.

[76] H. Peacham, *The Compleat Gentleman* (1622), London, 1634, 109.

tions, obliged the viewer to an often difficult effort of connoisseur-
ship. Did he have before him the original? Was not the very basis of
esthetic judgment undermined if one could unwittingly pay tribute to
Raphael's mastery in the presence of a copy of one of his works by a
lesser painter? Ignorance and local pride added to one's burdens.
When Edward Wright visited the ducal collection at the Court of
Parma, he was shown as Raphael's original version Andrea del Sarto's
copy of the master's portrait of Leo X with his nephews. Being better
informed, he advised the keeper to admit in the future that it was only
a copy, and to stick to the story, for he had heard that "even Giulio
Romano could not distinguish [it] from the original, tho' he himself
had work'd in one part of it."[77]

The list of monuments, works of art, and curiosities of all kinds
urged upon the traveler was then, as now, so charged that it can
scarcely have been conducive to detached contemplation. Although
the inventory of notable works varies somewhat from writer to writer,
and the word "masterpiece" comes more freely to one than to
another, a certain consensus is present. Rome was the high point of
the journey and nothing on this parnassus surpassed the Pantheon,
St. Peter's, and Raphael's *Transfiguration*. Among the admired paint-
ings below this supreme *chef d'oeuvre*, Daniele da Volterra and
Domenichino's already mentioned works were joined for some
writers by Andrea Sacchi's *St. Romuald* in the church of the same
name.[78] Michelangelo's *Last Judgment* in the Sistine Chapel is cited as
his outstanding work, though often with some qualification for its "ex-
travagancies." His ceiling frescoes, on the other hand, receive dis-
tinctly less attention. Among the works of sculpture on view in the
city, the statues of the Ancients naturally occupy a large place. Bernini
incurred some censure for his departure from decorum but his *St.
Bibiana* (Fig. 43), together with Duquesnoy's *St. Susanna* in S. Maria di
Loreto, are cited as the best achievements of modern times.[79]

In Bologna, the works of the Carracci and their followers were
highly recommended. Agostino's *Communion of St. Jerome* in the Cer-
tosa was touted by the Bolognese as superior to Domenichino's cele-
brated treatment of the same subject in Rome. Parma was notable for
its Correggios, and the master's *Nativity* in the ducal collection en-
joyed the greatest fame (Fig. 44). Venice was the city of Titian's *Mar-
tyrdom of St. Peter Martyr* and *Virgin of the Steps*, generally recognized as
his greatest works, of Tintoretto's Scuola di San Rocco paintings and
of Veronese's *Marriage at Cana* (Fig. 45). More originally, Peacham

[77] Wright, *Observations*, II, 455. [78] Ibid., I, 251. [79] Ibid., I, 223, 252.

urged on his readers Gentile and Giovanni (?) Bellini's lost *Naval Battle* in the Great Chamber of the Council, "the only and most esteemed Peece in the world for Judgement in Art."[80] In nearby Padua, neither Giotto's Arena Chapel frescoes nor Donatello's Santo altar yet made much of an impression, but there was much admiration for the church of Santa Giustina, mistakenly thought to have been built by Palladio.[81] Leonardo was the major attraction of Milan, though the unsatisfactory state of preservation of the *Last Supper* led some travelers to remark that it could be seen to better advantage through copies elsewhere.[82] The treasures of the Ambrosiana are noted with interest. In the Duomo, whose Gothic style and unfinished state were deplored, there was a more surprising object of wonder in the *St. Bartholomew* carved shortly after 1562 by Marco d'Agrate (Fig. 46). The standing saint, whose painstakingly delineated musculature resembles that of an *écorché* from a medical textbook, initially decorated the cathedral's exterior, and was "esteemed an excellent Masterpiece."[83] In the second half of the seventeenth century, it was moved within the north transept of the church, and it was possibly at this time that the base was furbished with the flattering inscription: Non Me Praxiteles Sed Marcus Finxit Agratus. The work inspired a copious body of admiring comment and still made a strong impression on Mark Twain.[84] Much of its claim to the rank of *chef d'oeuvre*, however, rests on the sheer display of sinew, vein, and muscle bordering on the exhibitionistic. Cast in a superficially Michelangelesque mold, it flaunts the sculptor's virtuosity in the old-fashioned vein of late Medieval demonstration pieces. In time, the contradiction of values was to fatally compromise its reputation.

In Florence, the principal claim to the attention of the visitor was the collection of the Medici, known as the *Museo Fiorentino*, housed in Vasari's Uffizi. A guidebook of 1826 describes it as "the most famous, the richest and the largest collection for antique statuary, bronzes,

[80] Peacham, *Compleat Gentleman*, 137.

[81] Addison, *Remarks on Italy*, 384; R. Lassels, *An Italian Voyage, or a Compleat Journey through Italy*, London, 1698, II, 263; and Wright, *Observations*, I, 39. It is true that after 1579, Donatello's sculpture was no longer visible in its original setting.

[82] On its condition, multiple restorations, and copies, see E. Möller, *Das Abendmahl des Leonardo da Vinci*, Baden-Baden, 1952, 74ff.

[83] Evelyn, *Diary*, 249. On the work, see L. Price Anderson, "Marco d'Agrate's San Bartolommeo: An Introduction to Some Problems," *Il Duomo di Milano*, Congresso Internazionale, Milan, 1969, I, 189ff.

[84] M. Twain, *Innocents Abroad*, in *The Writings of Mark Twain*, I, New York and London, 1906, 229.

medals, precious paintings, not to mention other curiosities of nature and masterpieces of art."[85] The most outstanding of these had been congregated in the octagonal chamber or *Tribuna* built for this purpose by Bernardo Buontalenti between 1585 and 1589 (Fig. 47). The ancient statues, beginning with the *Medici Venus*, the *Satyr*, the *Wrestlers*, and the *Knife Grinder* were the most celebrated pieces of this vast ensemble.[86] For the Renaissance, the glories of the Florentine Quattrocento, which we hold in such high regard, were overshadowed by more recent works: Raphael again, Titian's *Venus of Urbino*, Correggio, the Bolognese. Siena, in this perspective, had less to offer. Its cathedral, though, seems to have been the most respected Gothic edifice in Italy. Addison wrote that "a man may view it with pleasure after he has seen St. Peter's, though it is quite of another make, and can only be looked upon as one of the masterpieces of Gothic architecture," and he speculated on what miracles of construction its builders might have accomplished had they been properly instructed.[87] A high point for many visitors was the historiated pavement of encrusted marble, a work carried out by a succession of Sienese masters between the fourteenth and the end of the sixteenth centuries.

A masterpiece was not only the most accomplished work of its kind, but one from which the guiding precepts of meritorious performance could be derived. The Président de Brosses speaks of Agrate's Bartholomew in half ironic terms as a "complete course in anatomy."[88] For Richard, Daniele da Volterra's *Massacre of the Innocents* in Florence "could be considered, for the number and variety of figures which it contained, a school of drawing."[89] In its perfection, the masterpiece becomes indistinguishable from Nature herself and possesses the same authoritative status. It is better to imitate a masterpiece than to sally forth on one's own. However, imitation, like fidelity to Nature, is by no means to be literal, or indeed always recommended. "Homer's poems," wrote Saint-Evremond, "will always be masterpieces, yet not models in all respects. They will form our judgment, and this judg-

[85] Richard, *Guide du voyageur en Italie*, Paris, 1826, 284.

[86] O. Millar, *Zoffany and His Tribuna*, London, 1966, 10-11; and D. Heikamp, "Zur Geschichte der Uffizien-Tribuna," *Zeitschrift für Kunstgeschichte*, XXVI, 1963, 193-268, and "La Tribuna degli Uffizi come era nel Cinquecento," *Antichità Viva*, III, 1964, no. 3, 11-30.

[87] Addison, *Remarks on Italy*, 498.

[88] C. de Brosses, *Lettres familières écrites d'Italie en 1739 et 1740*, Paris, 1836, I, 84.

[89] Richard, *Guide du voyageur*, 288.

ment will govern our present endeavors."[90] What the critic and practitioner hoped to discover was a body of rules comparable in its finality to that which was believed to have been validly legislated by Aristotle, Horace, and Boileau in the realm of poetry, and by others for music. Genius, perfection, and the mysterious but telling *je ne sais quoi*[91] impressed themselves readily enough upon the imagination, but only an understanding of true principle, the fruit of prolonged observation and reflection upon the greatest *chefs d'oeuvre*, would make possible a reasoned choice among the lessons taught by the best works of different styles and schools.

To look upon a work of art as a tool for instruction makes its assessment depend, beyond its intrinsic qualities, on what we think is its message, and what we believe the effect of this message upon the audience will be. When the idea of mastery was still measured in terms of technical excellence, the issue did not arise: skill and know-how are admirable in themselves and do not speak for this or that opinion. But if they are made to do so, what should we ask them to proclaim? The question will be answered in different ways and with the greatest urgency by those who are convinced that works of art are powerful instruments of persuasion. Diderot, with the erotic aspects of the rococo in mind, advised artists to remain within the bounds of decency, for anything which incited man to depravity would bring on its own destruction, the more surely so if its message was made more tempting by its formal perfection.[92] Rousseau's indictment of the corrupting pleasures of refined society inveighs in a similar way against the public exhibition, in gardens and galleries, of *chefs d'oeuvre* inspired by ancient mythology, which were for him so many incitements to vice.[93] Both authors hoped to promote virtue through works of art with subjects of an edifying nature, the former with greater confidence that this could be achieved than the latter. Rousseau was deeply moved by the Pont du Gard, which made him regret that he had not been born a Roman. He also recorded that the charms of Mme de Larnage, his mistress, seemed to him discredited by the monument, a

[90] Saint-Evremond, *Sur les poèmes des anciens*, in *Oeuvres complètes*, Amsterdam, 1726. See also on this and related ideas, R. Wittkower, "Imitation, Eclecticism and Genius," *Aspects of the Eighteenth Century*, ed. E. R. Wasserman, Baltimore, 1965, 143-61.

[91] S. H. Monk, "A Grace Beyond the Reach of Art," *Journal of the History of Ideas*, V, 1944, 131ff.

[92] Diderot, *Salon of 1767*, in J. Seznec and J. Adhémar, *Salons*, III, Oxford, 1963, 198.

[93] J.-J. Rousseau, *Discours sur les sciences et les arts* (1750), in *Oeuvres complètes*, III, ed. B. Gagnebin and M. Reymond, Bibliothèque de la Pléiade, Paris, 1964, 25.

disconcerting price to have to pay for the gain in good judgment, but one consistent with his high opinion of the power of art.[94] In Venice, a short time later, the same experience was repeated, with much more dramatic results, in Rousseau's encounter with the beautiful courtesan Zulietta. "A masterpiece of nature and of love," he thought her, though he was soon overcome with melancholic thoughts over the low moral estate into which this beauty had fallen. Although, thanks to Zulietta's tact, he was able to overcome these scruples, he suffered another debilitating blow just as his passion was on the point of being requited: one of her breasts appeared to him to differ from the other, and this small imperfection set off another chain of morose self-questioning. This time, the exasperated *chef d'oeuvre*, to whom he had the ill grace to mention the cause of his concern, gave him this advice: "Zanetto, lascia le donne e studia la matematica."[95]

[94] *Confessions,* in *Oeuvres complètes*, I, Paris, 1959, 256.
[95] Ibid., 321-22.

VII

THE ABSOLUTE
MASTERPIECE

In Honoré de Balzac's novella *Le chef d'oeuvre inconnu* (1837), the concept of masterpiece is seen in a new light, inaugurating its still current, and perhaps final reincarnation.[1] The story is cast in early seventeenth-century Paris, in a setting of ateliers and artists' shoptalk. Although Balzac's characterization of the historical background is sketchy at best and not free from inconsistency, the time of the action is significant: Raphael and Titian have spoken in their unforgettable ways. Mabuse, who is presented to the reader as the teacher of the chief protagonist, the obsessed genius Frenhofer, has transcended perfection itself and shown the way to endow his creations with the very illusion of life. The weight of these achievements hangs heavily on everyone. The painter Porbus is an accomplished and respected figure who, in Frenhofer's eye, has sought to come to terms with the best examples of both northern and Italian Schools. His *St. Mary of Egypt*, destined for the Queen of France, is regarded by all as a masterpiece. However, for Frenhofer, it is flawed and lifeless. For all its qualities, there is a profound chasm between a performance of irreproachable excellence, sanctioned by general and public recognition, and the highest realm of art. Only the initiated few can hope to gain an insight into this uncharted area. Porbus' failing is not some error in taste or judgment. It is to have been a "mere" imitator of nature, not a poet. When Frenhofer borrows his palette to rectify the shortcomings of the painting, it is not to make any fundamental alterations in the drawing and composition. A few miraculously well-placed strokes of

[1] H. de Balzac, *Le chef d'oeuvre inconnu*, Paris, 1837. On the genesis, sources, and significance of the work, see P. Laubriet, *Un catéchisme esthétique: Le chef d'oeuvre inconnu de Balzac*, Paris, 1961; and A. Timar, "Le chef d'oeuvre inconnu: Krisenzeichen der klassischen Malerei in einer Novelle von Balzac," *Acta Historiae Artium*, XVII, 1971, 91-101.

the brush, delivered with an inspired urgency, suffice. Porbus himself, and the young Nicolas Poussin, just before a fervent admirer of the *St. Mary of Egypt* in its first state, are utterly won over to its transformation.

Frenhofer himself, whose least effort is taken by Poussin for a Giorgione, is at work on his *Catherine Lescault*, or *Belle Noiseuse*. It is a painting of a reclining woman framed by curtains, a subject reminiscent of Titian, on which the aging master in secrecy and for some ten years, has lavished every treasure of his unrivaled talent. When it is at last revealed, it turns out to be both a triumph and a failure. The canvas is covered only with "a confusing mass of colors contained by a multitude of lines which form a barrier of paint." But in a corner of this "chaos of hues, of indecisive nuances, a kind of fog without shape," part of a foot, of indescribable beauty, emerges. The *Belle Noiseuse* is a demonstration of the boundless possibilities of art, but also of its limitations. Frenhofer is compelled by forces larger than himself into a struggle to defeat these limitations, but this at the inevitable cost of self-delusion or madness. Porbus and Poussin's more settled artistic vision can only make them harsh judges of the old painter's wild daubings. Yet the fleeting glimpse into the miraculous afforded to them by the painting is an implicit devaluation of their own best efforts.

Frenhofer's relationship with his work was modeled by Balzac on the story of Pygmalion. The painter refuses to show his canvas as he would not exhibit to foreign eyes his own spouse. However, his passion for the Galatea of his own creation is of a less innocent, more problematic nature than in the ancient myth. Frenhofer's jealousy— he is prepared to kill anyone who would sully his *Belle Noiseuse* with so much as a glance—is that of a lover who is at heart unsure of his powers. On a narrative level, he is after all an old man, not an ardent youth. But the dreaded profanation of the beloved is rather a metaphor for the uncomprehending gaze, the "cold look and stupid criticism of the imbeciles." Challenged in his vision and confounded by the less illusory beauty of Poussin's mistress Gillette, Frenhofer dies in a half suicide, half *Liebestod*.

In Balzac's account, Frenhofer's dedication to the elaboration of his *chef d'oeuvre* is presented as a mysterious but irresistible imperative. The old master has evidently painted works of a more conventional sort, capable of commanding the greatest respect. His position seems socially and materially secure. The *Belle Noiseuse* is thus made to appear as a wholly irrational venture, and this all the more since the ef-

fort to imbue the figure of Catherine with life is necessarily doomed to failure. Pygmalion's creation is also the creation of a Dedalus. The tragic resolution of the story is made inevitable not by some shortcoming of the painter in his craft, but by the force which compels him into striving for the absolute. Through his long communion with the ideal, the artist may be won over to "the unknown sphere of things which do not exist," and lose touch with the world of sounds and sensations. There is a measure of apprehension here for his seduction by metaphysical speculation and the debilitating mixture of unmanageable expectations and corrosive self-questioning which such an engagement with the infinite can engender in the creative spirit. Yet such is the fate, Balzac seems to say, of the quest for lasting significance, the price that must be paid if the artist is to assume his true vocation.

Emile Zola's L'oeuvre (1885) is one of several novels built around artists' lives more or less directly inspired by Balzac's story.[2] Claude Lantier, the unhappy hero of the work, similarly seeks to surpass himself in a great painting and is driven to despair and a miserable death. The idea for the painting impresses itself on Lantier in an ecstatic vision from a bridge over the Seine. It is to be a view of the heart of Paris, with a river in the middle, the Ile-de-la-Cité in the background, and the bustle of laborers on the quays along the banks. The painter, already in desperate financial straits, leases a hangar in Montmartre in order to accommodate the enormous canvas, which measures some twenty-four by fifteen feet. The rift between himself and Christine, his wife, begins almost immediately, for she has sensed that already on the bridge in the midst of his vision, "he had forgotten her, as if she had ceased to be his." Christine's struggle for the soul of her husband is soon made more acute by Lantier's decision, against the claims of verisimilitude, to introduce a group of three female bathers in the middle of the composition. She must now pose for the nude figure among these, and experience the contradictory torments of assisting her husband in the invention of her rival. After a promising start, the painting becomes progressively more labored and incoherent. The grueling effort of creation, the fashioning of flesh and its infusion with the breath of life, "the impossible task of encompassing nature in its entirety on a canvas" without demeaning tricks and compromises,

[2] E. Zola, L'oeuvre, Paris, 1885. On the work, see R. Niess, Zola, Cézanne and Manet, Ann Arbor, 1968. Chef d'oeuvre occurs among the titles which Zola considered for the novel. See the notes of the edition in Les Rougon-Macquart, IV, ed. H. Mitterand, Bibliothèque de la Pléiade, Paris, 1966, 1338.

take their toll. Five years of toil, punctuated by frenzied triumphs and bouts of discouragement wring from the painter the terrible words: "It will kill me and it will kill my wife, my child and everything around me, but it will be a masterpiece, by God." Five more years, reduced to the most appalling misery and his child indeed now dead, Lantier is forced to recognize that he will never be able to bring the work to completion. Soon thereafter, he ends his life.[3]

Although the frustrations of Frenhofer and Lantier alike stem from their inability to realize what they perceive to be the highest demands of art, they are different men confronted by different problems. Unlike Balzac's hero, who cannot succeed because he takes on an inherently impossible task, Lantier's difficulties lie within the frontiers of the feasible. His *chef d'oeuvre*, however ambitious or ill-advised an undertaking it might seem, is to be a work of art in the accepted sense of the word. The painter's struggle to lend life to his figures has here an entirely formal and psychological dimension. If Lantier's troubles seem thus more manageable, he is on the other hand a far less assured performer than Frenhofer, beset as he is by stress and deeply rooted incapacities. Beyond these factors, the artistic situation in which the men found themselves, and hence their understanding of what the supreme masterpiece should be, had undergone dramatic changes in the fifty years separating the two stories. Balzac's Frenhofer takes it for granted that the best that is humanly possible has already been done by the great masters of the past. The choices open to the artist are thus limited.[4] He may through ability, intelligence, and discrimination come close to equaling these brilliant antecedents. The alternative—Frenhofer's—is a quantum leap into an altogether different realm, the only true challenge remaining, whatever the risks. In Zola's novel, the ground of tradition is much less distinctly sketched. Lantier's horizons are defined by the varied directions of French painting in the third quarter of the nineteenth century: the fashionable superficialities of the Salons, Impressionism, the forthright realism represented by the Courbet-like figure of Bon-

[3] It might be asked whether the theme of Lantier's painting is not distantly reflected in Robert Delaunay's *La ville de Paris* of 1912. On this work, see M. Hoog, " 'La ville de Paris' de Robert Delaunay: Sources et développement," *Revue du Louvre*, 1965, 29-38.

[4] The problem of the artist's consciousness of his "lateness" is discussed by W. J. Bate, *The Burden of the Past and the English Poet*, Cambridge, 1970; and H. Bloom, *The Anxiety of Influence: A Theory of Poetry*, New York, 1973. In his essay "Poetry, Revisionism and Repression," *Critical Inquiry*, II, no. 2, 1975, 235, Professor Bloom cites and discusses the argument of Giambattista Vico that "great masterpieces of anterior art must be destroyed, if any great works are still to be performed."

grand. There are no really towering models in sight, and the painter's exertions are therefore journeys to a vast and as yet unmapped territory. On his way, he can expect to be derided or entirely ignored by the public. Fellow artists with their own convictions or vested interests to defend are even less understanding, while the more benign of their number gently pillage his discoveries and earn undeserved reputations by retailing insipid versions of them to the crowd. Only at some distance is it noted that the seed has borne fruit, that the course of painting has been altered at some fundamental level through his example.

Students of *L'oeuvre* have understandably found it tempting to see in the tragic unfolding of Lantier's career an attack on the most advanced artistic developments of the time, and particularly on Cézanne, whose personality seems to be reflected in the tragic hero of the novel. But Zola is not primarily interested in Lantier's painting as an art critic. Much more, the *chef d'oeuvre* is for him a significant biographical event, one of those incidents in a creative life which puts character to the highest test and throws into relief its hidden springs in their psychological and social dimensions. In the outline sketch (*ébauche*) for the novel, he lists within the gallery of artists who are to figure in the story "the author who, after a masterpiece, struggles to live up to his name," and he reminds himself "to put in the background a personage of enormous vanity, always pleased with himself, convinced of his masterpiece, living in quasi-divine complacency."[5] Zola's artists carry within them on a permanent basis a painful awareness of their fragile position in regard to the absolute claims of art. If they have ascended to their Everest, they cannot innocently return to lesser peaks. The fact of having scaled the heights nevertheless procures them a measure of respect which is denied to the timid and to those who have purchased success on easier terms.

In Zola's novel, the revelation of mastery is bound up with the always unpredictable reactions of critics and the public. In the eighteenth century, and still in Balzac's story, the *chef d'oeuvre* is recognized for what it is by all well-meaning persons. Public acclaim is noted, but it functions more as an endorsement of what is taken to be already beyond discussion than as evidence for what still needs to be established. In Lantier's career, on the other hand, the margin between greatness and oblivion is, beyond the merit of his own accomplishments, dependent on the happy outcome of petty transactions that lie

[5] *Rougon-Macquart*, 1355-56.

outside of his control. His work must first be admitted to the Salon, for exclusion from this all-important exhibition denies to him the chance to make his work known and to obtain commissions which would enable him to persevere in his chosen path. As Zola clearly indicates, the selection procedure is scarcely a model of judiciousness and seems indeed to have been designed to exclude any effort of originality. If the painting has been accepted, it may still be radically devalued, even in the painter's own eyes, by being badly hung.[6] Here, too, it is made to appear that the artist cannot expect much intelligence from those in charge. What Zola reports of the atmosphere which prevails at the exhibition is further calculated to dramatize the difference between true standards and what passes for such in the eyes of the visitors. Their inept and cruel comments for what does not flatter their own shallow tastes must make us doubt that any competent judgment could be rendered by them.

In spite of the wall of incomprehension which the serious artist must face, a favorable verdict of public opinion remains for Zola a positive factor in the ultimate assessment of the work. Looking at paintings side by side on the walls of the Salon and seeing how one stands out triumphantly while the weaknesses of another are exposed beyond appeal is for him an experience that does not lie. The excited movement of the crowds at the exhibition, the mysterious attraction exercised by one entry in preference to another, the outpouring here and there of comments, uninformed or ill-focused as they may be, are treated by him as data as worthy of attention as the work of art itself. The plea of Lantier's friend Sandoz, in whom the author probably meant to portray himself, that the painter clothe the nude figure in his view of Paris, acknowledges the same assumption. Although Sandoz's fear that the public will not accept this apparent slight to pictorial convention is well meant in that it is designed to spare Lantier from a humiliating rejection, there is no doubt that he is also personally convinced that in this instance, the painter has "gone too far."

The large body of nineteenth-century fiction concerned with artists' lives touches repeatedly on these themes.[7] There is the demon of over-deliberation. The Old Masters seemed to have allied thought

[6] On the damaging effect of poor hanging as in a number of other details, Zola's account resembles the story of Géricault's *Raft of the Medusa*, found in Charles Clément's biography of 1867 (*Géricault: Etude biographique et critique*, ed. L. Eitner, reprint, Da Capo Press, New York, 1974, 148).

[7] A catalogue of works and themes is given by Th. Bowie, *The Painter in French Fiction*, Chapel Hill, N.C., 1950.

and action in an unself-conscious way. The new men are half para-
lyzed by their grand yearnings for the ideal or else feel themselves
drawn into calculating accommodations which prove no more reward-
ing. The easy and apparently self-evident authority possessed by
Raphael and Titian's masterpieces seems no longer attainable. The
acclaim which was rightly theirs and freely granted them must now be
purchased at the cost of ignoble compromises. To give the most po-
tent exhibition of itself, mastery must take the measure of overwhelm-
ing rivals or persuade us that it is the standard of some entirely new
order of value. Theobald, the hero of Henry James' short story "The
Madonna of the Future," sets his sights on Raphael's *Madonna della
Sedia*, which he regards as a perfect work.[8] Lantier's project is reso-
lutely "modern" in its orientation, beginning with an ambitious foray
along the advanced lines of the contemporary artistic front and pro-
gressing in successive stages into the critical no man's land beyond.
Looking forward or to the past, both strategies seek to allay a funda-
mental anxiety about the normative basis of esthetic judgment. The
conviction that masterpieces beyond challenge exist, that striving to
bring them into being is the highest goal that an artist can set for him-
self, is allied to gnawing doubts that the effort can have a finite and
irrefutable end. The loss of assurance is often accompanied, as a kind
of compensation, by an insistence on the psychological effect wrought
by great works, their capacity like the old icons to generate extraordi-
nary sensations or transformations of the personality. In Gogol's
short story "The Portrait," the painter Chartkov, who has taken the
easy road to worldly success, falls under the spell of a picture which he
has purchased and is eventually driven insane by its accusatory pres-
ence. The impression made by Holbein's *Dead Christ* upon Dostoevski
and the mysterious aura of the *Mona Lisa* noted by many nineteenth-
century viewers easily convince us that they can be no ordinary paint-
ings whose place in the hierarchy of merit must be decided by a
laborious exercise of evaluation hedged by uncertainty.[9]

The most explicit symbol of the heroic striving for greatness in this
Romantic fiction is the *non finito* to which these efforts are con-

[8] H. James, "The Madonna of the Future," originally published in the *Atlantic
Monthly* in 1873, is reprinted in *Stories of Writers and Artists*, ed. F. O. Matthiessen, New
York, 1944. On the work, see Laubriet, *Catéchisme esthétique*, 154ff.

[9] N. Gogol, *The Portrait*, in *The Collected Tales and Plays of Nikolai Gogol*, ed. L. J. Kent,
New York, 1964, 510-61. On the *Mona Lisa* in the nineteenth century, see R. MacMul-
len, *Mona Lisa: The Picture and the Myth*, Boston, 1975, 163ff.; and earlier, G. Boas, "The
Mona Lisa in the History of Taste," *Journal of the History of Ideas*, I, 1940, 207-24.

demned.[10] As it does not for Michelangelo or Rodin's sublime figures struggling for liberation or completeness, the unfinished here carries the burden of failure. It is not truly an intermediary state between a beginning and an end but a moment past the point when the work of art could have been brought to perfection. It is unfinished and at the same time already overworked. Yet this condition is not easily avoidable since every final gesture is at once an act of renunciation, and ever renewed effort is the artist's only chance to reach his goal.[11] Death, thus, is the inevitable partner in this symbolic representation, since it can be the only dignified end to this ceaseless travail.

This dark vision of the prospects of the moment has a nostalgic pendant in the picture of mastery in radiant former days. The backward glance into the studios of the Renaissance masters showed a world whose harmony was as yet undisturbed. It was a comforting theme, congenial to a history painting of timid heroics and unadventurous piety. In A. Brune-Pagès' *Leonardo Painting the Mona Lisa* (1845), the artist stands before the completed work, which is contemplated with rapt admiration by, Luca Pacioli and Giorgio Vasari (Fig. 48). The visit of a princely patron in such distressingly respectable productions as E. Gelli's *Charles I in the Studio of Vandyke* or A. A. Lesrel's *Flemish Notables Visiting the Studio of Rembrandt* conveys the impression of a religious pilgrimage.[12] We are transported back to the scene of the miracle by an exercise in style which is at the same time a manifesto. Through the calculated appropriation of the conventions of older art, the event is made tangible and endowed with appropriate solemnity. Yet the same means make equally plain the distance which separates us from it.

The spatial and temporal geography of this time not yet out of joint was dominated by the Age of the Masters, those brief decades around

[10] See the collection of essays edited by J. A. Schmoll gen. Eisenwerth, *Das Unvollendete als künstlerische Form*, Bern and Munich, 1959.

[11] Paul Valéry remarked in regard to Degas: "Je crois bien qu'il pensait qu'une oeuvre ne peut jamais être dite achevée." And in another context, he declares: "Le désir de créer quelque ouvrage ou paraisse plus de puissance ou de perfection que nous n'en trouvons en nous mêmes, éloigne indéfiniment de nous cet objet qui échappe et s'oppose à chacun de nos instants. Chacun de nos progrès l'embellit et l'éloigne." (M. Bémol, "L'inachevé et achevé dans l'esthétique de Paul Valéry," in *Das unvollendete als künstlerische Form*, 155ff.)

[12] Paintings devoted to this theme are listed by R. Huyghe and H. and J. Adhémar (*Courbet, l'atelier du peintre: Allegorie réelle*, Monographie des peintres du Musée du Louvre, III, Paris, 1944, 20-21) and are treated in various discussions of Courbet's *Studio*. For the religious dimension, see F. Württemberger, "Das Maleratelier als Kulturraum im 19. Jahrhundert," *Miscellanea Bibliothecae Hertzianae*, Munich, 1960, 502-13.

1500 when in Italy art stood at its most exalted level and masterpieces of a quality never again equaled were brought forth. Nineteenth-century histories of art salute this peak in nearly obligatory fashion and are no longer constrained, as their predecessors had been, to a show of loyalty toward the Ancient past.[13] But Ruskin's championship of the second half of the Quattrocento signaled a new summit in Botticelli, Mantegna, Carpaccio, and their most brilliant contemporaries.[14] Rembrandt and Rubens, Dürer and Holbein, Guido Reni and Murillo, had their own partisans, extending further the frontiers of the promised land. Beyond individual preferences, there was an all-embracing category to which artists of the Renaissance to the period before 1700 belonged: the Old Masters. It called to mind a settled order of value and genre, an unmistakable "look" or timbre completely distinct from the flourishes and parades of the present. Austin Dobson found it in an old Gothic manuscript:

> Then a book was still a Book
> Where a wistful man might look,
> Finding something through the whole
> Beating,—like a human soul.
>
> In that growth of day by day,
> When to labor was to pray,
> Surely something vital passed
> To the patient page at last;
>
> Something that one still perceives
> Vaguely present in the leaves;
> Something from the worker lent;
> Something mute—but eloquent![15]

[13] J. Ruskin, "Verona and Its Rivers" (1870), in *The Works of John Ruskin*, ed. E. T. Cook and A. Wedderburn, London, 1905, XIX, 442ff.: "Perfect. It is a strong word. It is also a *true* one. The doing of these fifty years is unaccusably Right, as art. . . . As art . . . it admits no conception of anything better." The expression "Age of the Masters" is found in the same essay, p. 443. In his *Handbuch der Geschichte der Malerei seit Constantin dem Grossen*, Berlin, 1837, I, 491, Franz Kugler similarly remarks about this moment of the Italian Renaissance that "in edelster Form, mit tiefsinnigster Auffassung sehen wir die würdigsten Gegenstände in den Meisterwerken dieser neuen Periode dargestellt, wie es die Folgezeit bis jetzt noch nicht wieder erreicht hat."

[14] J. Ruskin, *Modern Painters*, II (*Works*, IV). In 1845, Ruskin noted: "Raphael and Michelangelo were great fellows, but from all that I can see they have been the ruin of art" (p. xxxii). On the background of this conversion, see J. Evans, *John Ruskin*, New York, 1954, 96ff.

[15] "To a Missal of the Thirteenth Century," in *The Complete Works of Austin Dobson*, Oxford, 1923, 170-71.

Writing in 1699, Florent Le Comte explained that the expression "vieux maistres" was used to describe the German engravers of the fifteenth and sixteenth centuries who were generally known otherwise only through their monograms.[16] Their quality as "old" masters was defined by their anonymity and by their comparatively archaic art—Le Comte spoke of "estampes gothiques"—these two characteristics understood as being naturally linked. Something of this notion survived into later usage. Unlike their predecessors at the summit of artistic achievement, the Old Masters were not in the first instance men of individual distinction, but a vast collectivity comprising artists of widely different outlook and ability. By the middle of the nineteenth century, they had grown to even more imposing numbers as movements, tendencies—the slow upward curve reaching from the Tuscan Dugento to Raphael and downward again through erratic permutations—lost their earlier vehement contours and came to be perceived as possessing an underlying unity. But, unlike the *vieux maîtres*, the Old Masters were painters first and foremost, and it is the fate of this branch of art on which their mellow surfaces and stately rhetoric most directly impinged. It was painting that the likes of Theobald, Lantier, and Frenhofer had elected as the theater of their combat, and here that the central energies of modernism would be engaged.[17]

[16] F. Le Comte, *Cabinet des singularitez d'architecture, peinture, sculpture et graveure*, Paris, 1699, I, 160-61. P. Levieil, *L'art de la peinture sur verre et de la vitrerie*, Paris, 1774, 160ff., also speaks of the Old Masters as active in a time when works of art were not signed. In the sixth volume of his *Le peintre graveur*, Vienna, 1803, devoted to *Vieux maîtres allemands*, A. Bartsch proposes to describe with this expression "tous les artistes qui ont vécu depuis l'origine de la gravure jusqu'à la fin du seizième siècle." The history of the English term "Old Masters" requires further investigation. In the translation of L. Lanzi's *History of Painting in Italy*, London, 1828, the earliest painters of various schools, most of them anonymous figures of the Dugento and Trecento, are called Old Masters. The more comprehensive definition with which we are concerned is found in Ruskin's *Modern Painters* (*Works*, III, 84) and is broadly vulgarized in such titles as C. Fallet's *The Old Masters: The Princes of Art*, Boston, 1870, or S. Tytler (Mrs. Keddie), *The Old Masters and Their Pictures*, Boston, 1874. On the nineteenth-century interest in the Old Masters generally, see F. Haskell, *Rediscoveries in Art: Some Aspects of Taste, Fashion and Collecting in England and France*, Ithaca, 1970, 71ff., and "The Old Masters in 19th Century French Painting," *Art Quarterly*, 1971, 55-85.

[17] In his critical writings, Clement Greenberg has shown how the consciousness of Old Master qualities has shaped certain aspects of contemporary painting (see his *Art and Culture*, Boston, 1965, 41ff., and passim). The special significance of painting on the present scene has been stressed by Hilton Kramer, "The Return of 'Handmade' Painting," in *The Age of the Avant-Garde*, New York, 1973, 543-45, and elsewhere in his perceptive writings. See on this subject also the discussion "Painters Reply . . . ," *Artforum*,

There was much speculation on the causes of the present predicament. At the most practical level, the special qualities of Old Master paintings hinted at a knowledge of techniques and recipes, now lost, which might yet be recovered through a study of old texts and workshop methods. Yet the dimensions of the problem suggested a larger crisis. The old masterpieces had often been inspired by religious subjects, but even where this was not the case, they seemed to nineteenth-century observers to be suffused with a religious aura. Did these intimations of the spiritual not reflect a more elevated social order? For many, the Reformation was the chief villain for the descent from the peaks of greatness because of its more or less pronounced antagonism toward images. G. F. Waagen, with remarkably suggestive arguments, pointed instead to the invention of printing. Before Gutenberg, he maintained, pictures were the chief vehicle for general instruction and the edification of the spirit. Afterward, this role was assumed by the printed word, and the artist was relegated to a marginal situation.[18] This yoke imposed upon him by history is a theme on which Delacroix meditated at length in his *Journal*. Like many of his contemporaries, he subscribed to the view that the sixteenth century had marked the highest standards attainable in every branch of art. Since then, all creative labor stood in the shadow of decadence. The modern painter, he remarks, has no palatial spaces at his disposal, no generous patron for whom great works of art were a source of intense pride, no enlightened and munificent merchant corporations which might enlist his services. Worse, the times encourage mediocrity, favor practical knowledge, brutalize the imagination. There is only a single moment in the course of civilization when it is given to human intelligence to show itself in all its force, and in a lesser time, talent and genius alike are devalued.[19]

True masterpieces, it was discovered, are always in danger of being

September 1973, 26ff.; and the essay by A. Forge, "Painting and the Struggle for the Whole Self," in the same issue 45-49.

[18] G. F. Waagen, *Kunstwerke und Künstler in Paris*, Berlin, 1839, II, 10ff. Much the same "McLuhanesque" argument was made in Victor Hugo's *Notre-Dame de Paris* in the aphorism "Ceci tuera cela": the printed Bible will kill Medieval architecture, the Bible of Stone.

[19] E. Delacroix, *Journal*, ed. A. Joubin, Paris, 1932, III, 2ff. and 20, where under the heading "Décadence" he remarks that the arts have been in decline since the sixteenth century, "point de la perfection." Elsewhere (II, 288), Delacroix quotes Chenavard's remark that "les talents valent moins dans un temps qui ne vaut guère." On Delacroix's ideas, see G. Mras, *Eugene Delacroix's Theory of Art*, Princeton, 1965. The *Journal* spans the years 1822-63.

ignored and an enticing show of brilliance celebrated in their place. Delacroix attributed this curious phenomenon to the blinding effect of fashion, which offers us the comforts of a spurious contemporaneity. The true masterpiece appears strange at first because it challenges the accepted pieties. Yet the ability to distinguish the genuine from the counterfeit, the permanent from the ephemeral, is not, as it was for Voltaire and the eighteenth century, a thing subject to amelioration. It is presented as a basic infirmity, symptomatic of the time's ills, which is made all the more flagrant by well-meaning attempts to circumvent it. A masterpiece should not strive too hard to look like one. It must declare itself in an inescapable way, yet avoid those trappings which would confirm its identity and just as surely mislead us. We must look to history to redress the correct order of value, which, as Delacroix felt, it has rarely failed to do. In this scenario, the great artists figure as the unjustly persecuted, whose reward will be admission into immortality. Their belated recognition achieves a kind of restoration of all things to their true state.[20]

This mood of lofty resignation is effectively countered in those of Delacroix's utterances which are a more personal product of his sensibility. The case of Rubens was particularly striking since, though born in a period of "relative decadence," he had shown himself to be fully the equal of the masters of the Italian High Renaissance. To have been Rubens in his time or to be Rubens in our own is more remarkable than to have achieved this feat in the age of Raphael and Michelangelo, since the latter role would have been enacted as part of a crowd, while playing the former was to shine all alone. In a later and even more unpropitious epoch, Gros, David, Prud'hon, Géricault, and Charlet have shown themselves to be as deserving of admiration as Raphael, Titian, and their kind. Delacroix himself—no doubt drawn

[20] *Journal*, II, 430-31. These sentiments occur in an article, "Sur les chefs d'oeuvre," which Delacroix intended as an entry in a projected *Dictionnaire des Beaux-Arts*. Delacroix also copied in his *Journal* (III, 263) a passage from an article by L. Vitet, *Pindare et l'art grec*, published in 1860, where this author, commenting on the effect of the discovery of the Parthenon marbles and the Venus de Milo, wrote with affecting eloquence that masterpieces "nous prennent au dépourvu, nous troublent dans la routine de nos admirations; puis bientôt leur ascendant triomphe, ils s'emparent de nous et tournent à leur profit notre penchant à l'habitude; alors, ils nous font voir sous un aspect nouveau, ils font descendre à un rang secondaire tout ce qui régnait avant eux." Ingres, in the same vein, remarked: "Les chefs d'oeuvres ne sont pas faits pour éblouir. Ils sont faits pour persuader, pour convaincre, pour entrer en nous par les pores" (P. du Colombier, *Les plus beaux écrits des grands artistes*, Paris, 1946, 225).

to the part of the Antwerp Master—has done some things, he feels, that would not be despised by these titans.[21]

Delacroix's strong interest in music furnished him with additional substance for reflection on the relation of talent, history, and the *chef d'oeuvre*. Music was especially pertinent to these concerns since its development as it was understood in the painter's time had just passed the point marked by art at the end of the High Renaissance. Indeed, the comparison of Mozart and Raphael was a commonplace. In the composers of the generation after Mozart who were roughly Delacroix's contemporaries, one could hope to study *in vivo* the odyssey of an art just after the summit had been reached. In music as in painting, Delacroix was critical of direct imitation, which always perpetuated the most conventional aspects of a master's work, as well as its most superficial mannerisms. Rossini's ornaments and *fiorituras*, a weakness in this otherwise genial composer, make the music of his followers unbearable. Beethoven, Weber, and Rossini illustrated in Delacroix's comments the ambivalence but also the opportunities of the modern position. Mozart is superior to all in his complete formal perfection, but for this reason he is less arresting than his successors and does not convey the same suggestion of contemporaneity. As in the case of Rubens, lapses in judgment and other irregularities, to be deplored in themselves, are redeemed by their contribution to the total effect. Although it is possible to read more into them than the author may have intended, finally, certain remarks on the sensual immediacy of music and on what he regarded as its objective, internally structured order seem to prophesy the masterpieces of a later time.[22]

What one hoped to uncover was a modern approximation of past greatness: the gesture, condemned to remain elusive, which the Old Masters would have performed had they been alive today. Fromentin, stimulated by the great Dutch paintings of the seventeenth century,

[21] *Journal*, II, 248 and 288: "Ce que j'aurais été au temps de Raphael, je le suis aujourd'hui. Ce qu'est Chenavard aujourd'hui, c'est-à-dire ébloui par le gigantesque de Michelange, il l'eut été, à coup sur, de son temps. Rubens est tout aussi Rubens pour être venu cent ans plus tard que les immortels d'Italie: si quelqu'un est Rubens aujourd'hui ou tout autre, il ne l'est que davantage. Il orne son siècle à lui tout seul, au lieu de contribuer à son éclat en compagnie d'autre talents." Similar sentiments appear in Baudelaire's *Salon de 1859* (*Oeuvres*, ed. Y. Le Dantec, Bibliothèque de la Pléiade, Paris, 1956, 786).

[22] Delacroix, *Journal*, II, 25, 156, and III, 60. On Delacroix and music, see E. Locspeiser, *Music and Painting: A Study in Comparative Ideas from Turner to Schoenberg*, New York, 1973, 37ff.

formulated these aims in lucidly paradoxical fashion: "[Let us] make a beautiful work which contains all of ancient art though with a modern spirit, which embodies the nineteenth century and France, resembles a Metsu line for line, yet does not reveal that this is what was intended."[23] The new masterpieces envisioned in this program were to be active participants in the process of collective self-definition. They would speak in the voice of one's time and in the language of a place, seeking to reach the universal through the essence of the particular. New Schools would take their place beside those of the history books, giving expression to the singularity of personal vision, of local and national character as yet unspoken for. Not the normative but the unique was enjoined as the supreme goal.[24] Fromentin's latter-day Metsu would be a *chef d'école*, a proper subject for an *hommage* or *tombeau* (Fig. 49), wherein, like the ancestral head in a family picture, his symbolic presence would preside over a large and respectful company.[25]

Of the Schools whose existence was bound up with national destiny, the Greek, the Italian, and the Dutch were thought to possess the greatest (and most enviable) degree of specificity. In Holland, as Fromentin sensitively observed, the premises of an original art, the image of a practical, austere, and civic-minded people, were apparent at the beginning of the seventeenth century. English art was revealing a powerful individuality of its own, but many countries which were asserting their national consciousness had not yet generated an authentic expression of their particular nature. There was intense speculation about the conditions which helped to promote the flowering of native genius. On this point, the lessons of the past were ambiguous. The stupendous enterprises of the Roman emperors or of

[23] E. Fromentin, *Les maîtres d'autrefois*, Paris, 1898, 241, a passage also noted by M. Schapiro in his introduction to an English edition of Fromentin, *Lives of the Old Masters*, New York, 1963, xxxiii. In an entry of his *Journal*, Delacroix similarly wonders (II, 218), "Ce qu'auraient été Raphael et Michelange à notre époque." Stendhal derides painters who ask, "Qu'eut fait Raphael à ma place?" (*Du Romantisme dans les arts*, ed. J. Starzynski, Paris, 1966, 82).

[24] H. Osborne, *Aesthetic and Art Theory*, London, 1968, 132-33. See also the critical remarks of H. W. Janson in the symposium volume *Art and Philosophy*, ed. S. Hook, New York, 1966, 24-31.

[25] S. Gohr, *Der Kult des Künstlers und der Kunst im 19. Jahrhundert: Zum Bildtypus des Hommage*, Vienna and Cologne, 1976. The *tombeau* began as a sixteenth-century poetic genre of posthumous praise. It has more recently been illustrated by Ravel's *Tombeau de Couperin* and Dufy's drawing, *Le Tombeau de Debussy* (reproduced in E. Lockspeiser, *Debussy: His Life and Mind*, London, 1962-65, II, 210).

Louis XIV argued for the beneficial effects of autocratic rule, but Athens, Florence, and Antwerp, as Charles Blanc noted, had been republics in their time of greatness.[26] Was it the strength of faith which gave us the cathedrals or the stirrings of the critical spirit in the Medieval towns? The advantages of a country's long cultivation of the arts at their most refined were weighed against those of inexperience and naiveté.

Among the newer nations, America's prospects excited high hopes, for it was untouched by the decadence of the Old World and would fulfill, as Berkeley had prophesied in his famous verses, the old imperial dream of westward renewal.[27] The beginnings were more prosaic. The masterpieces recognized in the new land were long to be those of the old. John Smibert, who established himself in Boston in 1728, brought over casts of antiques, engravings, and copies of such works as Raphael's *Madonna della Sedia*, Poussin's *Continence of Scipio*, and Van Dyck's *Portrait of Cardinal Bentivoglio*, the latter in turn copied by Washington Allston and John Trumbull.[28] Governor James Hamilton's collection boasted a *St. Ignatius* by Murillo, and Charles Willson Peale, in what the first historian of American art, William Dunlap, called "a dangerous and foolish experiment" piously named his children Raphael, Angelica Kaufmann, Rembrandt, Titian, and Rubens.[29] The tragic drama of the artist's overwhelming effort yet ultimate frustration in seeking to rival the most ambitious achievements of the past was enacted on these shores, too, in Allston's *Belshazzar's Feast*, left unfinished at the painter's death in 1843 after some twenty-five years of intermittent labor (Fig. 50).[30] A generation later, James Jackson Jarves could still call it "the greatest, best composed and most difficult painting yet attempted by an American artist. . . .

[26] C. Blanc, *Les artistes de mon temps*, Paris, 1876, 412; and E. Chesneau, *Les nations rivales dans l'art*, Paris, 1868.

[27] On this and other hopes for artistic greatness in America, see N. Harris, *The Artist in American Society: The Formative Years, 1790-1860*, New York, 1966, 52 and 177ff.; and F. Kermode, *The Classic: Literary Images of Permanence and Change*, New York, 1975, 83ff.

[28] H. W. Foote, *John Smibert, Painter*, Cambridge, Mass., 1950, 121ff., and Appendix D, 229ff. On Old Master collections in America, see L. B. Miller, *Patrons and Patriotism: The Encouragement of the Arts in America*, Chicago and London, 1966, 148ff.; and W. G. Constable, *Art Collecting in the United States of America*, Toronto and New York, 1964, 91ff.

[29] W. Dunlap, *A History of the Rise and Progress of the Arts of Design in the United States*, Boston, 1918, I, 44 and 162.

[30] J. B. Flagg, *The Life and Letters of Washington Allston*, New York, 1892, 334ff.; and E. P. Richardson, *Washington Allston: A Study of the Romantic Artist in America*, Chicago, 1948, 122ff., and 152.

Completed as indicated in details, it would have been a masterpiece, marking an important era in American art."[31]

But in the early years of the nineteenth century, voices were raised as elsewhere in favor of an art that would give expression to the special character of the American setting. The sublimities of our wilderness offered the painter the best chance to distill the essence of indigenous greatness. The landscapes of Thomas Cole were warmly received as the cornerstones of a truly native school, and after him F. E. Church and Albert Bierstadt stood high in the public esteem. But critics, buoyant with confidence in the future or beset by doubts about the precarious foothold of artistic culture in the society emerging around them, found it difficult to add American voices to the chorus of universal *chefs d'oeuvre*. A compilation of *Art Treasures of America* published in 1879 consists almost entirely of European paintings.[32] Jarves, with others, thought that an accumulation of the accepted heights of mastery was a necessary first step in the growth of taste and a national art of consequence, providing Americans with the "floating esthetic capital" that Europeans had long and effortlessly enjoyed.[33]

In the first volume of his *Modern Painters* (1843), the youthful Ruskin made a case for the possibilities of the modern position that was mindful in a different way of the crowding effect of the Old Masters on the consciousness. It is evident that these did not have for him, collectively or in particular works, the same canonical status they were generally accorded by his contemporaries. The best among the achievements of the past four thousand years, he argued, must necessarily outweigh what a single generation could do, if only by a process of sheer accumulation. It is thus inevitable that we cannot accomplish as much, and this condition is not a sign of our inferiority. Moreover, there is much in the vast treasure of past achievement that falls short of the highest standard. For Ruskin, the human limits of perfection are reached only in a handful of works: one or two fragments of Greek sculpture, the art of Michelangelo, and Raphael's *Sistine Madonna*. This leaves much room for completion or improvement. Furthermore, "every nation, perhaps every generation, has in all probability some peculiar gift; some particular character of mind enabling it to do something different from or something better in some sort than has been done before." The great work, capable of surpass-

[31] J. J. Jarves, *The Art-Idea*, New York, 1875, 208.

[32] E. Strahan [Shinn], *The Art Treasures of America, being the Choicest Works of Art in Public and Private Collections in North America*, Philadelphia, 1879.

[33] Jarves, *Art-Idea*, 176.

ing the masterpieces of past ages, we are told, would not fit any pre-
conceived notion, but would be "totally different in manner and mat-
ter from all other productions." Like Delacroix, Ruskin did not expect
the merits of the great work to be recognized by the public, and he
goes even further to assert that the degree of recognition will be less
"in proportion as the merits of the work are of a high order." History
is for him, too, to be the final arbiter of what constitutes a *chef d'oeuvre*,
but its verdict is not seen so much as a correction of present error as a
vindication of the opinions of the "right few," which gradually com-
mend themselves to a wider public.[34]

These are the preliminaries for a long and spirited defense of the
claims of modern landscape painting to have surpassed the efforts in
the genre of the painters of the past. Although Ruskin was soon after
to modify and partly repudiate his views on the subject, his argumen-
tation remains nonetheless arresting. Superficially, it takes the form
of the traditional debate between Ancients and Moderns, though the
former are not in this case the Greeks and the Romans, but the mas-
ters of the Renaissance. These encounter no truly serious challenge
by the critic to their supremacy in the high realm of history and reli-
gious painting but rather a flanking attack which seeks to demonstrate
their limitations and hence carve out for the Moderns a territory
where the terms of highest mastery are still theirs to set. Ruskin's
more than ambiguous but morally compelling criterion of truth en-
ables him to fault for their depiction of nature a long list of respected
masters from Medieval times through the eighteenth century and to
celebrate in Turner's best paintings a perfection equal to that
achieved in their time by Phidias and Leonardo. Such works as his
Juliet and Her Nurse, the *Old Temeraire*, and the *Slave Ship* (Fig. 51)
seem to him "incapable, in their way, of any conceivable improvement
by the human mind."[35]

The substance and style of Ruskin's praise of Turner is recogniz-
able in much of the later comment on the painter's art. Authors of an
otherwise skeptical disposition toward the art of the modern era are
nonetheless convinced that in his sphere he was and is likely to remain
the greatest painter of all time.[36] Even though this extraordinary ap-

[34] J. Ruskin, *Modern Painters*, (preface to the second edition), in *Works*, ed. Cook and
Wedderburn, III, 11ff. and 79ff.

[35] Ibid., 247-48.

[36] See, for example, the preface of Thornberry's *Life of Turner*, 1861, which largely
repeats this judgment of Ruskin; W. Knight, *Six Lectures*, Chicago, 1909, 22, where the
painter is compared to Shakespeare, Beethoven, and Wordsworth, and on a more
popular level, Nancy Bell (D'Anvers), *Elementary History of Art*, New York, 1875, 487.

preciation of Turner is primarily found among English and American writers, it does not seem that any other artist of the nineteenth century was ever placed on such a high plane by any qualified body of opinion. Ruskin's election of landscape as the right arena for the creative efforts of modernity has, to be sure, an anchor in nineteenth-century thought much wider than his own esthetic credo. Immersion into nature meant the stripping away of false sophistication, the hope of recovery of a lost purity of vision, establishing a point of contact with the Spirit. For some, landscape painting as such was the century's most significant artistic utterance. The methods proper to it, Fromentin observed, had invaded other genres and subjected them to its principles.[37]

Yet these elaborate strategies, the assertion of the special claims of inspired vision and the ultimate appeal to the verdict of history could only mask in part the underlying tension between a progressive view of the dynamics of art and an idea of masterpiece which had become imprisoned in a shell of respectability. When Proudhon remarked that ten thousand pupils who have learned how to draw would more effectively further art's advancement than the production of a single *chef d'oeuvre*,[38] he meant to deny that egotistical self-expression in the service of the egotism of a privileged class could speak for the ideal. Masterpieces worthy of the name attested to a deep communion between the artist and the genius of his people. He was its spokesman, but the merit of his work could not be ascribed to personal ability alone. There was an indispensable echo of the collective striving of thousands in each of his gestures. The English Parliament, the Gothic Cathedral, or the folk music of a people could be described as vast creations wrought by an unfailing yet anonymous mastery.[39] But mastery itself, with its suggestion of a hierarchical order in and perhaps beyond the sphere of art would prove unpalatable to the antinomian sensibility of later and more radical critics.[40]

[37] For Fromentin's insight, see *Maîtres d'autrefois*, 284ff. The critic Kenyon Cox, *Old Masters and New*, New York, 1905, 137, while following Ruskinian lines in upholding the supremacy of landscape in the art of the nineteenth century, gives the palm of honor to the Barbizon School, which "produced the art of the century that most nearly equals the great art of the past."

[38] P. J. Proudhon, *Du principe de l'art et de sa destination sociale*, Paris, 1865, 172. In his otherwise useful *Histoire de l'esthétique française, 1700-1900*, Paris, 1920, 157, T. H. Mustoxidi dismisses this opinion as an "énormité, en contradiction avec le bon sens."

[39] Proudhon, *Du principe de l'art*. In his *Cathédrales de France*, Paris, 1914, 4, Rodin also holds that the cathedrals are true masterpieces because they speak "avec une âme de foule."

[40] M. Warnke, "Weltanschauliche Motive in der kunstgeschichtliche Populär-

For a public drawn to masterpieces by the promise of sweet poetry and grand emotions, by sentiments too recommendable to suffer decent challenge, these could only be the sounds of a distant thunder. In the nineteenth century, the favored terrain for such ceremonious encounters with greatness had become the museum, the chief repository of *chefs d'oeuvre* formerly in ecclesiastical and princely hands. The assiduous prospection of distant places which the eighteenth-century traveler was willing (and able) to undertake became rarer. The modern tourist, pressed for time and less secure in his taste, found himself conveniently directed to the local palace of the arts. The Prado was opened in 1819, Schinkel's Alte Museum in Berlin in 1830, and the National Gallery of London, England's first public museum, in 1838.[41] The Louvre, enormously enriched by the spoils of the Napoleonic Wars, held a special place of eminence in the field. The accumulation of treasures in its vast premises led the director Jeanron in 1848 to propose the creation of a "Pantheon of Masterpieces" where, after the model of the Medici *Tribuna* in the Uffizi, the most outstanding of the museum's works would be displayed. The *Salon Carré* was remodeled for this purpose by the architect Félix Duban and inaugurated three years later.[42] Under vaults with large personifications in stucco of Painting, Sculpture, and Engraving, and a frieze aligning the names of the great masters, the visitor could admire an elite among the *chefs d'oeuvre*: Jan Van Eyck's *Rolin Madonna*—the earliest in terms of chronology—Leonardo's *Mona Lisa*, Raphael's *Madonna of Foligno* and *St. Michael*, Titian's *Entombment*, and Veronese's immense *Marriage at Cana*. In Théophile Gautier's words, it was "the most glorious assembly of painters that could be seen in this world," and guidebooks earnestly entreated their readers that none should be overlooked.[43]

The museum formalized the experience of the masterful, and as some reports suggest, elevated it to a solemn, quasi-ritualistic act. References to museums as temples of art abound. Silence and reverence are prescribed. In Dresden, "in justice to its own merits and in kindness to other pictures in the gallery," Raphael's *Sistine Madonna* was placed in a room entirely by itself. For one author, it is "a revelation of heaven on earth," not a mere work of art but "an *appearance* of the

literatur," in M. Warnke, ed., *Das Kunstwerk zwischen Wissenschaft und Weltanschauung*, Cologne, 1970, 88-106; and the essays of Berthold Hinz and Ulrich Keller in the same rather shrill but provocative publication.

[41] G. Bazin, *The Museum Age*, New York, 1967, 193ff.

[42] Ibid., 215; and C. Aulanier, *Le Salon Carré*, Paris, n.d., 65ff.

[43] T. Gautier, *Guide de l'amateur du Musée du Louvre*, Paris, 1882, 25-26; and the more methodical description by Bayle Saint-John, *The Louvre*, London, 1855, 304ff.

Virgin."[44] This is testimony with a missionary flavor, appropriate to its object, but too one-sided as an account of a complex reality. Its tone makes one suspect that incomprehension or even indifference were not uncommon.[45] Was this a price that had to be paid for the increasing social regimentation of the artistic experience or merely a sign that for the *chefs d'oeuvre*, too, there would be a twilight of the gods? A.-J. Quatrèmere de Quincy, a vigorous critic of the phenomenon, early drew attention to some of the consequences of "museumization." He noted with insight that a significant expressive dimension of the work of art derived from the viewer's perception of its organic relation to its surroundings. The museum, he argued, dissolved this vital tissue of associations and inspired in people less a love for art than a conviction of its uselessness. The museum's way with the *chefs d'oeuvre* followed a bizarre but inexorable logic of its own. It was led "to accumulate for the sake of accumulation," to restore and readjust old works, "to complete series, to acquire missing pendants," in a word, to embalm instead of encouraging the production of new masterpieces. As the institution became the state's official guardian of artistic values, he predicted, the character of art itself would undergo a transformation, engagement with life receding in favor of the disembodied "museum piece."[46]

There was, furthermore, a growing incompatibility between a deepening historical consciousness and the static notion of high mastery attached to the famous statues of the Ancients and the paintings of the Old Masters. With Franz Kugler's *Handbuch der Kunstgeschichte* (1842), the story of art no longer begins with the Greeks, but in prehistoric times as far back as the artifacts of man will reach. The new universal art history meant to embrace not only the traditional corpus of the European West, but the Ancient Near East, the Orient, and the

[44] W. Lübke and L. Viardot, quoted in A. G. Radcliffe, *Schools and Masters of Painting*, New York, 1876, 468. For other testimony on the worshipful atmosphere of museums, see V. Plagemann, *Das deutsche Kunstmuseum*, Munich, 1967, 26.

[45] See the findings of P. Bourdieu and A. Darbel, *L'amour de l'art: Les musées et leur public*, Paris, 1966. Theodor Adorno has placed at the head of his *Jargon der Eigentlichkeit* the sentence from Samuel Beckett's *L'innommable*: "Il est plus facile d'élever un temple que d'y faire descendre l'objet du culte."

[46] A.-C. Quatrèmere de Quincy, *Opinion sur les musées* (1802), and *Considérations morales sur la destination des ouvrages d'art* (1815), where he remarks: "Since museums have come into existence to create masterpieces, there are no longer any masterpieces to fill museums." On Quatrèmere's criticism of museums, see R. Schneider, *Quatrèmere de Quincy et son intervention dans les arts, 1788-1830*, Paris, 1910, 179ff.

so-called Primitive and Folk cultures.[47] Karl Schnaase's *Geschichte der bildenden Künste* (1843-64), which covered the ground with unprecedented thoroughness, had reached the end of the Middle Ages in its seventh volume, the last one completed by the author.[48] Beside these works of the most uncompromising seriousness of purpose, there were numerous shorter volumes aimed at a wider public, the incunabula of a genre which it is as fashionable to disdain as it has proven difficult to do without, the "survey." In these, the effort of compression is necessarily extreme, a few key works being made to speak for an entire period or School, as may be seen in the title of R. J. Ménard's *Histoire des Beaux-Arts, illustrés de 414 gravures représentant les chefs d'oeuvre de toutes les époques* (1875), a representative sample itself of this type of literature. As the didactic intention becomes more pronounced, however, the traditional value system asserts itself beneath its encyclopedic skin. The newcomers are admitted to the wings, the old favorites remain in their central quarters.

A. G. Radcliffe's very popular *Schools and Masters of Painting*, initially published in 1876, was geared to the needs of European travel and is completed by a guide to the principal galleries of the Old World. It also offers a list of "World-Pictures," "twelve of the most popular paintings of celebrated artists, so familiarized by engravings and so dear to memory or imagination, that the thought of beholding the originals is one of the traveller's pleasantest anticipations."[49] The list is characteristically unadventurous, but no doubt must stand for a broad consensus of opinion: Raphael's *Transfiguration*, regarded according to the author, as the finest picture in the world; the *Sistine Madonna*; Michelangelo's *Last Judgment*; Leonardo's *Last Supper* and *Mona Lisa*; Titian's *Assumption of the Virgin*; Correggio's *Santa Notte* (*Nativity*); Guido Reni's *Aurora*; Rubens' Antwerp *Descent from the Cross*—the latter called "the *chef d'oeuvre* of Flemish art"; and Murillo's *Immaculate Conception* in the Louvre. Two comparative newcomers, Fra Angelico's *Madonna and Child with Angels* and Rembrandt's *Night Watch*, reflect more recent shifts in taste and found their way into the

[47] On Kugler, see W. Waetzoldt, *Deutsche Kunsthistoriker*, Berlin, 1965, II, 143ff.; and U. Kultermann, *Geschichte der Kunstgeschichte*, Vienna and Düsseldorf, 1966, 165ff.

[48] Waetzoldt, *Deutsche Kunsthistoriker*, II, 70ff.

[49] Radcliffe, *Schools and Masters of Painting* (1876), New York, 1900, 501. The diffusion of inexpensive reproductions of the great masterpieces is another aspect of this process of vulgarization. On this industry, see the review article of S. Metken, "Trivialkunst aus der Chromopresse," *Kunstchronik*, 1974, 145-51, which informs on other studies in this area.

list only in later editions of the book.[50] Copyists in the Florentine gallery, we are told, cannot work fast enough to supply the demand for reproductions of the angels in Fra Angelico's painting.[51]

The survey writers spoke with confidence about key works of the remote past, but they were generally much more diffident about naming those of a time closer to their own. David is taken by them as the founder of the modern period. Gros' battle pieces and Géricault's *Raft of the Medusa* are perhaps most frequently cited as the critical early works and acclaimed by the most sanguine as *chefs d'oeuvre*.[52] The general bent, however, is to await the sentence of history. J. L. Abbott, the author of an *Outlines for the Study of Art* (1891), allows that "great technical excellence is certainly manifested by many sculptors and painters in our times; but the future must decide as to the value of their works as examples of historic art."[53] The weightier W. Lübke (1874) warns that "we must bear in mind that the time has not yet come for a definitive historical survey. It is true, the artistic development of our own day has passed through more than half a century with enduring power and varied effort, and has produced a world of creations of every kind as evidences of its activity; but this movement has not yet reached its aim, it is as yet striving onwards with unwearied effort, and hence forbids a final verdict."[54] W. H. Goodyear protests that the criticism of modern art "must necessarily be so

[50] Up to 1885, two older favorites are found among the "World-Pictures," Domenichino's *Communion of St. Jerome* and Daniele da Volterra's *Descent from the Cross*, along with a second picture then persistently if not unanimously attributed to Reni, the so-called *Beatrice Cenci* of the Barberini Palace. In the editions of Radcliffe from that date onward, the *Mona Lisa* also joins the *Last Supper* on the list.

[51] Radcliffe, *Schools*, 1885, 492.

[52] W. Reymond, *Histoire de l'art depuis les origines jusqu'à nos jours*, Paris, 1886, 263; Lübke, *History of Art*, II, 448; and S. Reinach, *Apollo*, Paris, 1904, 296. Reinach's work, which has been steadily reissued in the original language as well as in translation, typifies the survey formula at its most successful. The author was a distinguished and prolific scholar and his history unfolds in twenty-five dense chapters from Paleolithic art to the then newly modish *art moderne*. The format of the book was a reflection of the circumstances of its composition. It is the record of a cycle of lectures given in the course of a single academic year at the Ecole du Louvre, and its subdivisions are therefore geared not only to the pattern of classification imposed on the material, but to the number of meetings available. Reinach, it would seem, was the inventor of the college art history textbook. As he remarks, his idea was received with great enthusiasm by the public, and it has not yet lost its appeal.

[53] J. L. Abbott, *Outlines for the Study of Art in Its Three Main Subdivisions: Architecture, Sculpture and Painting*, New York, Boston, Chicago, 1891, 6.

[54] Lübke, *History of Art*, II, 422.

largely of a 'technical' quality that professional artists or technical experts are its fittest critics."[55]

The historian might well have found greater purpose in urging on the public his own convictions instead of merely chronicling the ever more luxuriant burgeoning of tendencies, all that seemed left for him to do until the passage of time extricated him from his uncertainty. But in all fairness, he meant primarily to report, and it was not inaccurate on his part to observe that the unquestioned authority so mysteriously possessed by the "World-Pictures" attached to no modern work, and in the same measure, as Goodyear noted, perhaps only to Shakespeare's writings and to the music of the German Romantic composers.[56] The great period of "historic art" was acknowledged to have come to a definitive end, but the model of mastery which it evoked was still alive. The tribunal of universal acclaim could not be wholly disqualified, though a greater number of professional historians should have sensed that however they viewed their task, they were not neutral bystanders but active participants in its proceedings. It was the general failure to redefine the idea of masterpiece in terms more congruent with modern sensibility, as Baudelaire and Ruskin in different ways sought to do, that hindered the elaboration of a viable canon of newer works. But to have carried out such a redefinition, it would have been necessary to make a sacrifice of social and esthetic ideals deeply ingrained and not easily denied.

This position was bound to leave the present as an awkward and drawn-out period of suspense for which there were both psychological and material incentives to try to dissipate. Outside the jury room of history, a compound of prophetic insights, inflated hopes, and false revelations held the forefront of the stage. Sensational epiphanies and temporary immortalities were engineered by special exhibitions sent on tours under the sponsorship of dealers and a new breed of impresarios. Géricault's *Raft of the Medusa*, which received only mixed critical notices when it was first exhibited at the Salon of 1822, fared much better on its showing shortly afterward at William Bullock's Egyptian Hall in London, and that fact was eagerly advertised by early admirers of the painting.[57] But names like Meissonier, Makart,

[55] W. H. Goodyear, *A History of Art: For Classes, Art Students and Tourists in Europe*, New York, 1888, 351.

[56] Ibid.

[57] L. Johnson, "The Raft of the Medusa in Great Britain," *Burlington Magazine*, XCII, 1954, 249ff.; and L. Eitner, *Géricault's Raft of the Medusa*, London, 1972, 62, who quotes

Piloty, Cabanel, Munkaczy, and Breton are the more ordinary denizens of this world. The triumphal itinerary of Rosa Bonheur's *Horse Fair* took the painting from the Salon of 1853 to exhibitions in Ghent, Bordeaux (1854), and the principal cities of England and America.[58] In the publicity accompanying these traveling shows, the cultural pessimism of the critics is dispelled with a vengeance, and prospective buyers are addressed in language calculated to arouse in the most hardhearted an eagerness to play the Medici. Masterpiece, or preferably *chef d'oeuvre*, leaps from the hired pen with immodest abandon. The works presented to the fortunate viewer, it is typically declared, have been admired "in the art capitals of the world" by countless numbers of persons, among which a sampling of the socially prominent, academic authorities, and eminent painters are cited by name. The public honors heaped on the artist and on the painting are carefully rehearsed. Comparison with the great masters establishes a necessary frame of reference. In England, where this was not a mild compliment, Bonheur was called a "female Landseer" and thought to more than hold her own in the company of Rubens and other *animaliers* of the past.[59] Michael Munkaczy's *Milton, Christ before Pilate* (Fig. 52), and *Christ on the Cross* were intentionally executed to be displayed on tours of Europe and the lucrative American market. Brilliantly successful on this front, the painter was thought to have equaled Rembrandt and Velazquez and to have illustrated in his works the same conception "which characterizes Shakespear's dramas and renders them immortal, because they are intelligible and speak to all nations and generations."[60]

The great international fairs of the nineteenth century were other stations on this glorious road. The current tendencies in the art of the nations were here as nowhere else juxtaposed, and in the euphoric climate nourished by the ideology of progress, doubts over the lasting significance of the best efforts of modern times were easily

an announcement in the London newspapers on Bullock's behalf which speaks of "this *chef d'oeuvre* of foreign art."

[58] A. Klumpke, *Rosa Bonheur: Sa vie, son oeuvre*, Paris, 1909, 225ff.

[59] F. Lepelle de Bois-Gallant, *Memoirs of Mademoiselle Rosa Bonheur*, New York, 1857, 43, who quotes the London *Times*, July 18, 1855.

[60] See the promotional booklets issued by Munkaczy's dealer Charles Sedelmayer, *Christ on Calvary by M. de Munkaczy . . .*, New York, n.d., 23; and the even more inflated panegyric *Christ before Pilate by M. de Munkaczy*, Paris, 1886. For a recent treatment of the artist's career, see G. Perneczky, *Munkaczy*, Budapest, 1970.

suppressed.[61] The award of medals for excellence in different genres conveyed the approval of all that was enlightened in humanity. Hiram Powers' *Greek Slave* dazzled the throng at the Great Exhibition of London in 1851 (Fig. 53), and Medals of Honor—the highest award given—went to the prolific and much-adulated Louis-Ernest Meissonier in the Paris exhibitions of 1855, 1867, and 1878.[62] From scientific apparatus and machinery to painting and sculpture was a small leap and it was quickly made, in a spirit which confidently anticipated further triumphs in each sphere. The three heavy volumes of *Masterpieces of the Centennial International Exhibition* (Philadelphia, 1876), respectively embracing artistic, mechanical, and scientific achievement, are identical in format and display on their binding a gold-stamped vignette depicting in symbolic form the harmonious relation of agriculture, industry, and the Fine Arts. Among the masterpieces of art are the Salon's familiar array of heroic and sentimental subjects, erotic fantasies, and small bourgeois dramas—much like the new locomotives and printing presses, toughly rational organisms with a smooth and impersonal finish—dressed up in an eclectically historicizing garb.[63] Photography's *chefs d'oeuvre* occupy an honorable place, but this is not so much a sign of an adventurous disposition in matters of taste as of an eagerness to embrace the sanctified products of scientific discovery.

Masterpieces in a time which has not yet become a past will be masterpieces of publicists and seers. They will be works of genius and

[61] C. Beutler, *Weltausstellungen im 19. Jahrhundert*, ex. cat., Munich, Staatliches Museum fur angewandte Kunst, 1973.

[62] S. Roberson and W. H. Gerdts, *The Greek Slave*, Newark, 1965; and R. P. Wunder, *Hiram Powers: Vermont Sculptor*, Taftsville, Vt., 1974, 25ff. On Meissonier, see M. O. Gréard, *Jean-Louis-Ernest Meissonier: Ses souvenirs, ses entretiens*, Paris, 1897.

[63] Other examples in this genre of luxurious publication are G. A. Smith, *The Laurelled Chefs d'oeuvre d'art from the Paris Exhibition and Salon*, Philadelphia, 1890; E. Shinn, *The Chefs d'oeuvre d'art of the International Exhibition of 1878*, Philadelphia, 1878-80; and J. E. Reed, *One Hundred Crowned Masterpieces of Modern Painting*, Philadelphia, 1888. Among the better-known painters included in the Reed anthology are Alma-Tadema, Bierstadt, Cabanel, Breton, Gérome, Makart, Munkaczy, and Meissonier. About Rosa Bonheur's *Horse Fair* (Metropolitan Museum of Art), the author declares that it "will be considered one of the world's masterpieces and rank with Raphael's *Transfiguration*, Rubens' *Descent from the Cross*, Leonardo's *Last Supper*, Michelangelo's *Last Judgement* and Munkaczy's *Christ before Pilate*." The "blindness" of nineteenth-century critics has itself become a valuable rhetorical device. In his *The Failures of Criticism*, Ithaca, 1944, 29ff., Prof. Henri Peyre in a gleefully polemical spirit gives a long list of (literary) masterpieces misunderstood or ignored by the critics.

travesties, one mocking the other and mocked in return. After the last residues of Romantic emotion have been deflated, deflation itself will breed new and equally tenacious residues, to be demoted in their turn. The quality of mastery is subject to an endless process of re-definition. But symbols of permanence have other, more mysterious, ways. They must be sustained by metaphysical certitudes, and these are in short supply.

BIBLIOGRAPHICAL NOTE

The following summary of books and articles bears on various aspects of the subject treated in this essay. It does not constitute a precise record of my sources, which are acknowledged in the footnotes, but addresses itself to the larger picture.

The question whether greatness in art can be usefully defined at all is, after long debates, now like a battlefield with only weary combatants left on both sides. On the philosophical terrain, one may refer for a view of the present situation to the remarks of Meyer Schapiro and others in the symposium volume *Art and Philosophy*, ed. S. Hook, New York, 1966. A practical demonstration on the affirmative side is found in J. Rosenberg's *On Quality in Art: Criteria for Excellence, Past and Present*, Princeton, 1967. I have found very stimulating on a more general plane the essays of E. H. Gombrich, *Art History and the Social Sciences,* Romanes Lecture, 1973, Oxford, 1975, and "The Museum: Past, Present and Future," *Critical Inquiry*, III, no. 3, 1977, 449-70, as well as his exchange with Quentin Bell, "Canons and Values in the Visual Arts: A Correspondence," *Critical Inquiry*, II, no. 2, 1975, 395-410.

From a literary perspective, T. S. Eliot's essay of 1944 "What Is a Classic," reprinted in *On Poetry and Poets*, London, 1957, 52-74, is the starting point of the useful discussion of F. Kermode, *The Classic: Literary Images of Permanence and Change*, New York, 1975. The claims of more incommensurate ideals are treated by S. Monk, "A Grace Beyond the Reach of Art," *Journal of the History of Ideas*, V, 1944, 131-50. W. Stammler, " 'Edle Einfalt': Zur Geschichte eines kunstheoretischen Topos," in the author's *Wort und Bild*, Berlin, 1962, 161-90, studies a much-traveled term of praise. On the practical side again, H. Cairns, ed., *The Limits of Art*, New York, 1948, presents an anthology of prose and poetry held by a variety of "competent critics" to illustrate the highest reaches of achievement in these spheres.

Individual masterpieces and their posterity have inspired a number of good monographs. For the monuments of Antiquity, M. Bieber's *Laocoön: The Influence of the Group since Its Rediscovery*, New York, 1942; J. R. Hale, "Art and Audience: The Medici Venus, 1750-1850," *Italian Studies*, XXXI, 1976, 37-58; and W. MacDonald, *The Pantheon: Design,*

Meaning and Progeny, Cambridge, Mass. may be cited. H. Ladendorf, *Antikenstudium und Antikenkopie*, Abhandlungen der sächsischen Akademie der Wissenschaften zu Leipzig, Philologisch-historische Klasse, 46, no. 2, Berlin, 1958, offers an exhaustive bibliography. For the masterpieces of the Renaissance and later, some outstanding examples are: E. Möller, *Das Abendmahl des Leonardo da Vinci*, Baden-Baden, 1952; C. Seymour, Jr., *Michelangelo's David: A Search for Identity*, Pittsburgh, 1967; and L. Eitner, *Géricault's Raft of the Medusa*, London, 1972. Other significant single works of art are treated in the titles of the German series Reclams Werkmonographien and those of Viking/Penguin Books' Art in Context. Copies of *chefs d'oeuvre* by leading masters is the subject of M. Ayrton and K. E. Maison's *Art Themes and Variations: Five Centuries of Interpretations and Re-creations*, New York, 1962.

The relation between the masterpiece and views of artists and their work in the ambient world is illuminated through such works as E. Zilsel's *Die Enstehung des Geniesbegriffes*, Tübingen, 1926; E. Kris and O. Kurz, *Die Legende vom Künstler*, Vienna, 1934; and R. and M. Wittkower, *Born under Saturn: The Character and Conduct of Artists: A Documented History from Antiquity to the French Revolution*, London, 1963. M. Shroder's *Icarus: The Image of the Artist in French Romanticism*, Cambridge, 1961, carries the matter forward in time. The reputation of some of the greatest artists in the consciousness of later times is the subject of the following: M. Ebhardt, *Die Deutung der Werke Raffaels in der deutschen Kunstliteratur von Klassizismus und Romantik*, Studien zur Deutschen Kunstgeschichte, 351, Baden-Baden, 1972; E. Heye, *Michelangelo im Urteil französischer Kunst des XVII. und XVIII. Jahrhundert*, Strasbourg, 1932; J. Thuillier, "Polémiques autour de Michel-Ange au XVIIe siècle," *Bulletin de la Société d'Etudes du XVIIe siècle*, 6, 1957, 353-91; and Carl Gregor, Herzog zu Mecklenburg, *Correggio in der deutschen Kunstanschauung in der Zeit von 1750 bis 1850*, Studien zur deutschen Kunstgeschichte, 347, Baden-Baden, 1970. A specific case of influence and self-identification is studied in J. Gantner, *Michelangelo und Rodin*, Vienna, 1935, and a particularly fascinating example is discussed in R. McMullen, *Mona Lisa: The Picture and the Myth*, Boston, 1975.

The collection and display of ancient statuary masterpieces can be surveyed with the help of C. Hülsen, *Römische Antikengärten des XVI. Jahrhunderts*, Abhandlungen der Heidelberger Akademie der Wissenschaften, Philosophisch-historische Klasse, 4, Heidelberg, 1917; A. Michaelis, *Ancient Marbles in Great Britain*, Cambridge, 1882; and

for a celebrated example, H. H. Brummer, *The Statue Court in the Vatican Belvedere*, Stockholm, 1970. The monumental work of L. Schudt, *Italienreisen im 17. und 18. Jahrhundert*, Veröffentlichungen der Bibliotheca Hertziana, Vienna, 1959, is indispensable for the literature and fashions of travel, also considered from a narrower angle by C. Hibbert, *The Grand Tour*, London, 1969. The history of the museum and its ways is considered in J. von Schlosser, *Die Kunst-und Wunderkammern der Spätrenaissance*, Leipzig, 1908; and with emphasis on the later history, in G. Bazin's *The Museum Age*, New York, 1967; and V. Plagemann, *Das deutsche Kunstmuseum*, Munich, 1967. The collection of essays edited by B. O'Doherty, *Museums in Crisis*, New York, 1972, reflects more critical thinking of recent years on this institution, while the attitudes of the public are studied from a sociological point of view by P. Bourdieu and A. Darbel, *L'amour de l'art: Les musées et leur public*, Paris, 1966.

The reproduction of paintings by graphic means up to the nineteenth century was the subject of a recent exhibition with an important catalogue: *Bilder nach Bildern: Druckgraphik und die Vermittlung von Kunst*, Münster, Westfälisches Landesmuseum für Kunst und Kulturgeschichte, 1976. The effect of modern reproductive techniques on the perception of the qualities of older art was the subject of the influential essay of W. Benjamin, *Das Kunstwerk im Zeitalter seiner technischen Reproduzierbarkeit*, Frankfurt, 1963, originally published in 1936. The production and consumption of such mechanical reproductions, assessed more pessimistically with respect to music by Adorno, has received more recent attention in Germany, as in the group of essays edited by H. de la Motte-Haber, *Das triviale in Literatur, Musik und bildender Kunst*, Studien zur Philosophie und Literatur des neunzehnten Jahrhunderts, 18, Frankfurt, 1972.

INDEX

ILLUSTRATIONS

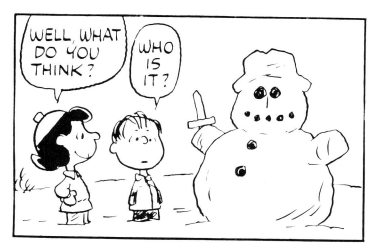

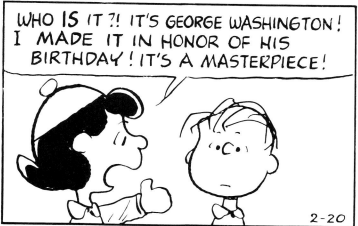

1. C. Schulz, *Peanuts*. © 1977 United Feature Syndicate, Inc.

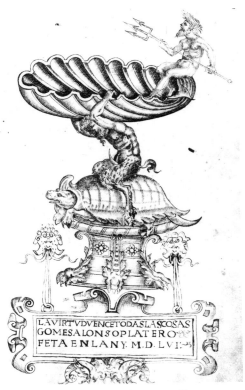

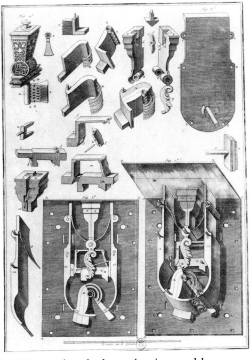

3. Masterpiece lock mechanism and key, from M. Duhamel du Monceau, *Art du Serrurier*, 1767, pl. XXX. Paris, Bibliothèque Nationale

2. Masterpiece project of Gomes Alonso, Barcelona, from the *Llibres de Passanties*, 1556, vol. II, fol. 104. Barcelona, Archivo Historico de la Ciudad

4. Masterpiece key, 1500-1600. Rouen,
Musée Le Secq de Tournelles

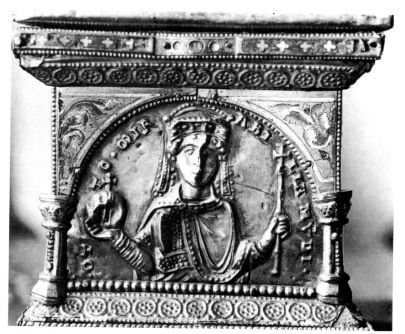

5. Otto III, arm reliquary of Charlemagne, 1165-66. Paris, Louvre

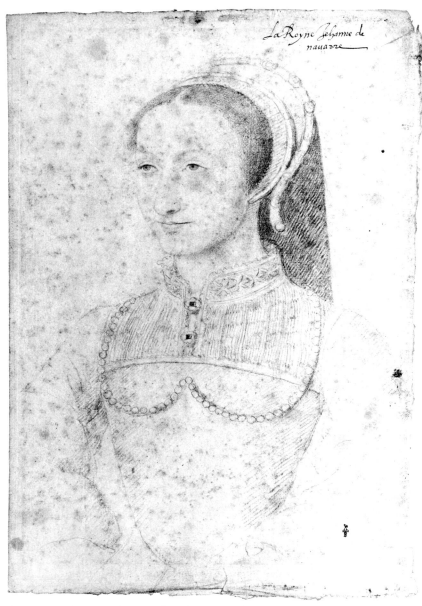

La Royne Jehanne de
nauarre

6. *Portrait of Jeanne d'Albret,* drawing, French, sixteenth century. Chantilly,
Musée Condé

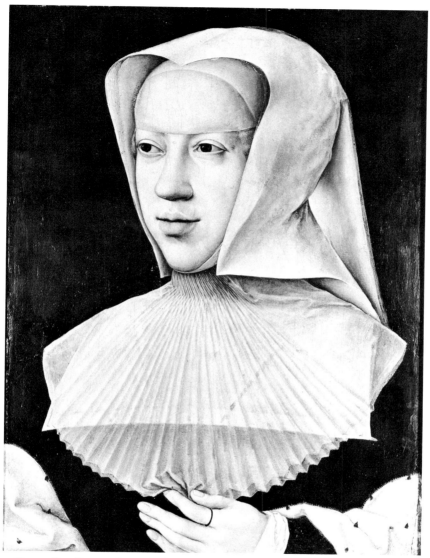

7. Copy after Bernard van Orley (1485-1542), *Margaret of Austria,* panel painting. Brussels, Musées Royaux des Beaux-Arts

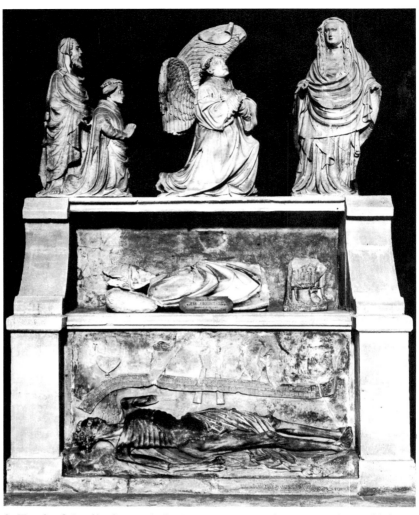

8. Tomb of Cardinal Jean de la Grange, 1402. Avignon, Musée Lapidaire

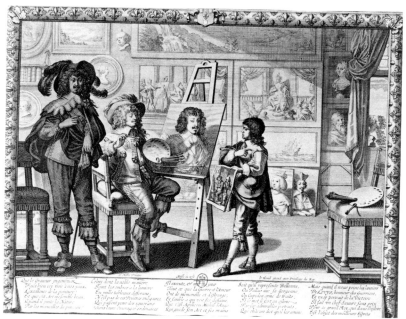

9. Abraham Bosse, *The Painter's Studio*, engraving, seventeenth century. Paris, Bibliothèque Nationale

10. Nantes, Cathedral of St. Pierre, west façade, late fifteenth century.

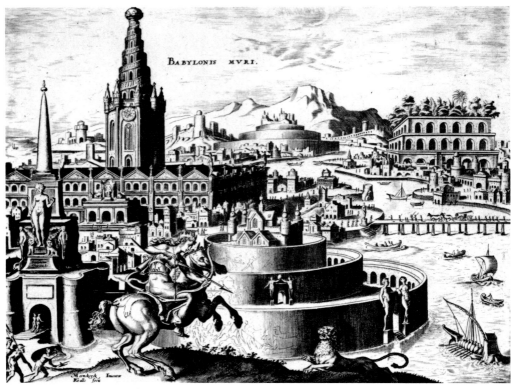

11. Maerten van Heemskerck, *Hanging Walls of Babylon*, engraved by Galle, sixteenth century. Paris, Bibliothèque Nationale

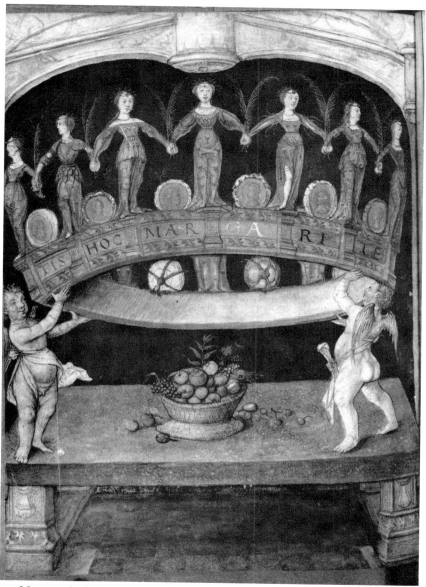

12. Margaret's *chef d'oeuvre* crown, illuminated manuscript, early sixteenth century, from J. Lemaire de Belges, *Couronne margaritique*, Vienna, Österreichische Nationalbibliothek, Cod. 3441, fol. 116.

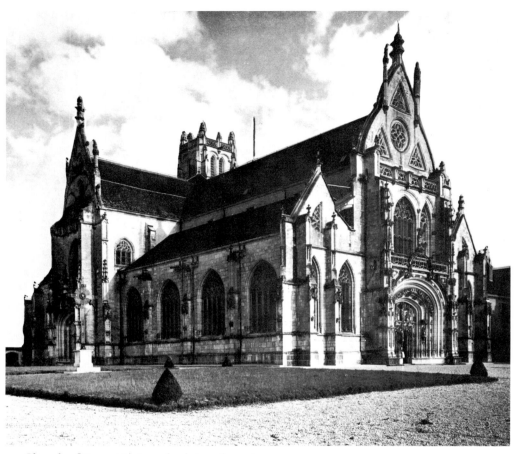

13. Church of Brou (Ain), early sixteenth century.

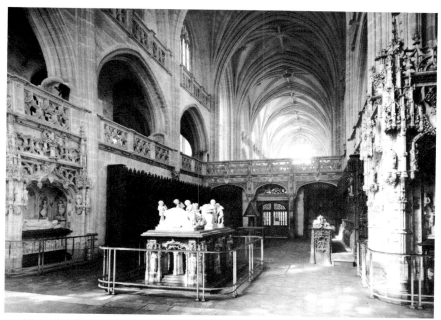

14. Church of Brou, interior and tombs.

15. Church of Brou, view into the oratory of Margaret of Austria.

16. *Temple of Jerusalem*, from J. Fouquet, *Antiquités judaiques*, 1473-76, Bibliothèque Nationale, fr. 247, fol. 163. Paris, Bibliothèque Nationale

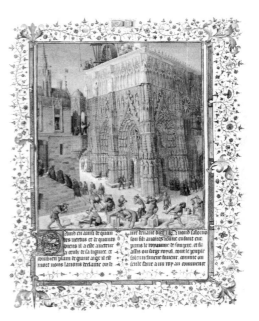

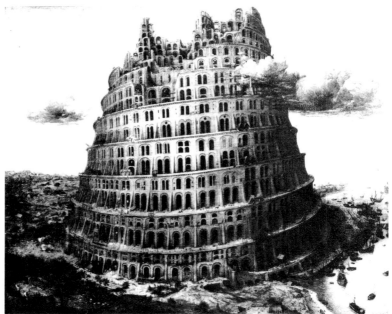

17. Peter Brueghel, *Tower of Babel*, panel painting, ca. 1563? Rotterdam, Museum Boymans-Van Beuningen

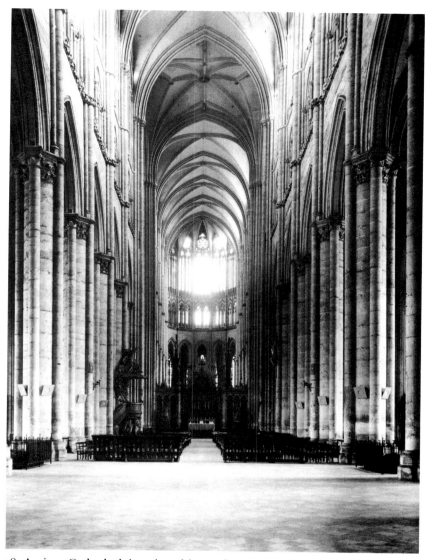

18. Amiens Cathedral, interior, thirteenth century.

19. Tomb of Berneval, Rouen, St.-Ouen, fifteenth century.

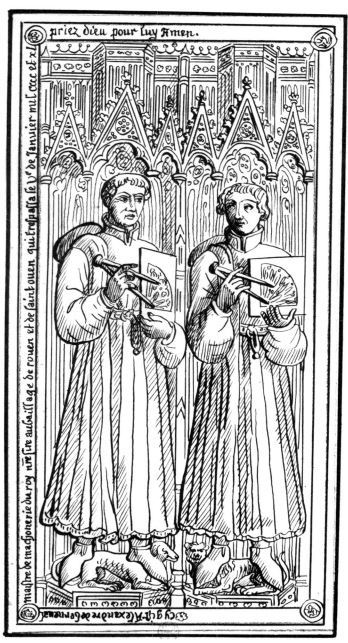

20. Tomb of Berneval, drawing made for R. de Gaignières, seventeenth century. Paris, Bibliothèque Nationale

21. Rouen, St. Ouen, south transept rose window (without glass), fifteenth century.

22. Rouen, St. Ouen, north transept rose window (without glass), fifteenth century.

23. Jacques Cellier, *Notre-Dame*, drawing, sixteenth century, Bibliothèque Nationale, fr. 9152, fol. 87. Paris, Bibliothèque Nationale

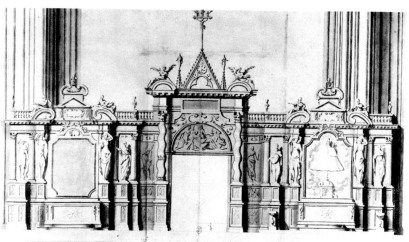

24. Robert de Cotte, Choir Screen, Notre-Dame, drawing, 1708. Paris, Bibliothèque Nationale

25. Jacques Cellier, *Sainte-Chapelle*, Paris, drawing, sixteenth century, Bibliothèque Nationale, fr. 9152, fol. 89. Paris, Bibliothèque Nationale

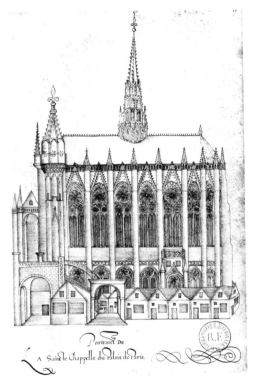

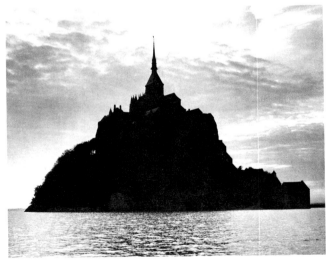

26. Mont-Saint-Michel, eleventh to fifteenth centuries.

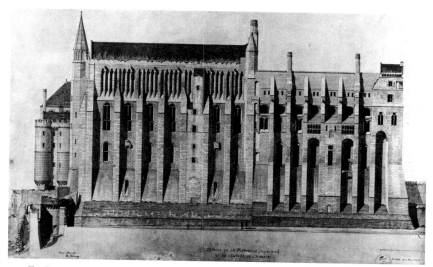

27. E. Corroyer, the *Merveille* (Mont-Saint-Michel), watercolor, nineteenth century.

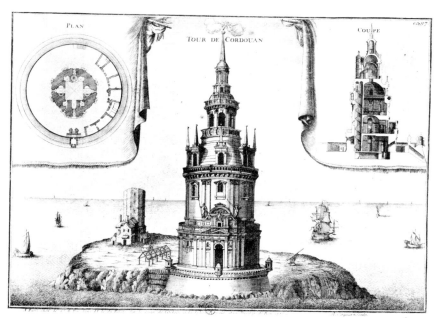

28. C. Chastillon, *Lighthouse of Cordouan* (Gironde), engraving, 1705. Paris, Bibliothèque Nationale

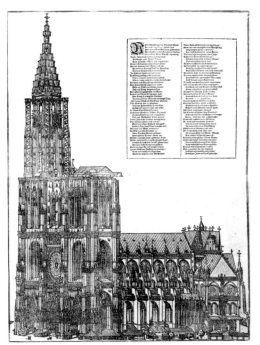

29. Bernard Jobin, *Strasbourg Cathedral*, engraving, 1575. Strasbourg, Archives de la Ville

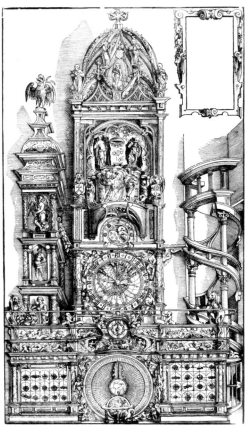

30. Tobias Stimmer, Astronomical Clock, Strasbourg Cathedral, engraving, sixteenth century. Strasbourg, Archives de la Ville

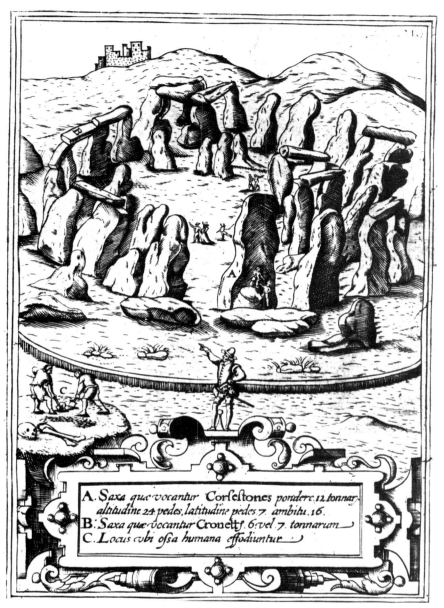

A. Saxa quæ vocantur Corſeſtones pondere 12 tonnar.
 altitudine 24 pedes, latitudine pedes 7. ambitu 16.
B. Saxa quæ vocantur Cronetts 6 vel 7 tonnarum
C. Locus ubi oſſa humana effodiuntur

31. *Stonehenge*, from W. Camden, *Britain*, 1610. New Haven, Yale University, Beinecke Rare Book and Manuscript Library

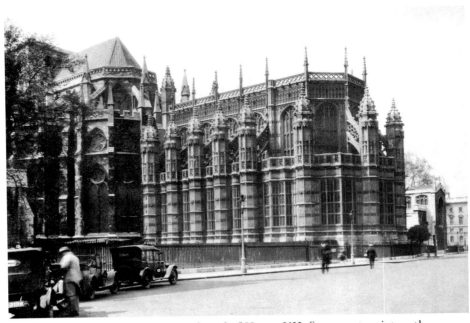

32. London, Westminster Abbey, Chapel of Henry VII, first quarter sixteenth century.

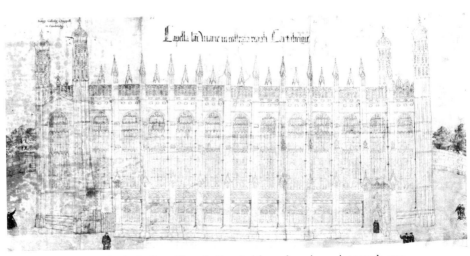

33. Anonymous, *King's College Chapel*, Cambridge, drawing, sixteenth century, from Cotton Augustus I, Vol. 1, fol. 2. London, British Library

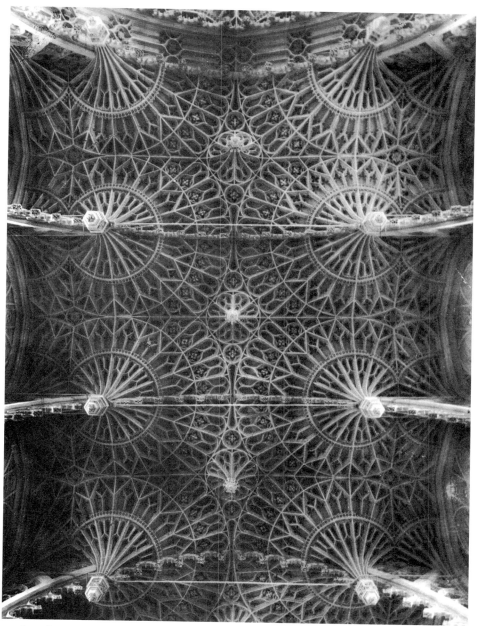

34. London, Westminster Abbey, Chapel of Henry VII, vaults, first quarter sixteenth century.

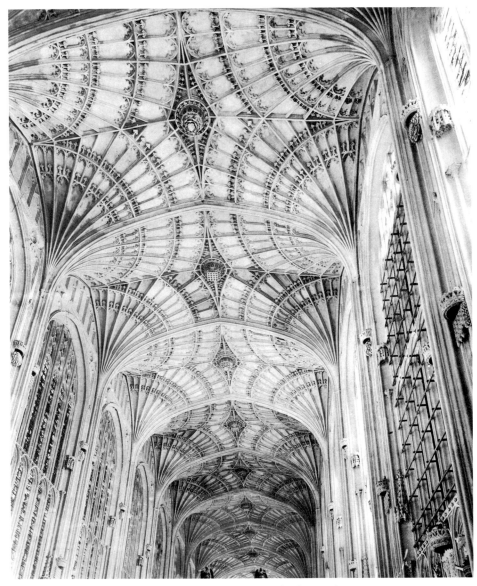

35. Cambridge, King's College Chapel, vaults, early sixteenth century.

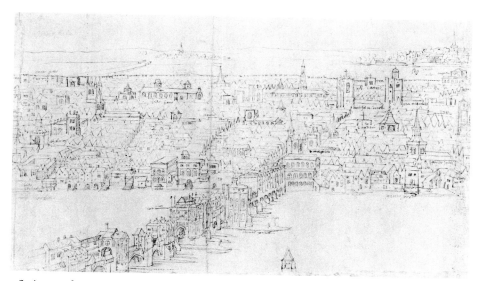

36. A. van den Wyngaerde, *London Bridge*, drawing, sixteenth century. Oxford, Ashmolean Museum

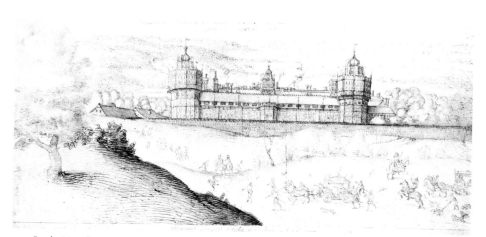

37. Joris Hoefnagel, *Nonsuch Palace*, drawing, 1568. London, British Museum

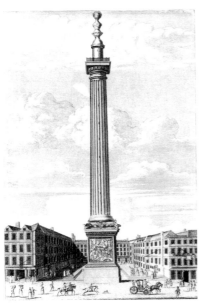

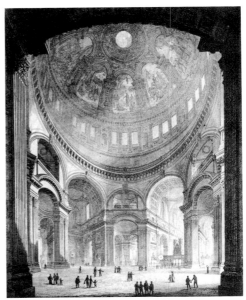

38. W. H. Toms, *The Monument* (London; designer, Sir Christopher Wren), engraving, eighteenth century.

39. J. Coney, *St. Paul's Cathedral* (London; architect, Sir Christopher Wren), engraving, nineteenth century.

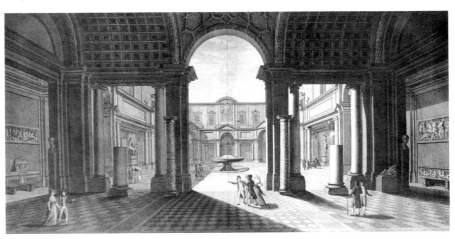

40. V. Feoli, *View of the Statuary Court of the Vatican Belvedere*, engraving, early nineteenth century. Rome, Vatican

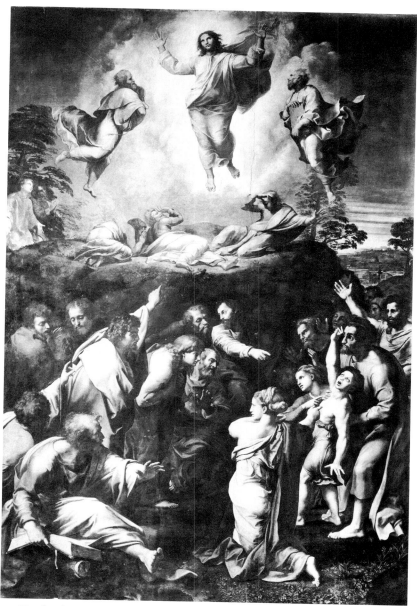

41. Raphael, *Transfiguration*, oil on canvas, 1517-20. Rome, Pinacoteca Vaticana

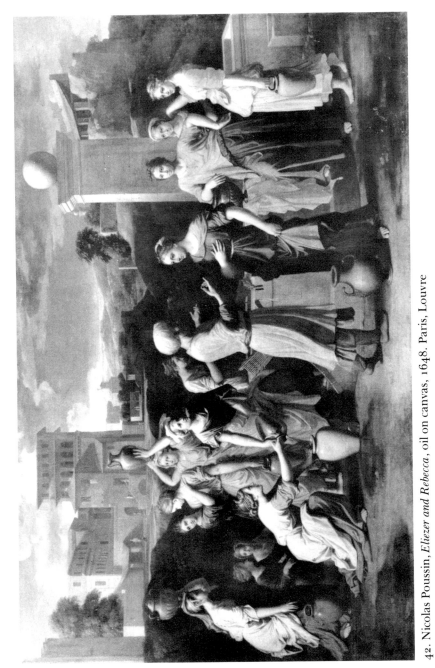

42. Nicolas Poussin, *Eliezer and Rebecca*, oil on canvas, 1648. Paris, Louvre

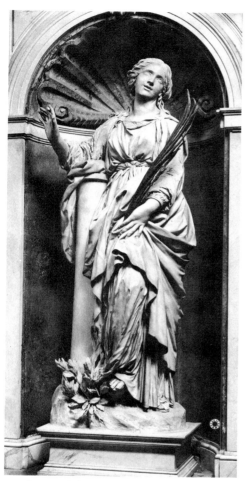

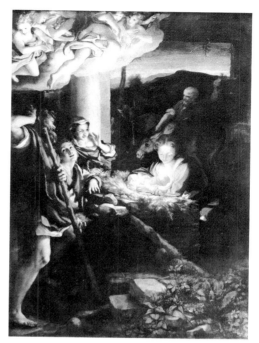

44. Antonio Correggio, *Nativity*, oil on canvas, 1527-30. Dresden, Gemäldegalerie

43. G. Bernini, *St. Bibiana*, marble, 1624-26. Rome, Church of St. Bibiana

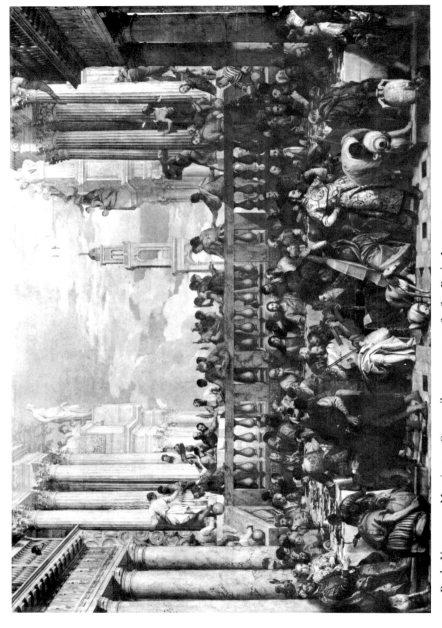

45. Paolo Veronese, *Marriage at Cana*, oil on canvas, 1562-63. Paris, Louvre

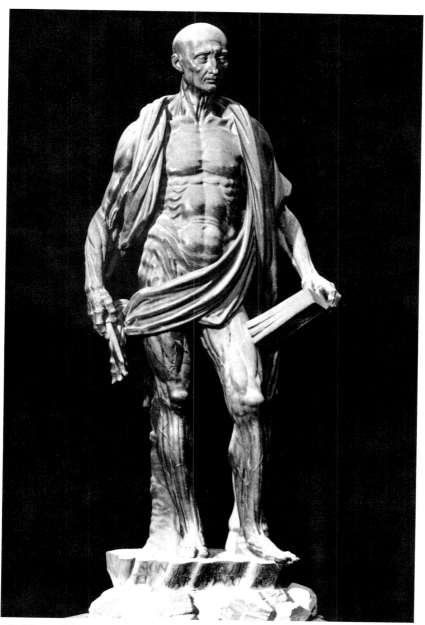

46. Marco d'Agrate, *St. Bartholomew*, marble, ca. 1562. Milan, Cathedral

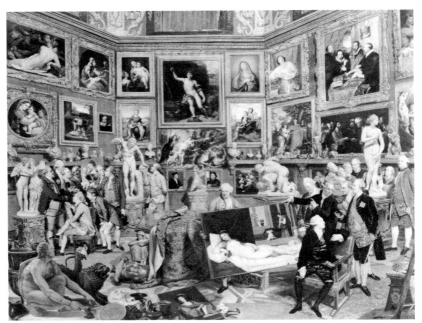

47. J. Zoffany, *The Medici Tribuna*, oil on canvas, 1772-78. London, Royal Collection

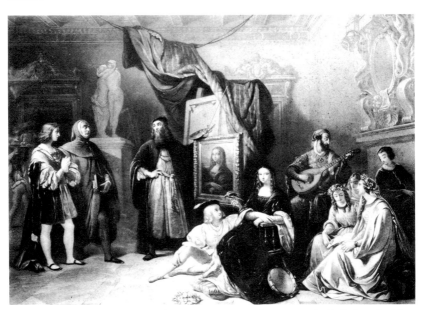

48. Ch. Lemoine, aquatint after A. Brune-Pagès, *Leonardo Painting the Mona Lisa* (1845). Paris, Bibliothèque Nationale

49. Fantin-Latour, *Homage to Delacroix*, oil on canvas, 1864. Paris, Louvre

50. Washington Allston, *Belshazzar's Feast*, oil on canvas, 1817-43. The Detroit Institute of Arts, Gift of the Allston Trust

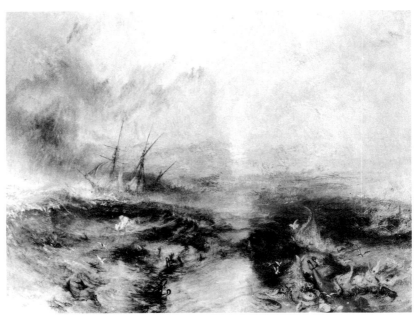

51. J.M.W. Turner, *The Slave Ship*, oil on canvas, 1840. Boston, Museum of Fine Arts

52. Michael Munkaczy, *Christ before Pilate*, oil on canvas, 1881. John Wanamaker, Philadelphia

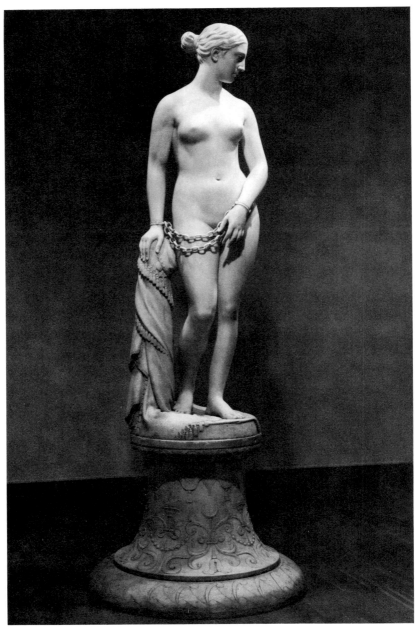

53. Hiram Powers, *The Greek Slave*, marble, ca. 1848. Yale University Art Gallery, Olive Louise Dann Fund

LIBRARY OF CONGRESS CATALOGING IN PUBLICATION DATA

Cahn, Walter.
 Masterpieces.

 (Princeton essays on the arts; 7)
 Bibliography: p.
 Includes index.
 1. Art—History. 2. Masterpieces, Artistic.
I. Title.
N72.5.C33 701 78-70281
ISBN 0-691-03945-3
ISBN 0-691-00320-3 pbk.